Grand Illusions

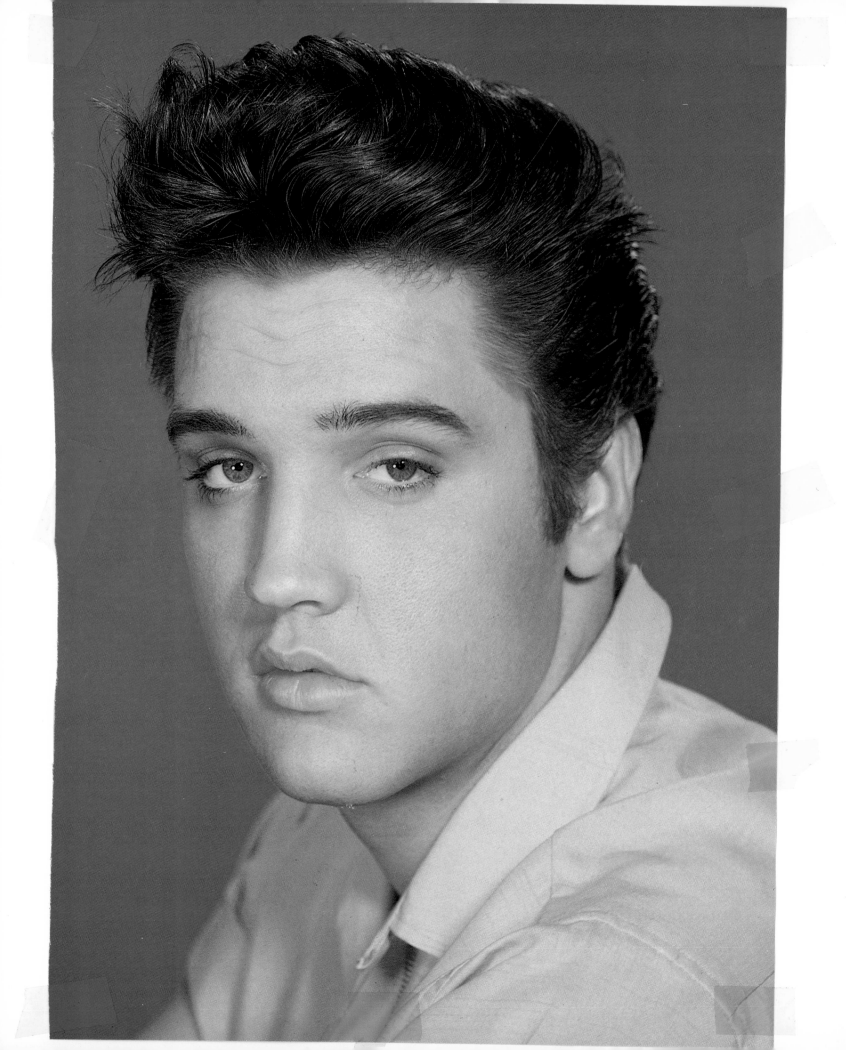

GRAND ILLUSIONS

by Richard Lawton

with a text by Hugo Leckey

McGraw-Hill Book Company

New York St. Louis San Francisco
Dusseldorf London Mexico Sydney Toronto

Library of Congress Cataloging in Publication Data
Lawton, Richard, 1943 Grand Illusions
1. Glamour photography. I. Leckey, Hugo, joint author
II. Title TR678.L38 779'.2 73-492
ISBN 0-07-036783-3

Designed by Richard Lawton

Printed in Italy by A. Mondadori, Verona

There are only diamonds in the whole world,
diamonds and perhaps the shabby gift of disillusion.

His was a great sin who first invented consciousness.
Let us lose it for a few hours.

— F. Scott Fitzgerald

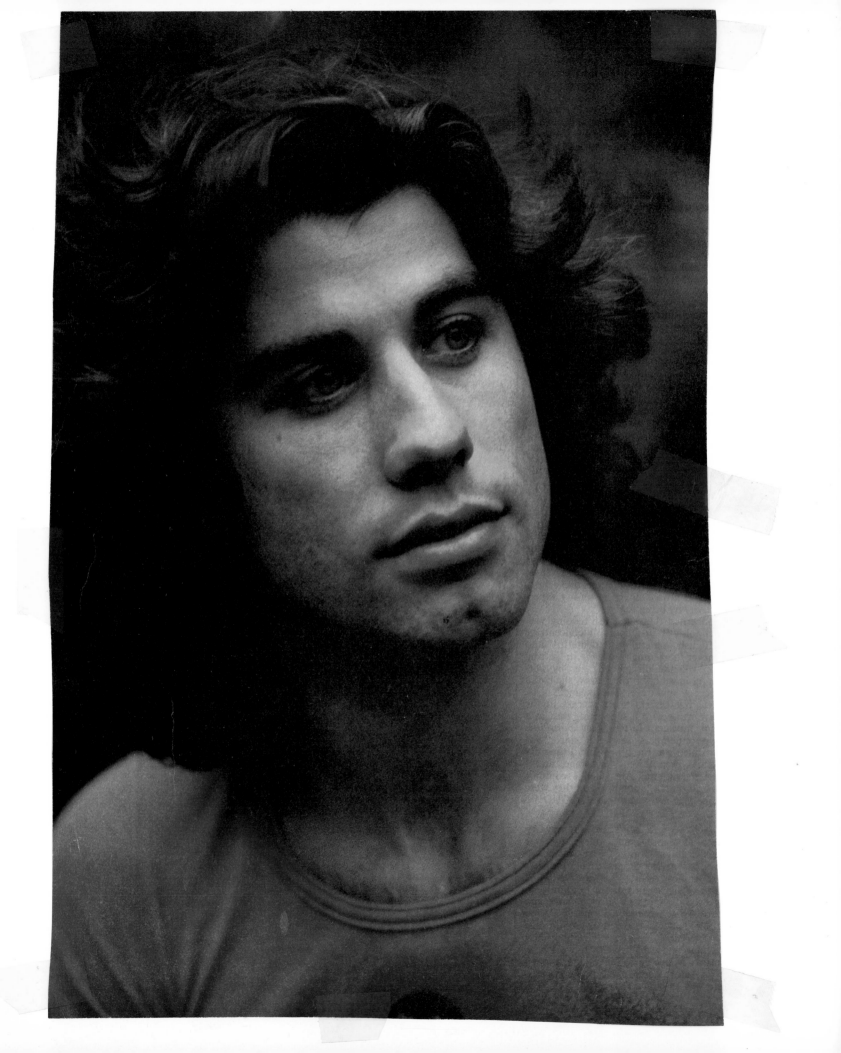

Contents

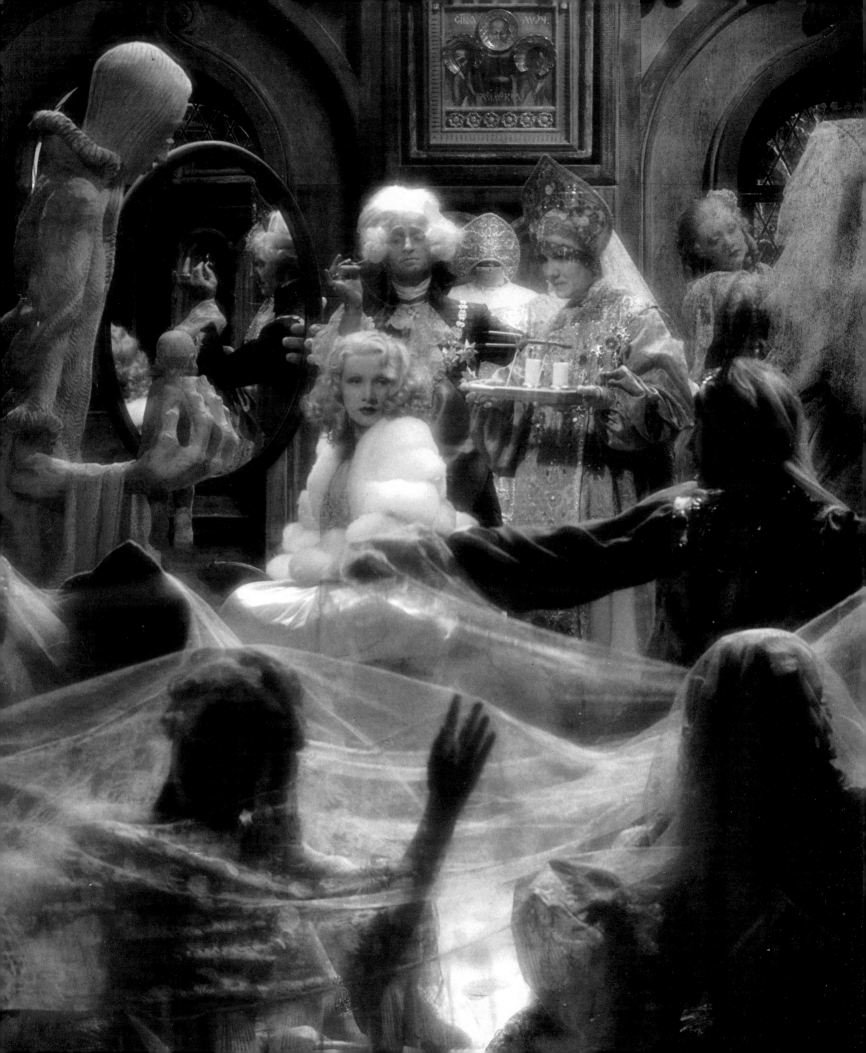

Introduction

Grand Illusions represents a selection of the most beautiful photographs to emerge from Hollywood's Golden Years. Their exquisite effects reflect the time and money lavished on every aspect of their production; the exotic beauty of their subjects speaks so tellingly of fantasies on which Hollywood balanced its success.

These photographs have been selected for their esthetic properties, and suggest where possible the range of images conjured through each decade. There has been no attempt to provide an exhaustive catalogue of movie personalities, while obversely, stars such as Lillian Gish and Marlene Dietrich are so clearly avatars, several portraits of them seemed irresistible.

Such a collection necessarily ends in the decade of the forties. After that time, the advent of candid photography and the financial decline of the big studios seldom allowed, and indeed discouraged, the calculated image-making of earlier decades. The photographs presented here were found mostly in private collections, remnants of a past whose luster is still fabulous.

Richard Lawton 1973

OPPOSITE Marlene Dietrich in *The Scarlet Empress*, 1934

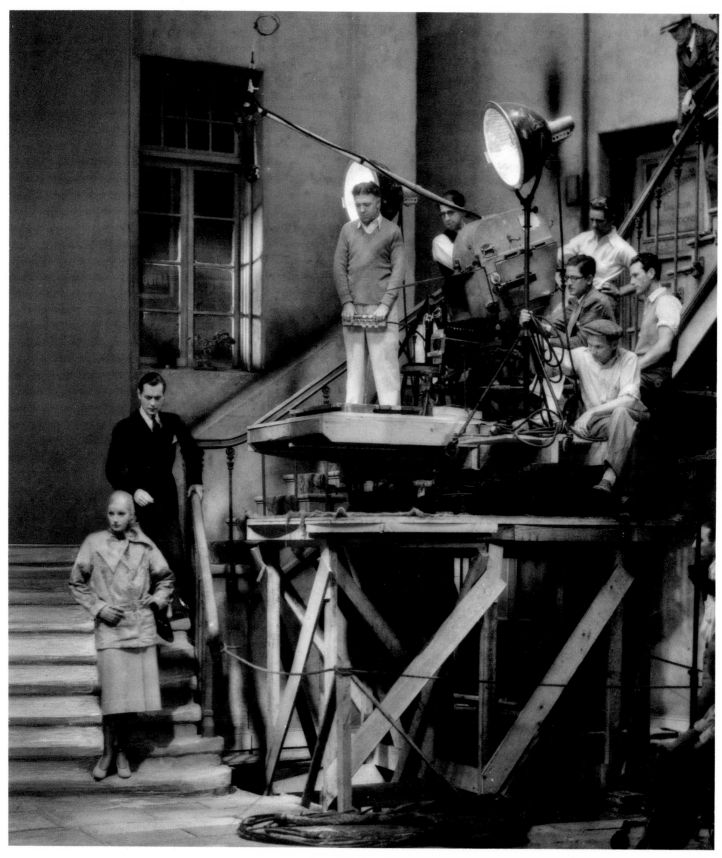

Greta Garbo, Robert Montgomery and Director, Clarence Brown on the set of *Inspiration*, 1931

Grand Illusions

by Hugo Leckey

I

Children, we were, when the movies first excited us. We whizzed on roller skates around the streets of Holywood in Northern Ireland, playing cops and robbers, cowboys and Indians. When cars swept by, we tumbled in the gutters, peering up girls' legs as they skipped rope on the sidewalk.

"Fit to be seen, clean to be worn," Ann Murphy sneered, skipping higher and higher until we could see her white cotton underpants. She sang as she skipped, her sandy hair dashing across her face and her white bloomers flashing as her skirt flew up and down:

> "Holy Mary, Mother of God
> I might have married Jimmy Todd
> But he's a Catholic, I'm a Prod
> Holy Mary, Mother of God!"

"Who's Jimmy Todd?" one of the girls asked.

"Oh," she said, catching her breath and placing her hands on her hips. "He's in the movies, and he's gorgeous!"

"Are you going tonight? There's something good on."

"Maybe and maybe not," Ann said. "Would you take a look at *her*."

A small girl, her hair drawn back tightly into braids, stood gazing at the ground.

"She can't go to the movies."

"And why not?" I asked.

"She's got religion. Her parents say the movies are graven images."

"What's a graven image?"

"Ask her, why don't you," said Ann. "She says it's something wicked. Like Catholics have."

"Is it true?" I asked her. "Will they not let you go?"

She kept her eyes down and backed away from us.

"Do you really believe in graven images?"

"My father says you're no better than Catholics."

"Go on away with you," Ann said. "You're a prig. You're a piggy-prig. You don't know what you're missing." She picked up her rope and began skipping.

"Graven images" – what a lovely way to think about the movies. I had no notion of what "graven" might actually mean, but it was a rich word, deep and doleful, something I wouldn't mind getting hold of. But wicked – imagine the movies being that. My parents were forever talking about *suitable* and *unsuitable* movies where I was concerned; but they'd never mentioned wicked. And if I'd saved my pocket money, and didn't have schoolwork, they'd let me go if they were of a mind to.

What a relief those movies were; an escape from the frightening thought of school. A church school. We arrived at nine in the morning to the tolling of a bell, and huddled in scarred desks for the daily round of spelling exercises, arithmetic and reading. We rubbed our knees together, shifted in our seats, and chewed the ends of pencils to the lead. The least sign of frivolity was punished by a caning; several strokes of a long, curved bamboo cane across the soft flesh of the palm.

My teacher, ancient and cranky, had taught my great-aunt the same boring round of multiplication tables. His ruddy face and wrinkled dewlaps turned purple when he got angry. He marched up and down the aisles marking time with his cane while forty children, shivering with fear, piped out in unison:

> "Three threes are nine,
> three fours are twelve,
> three fives are fifteen . . ."

He knew us all, knew every warbling pitch around him. One tremor of a mistake, a stutter or cough, and he was at your side; the bamboo

cane slamming on top of the desk with a crack that burned your heart. "Jesus Christ," he'd yell. "I'll cut the Charlie-balls off ye."

When the afternoon bell rang, we poured, we gushed like water from a broken pipe into the streets. The day's tension left us half-mad, running like wild dogs through the town, our satchels flying behind us. We came upon the village idiot playing with his stick in the gutter, and chased the poor man half-way up the street, until, in desperation, he grabbed with his bare hands horse manure lying in the road and pelted us with it until we fled on up into the hills and the woods.

I used to think of those woods, fresh and green, dotted with white, poisonous mistletoe. It was said the mistletoe had been grafted by the druids who centuries before had practised unspeakable rites there and gave the town its holy name. We scavenged for wild holly and mistletoe at Christmastime, decorating the house quite blithely with Christian and pagan tokens. "It's all in how you look at things," my grandfather observed. "And if you're serving dinner, bring on the duck first." In that spirit, Holywood came to be pronounced Hollywood, and occasionally the mail went astray by some six thousand miles.

From the hills, Holywood is one of the lovely towns in Northern Ireland. It falls to the blue edge of Belfast Lough, and looks at the green and black hulk of the Cave Hill across the water in County Antrim. Sun glints off the slated roofs and church steeples, one Protestant, one Catholic. Toy boats blow from the yardarms of the maypole which stands half-way between two cinemas. One, the old one, is gutted, burned to the ground; its blackened bricks, smothered with nettles, neglected since the days when silent movies were shown there. Those were the days, my grandfather told me, when for sixpence you could sit all afternoon watching movies, and munch from a bag of gobstoppers which came free with your ticket.

The other building, the new cinema, is a square brick building, the busiest in town, busier than either church or chapel, where Protestants and Catholics sit down together in the dark; where the poor and not-so-poor cough up their coins and let, for an hour or so, the bitterness of their lives dissolve in the glowing images on the screen, graven and serene.

We children were trapped in that town, preached at day and night to be decent law-abiding folk; pounded with one all-encompassing doctrine: "What will the neighbours think?" We walked in fear of the waggling tongue, the narrowed eye behind the lace curtain. For me, the only real relief lay in those graven images. How I needed some of those!

Randy for excitement and escape, I wedged the kitchen knife into the narrow lips of a piggy bank. The coins clinked tantalizingly against the blade and rolled away. Mantelpieces were carefully fingered for a penny or two left lying. The damp pockets of overcoats hanging in the hallway were ransacked for a sixpence buried in the fluff and grit of the lining. One shilling and ninepence – that's what it cost in my day. That was the admission to the cinema.

The cinema. The very name had a secret hiss to it, a hiss which made my ears prick up like a dog's and caused a tickle of delight in my stomach. The cinema, the flicks, the pictures or the movies – all the sacred names produced their own version of that intense sweep of joy. Ah, when my fingers stuck to the final coin in some dark corner. Had I counted right? By God, I had.

Not even the movies were as good as going to the movies. Once that handful of coins was jingling in my pocket, the movie of my life rolled on. Every action, line, and camera angle was carefully directed in my mind's eye until I was safely in my seat before the real screen.

But first of all, the authorities had to be cajoled into giving permission. A ritual had to be observed. This was no easy matter, for if I let slip an inkling of my intense excitement, the parents or grandparents would stiffen their Protestant backbones: Vice, alone, could drum such intensity, and the movies – certainly in Northern Ireland – are seen in the dim yellow light of such things.

In the early evening, my grandmother used

to sit, sewing or darning socks, close to the living room window where she could observe the passers-by and note, in particular, women's hats. Her vices were fairly simple. I would calm myself and drift into the room, sitting down to tease the dog, or listening with her to her favorite piece of music, "Roses from the South." Then I'd present myself close-up – bored, restless, complaining that my homework was finished and there was utterly nothing to do.

She'd go on sewing, silently; perhaps she'd lean forward to watch a hat go by.

"Do you think there's anything on at the flicks?" I'd suggest. Of course there was *something* on; there was always a movie showing. But "anything on" implied something suitable, edifying for youth.

She hadn't the vaguest idea, she said, wetting her thumb on her tongue and twirling her thread so that it would pass readily through the eye of the needle.

Then I would lounge, plastered with *ennui* on the floor, and sigh, and suggest since I had the money, perhaps I might go anyway. This listlessness, I learned, was vital; it implied such rare remove from the flesh that little harm could come to me, no matter what flashed across the screen.

There was a moment of stillness. A suspense which brought me close to shattering. The reasoning of adults was always so arbitrary and despotic. How could she refuse? I had gone through the ritual. I had told the acceptable lies. I hadn't asked for money. Oh, if only she would glance at the clock. That was a sign; then she was thinking about my bedtime, calculating when I might get home.

The moment stretched unbearably; it sagged. She licked her thumb again, and twirled her yarn. With a little jab she passed the moistened end through the needle. She glanced over the rim of her spectacles and nodded her consent.

Bingo! The camera speeded up. I skipped down the stairs and grabbed my jacket from a peg in the hallway as the front door floated from its hinges, tumbling slowly into space.

Moving through the growing darkness, past the church where the bell ringers were ringing their noisy hearts out. Past Granny Begg's orchard with its high brick wall. Images of pears and apples, the raw growl of her prowling dog, slipped out of focus as I began to run. Down the hill past Brook Street and the huge mound of earth where an ancient Irish king lay buried; past the Methodist Church where great water tanks and air-raid shelters were being dismantled; across the flat of Church Avenue, and around the corner onto Downshire Road.

There it was. The cinema. Blackish bricks plastered with billboards; recessed exit doors, their green paint scratched with slogans: Up the Pope! King Billy was here! There was a new movie every two days. Continuous showing at that.

The lobby floor gave off a reek of disinfectant. Behind a glass booth, the ticket girl, her hair in curlers, took my money. She pressed a button, and a ticket glided from the slot. Three steps more. The manager tore my ticket up, and pulled open the swinging glass paneled door. A bush of smoke and heat enveloped me. Shining through the dark was the great silver glow of the screen – white as mistletoe, mysterious, serene.

Ushers scuttled up and down the isles, their flashlights darting on the carpet, while the news flowed by. Troops marched across the Egyptian desert; bobsleds skidded on the shimmering curves in St. Moritz; invariably, King George waved and snipped a ribbon over dams or ships or hospitals. Oozing eyes of boxers and cigars and horses galloped by.

Girls with trays of lemonade and ice cream wandered up and down the aisles before the feature film started. Sixpences were passed from hand to hand along the packed rows, and plastic coated, dripping jugs and splintery wooden spoons came jostling back.

It didn't matter what the film was, not in those early days. The joy sprang from the wondrous images which floated on the screen; the lovely creatures and improbable sets they inhabited. It was an enchantment, where the mind, dancing with Betty Grable or wrestling

14

crocodiles with Tarzan or jumping from the ricochet of bullets, absorbed the swift violent frames, and then remembered them, augmented into one gigantic visual emotion.

Mile upon mile of celluloid was pulled across my eyes, reel by reel, year by year. I believed every foot and instant of it. While my parents lurked somewhere with the sure conviction that two types of movies, suitable and unsuitable, existed, my critical faculties were either missing or skillfully held in abeyance. Those graven images flowed on unhampered.

I have lost recollection of it, but my mother tells me that I had to be carried, screaming, from my very first movie, *Bambi*. The hunters' guns in combination with the little deer's mascara-loaded eyelashes could surely wring tears from stones. On the other hand, I have only intellectual reservations about blood sports; indeed, in my time I have indulged in many of them. I would like to think those early tears were my first critical stand against sentimentality and fantasy for its own sake. Not a great argument, perhaps, but at about age twelve such things began to concern me. I had gone for too long believing that the little mermaid in Andersen's fairy story had made a great mistake in relinquishing her beautiful tail for boney legs; legs, at that, which pained like knives driving into the flesh. How could anyone dispense with the gentle ease of underwater life for the agonies of school and life at home. Now I began to wonder what losing that tail might symbolize.

Ava Gardner kindly rescued me. I saw her in *One Touch of Venus* and the world of sensuality appeared. A dark flower grew.

This sharpening of vision – oh, it was a quick and pricking thing – led me to Belfast where the choice of theatres and movies was seemingly infinite. In Ireland, going to the movies is a national pastime, like talk. Belfast, a city of less than half a million souls, has on the order of ten major movie palaces, all of them packed every evening while queues three and four deep circle the block waiting for the next show. It is an unbridled passion.

When the death of King George VI was announced one morning in school, some of the girls began to cry. A lone warbling shriek rang out from the back row of the assembled school. "Dear God! They'll close the movies!" And they did.

Those great, gilded palaces in the heart of Belfast, all spectacle and romance. To enter from the raw drizzle and the clattering noise of traffic on the cobblestones into those immense foyers with their great-throated ceilings and deep-piled red carpets! It was like coming into a cathedral. Gold curlicues and brilliant chandeliers decorated the sweeping staircases and landings. People moved through these hallways with a certain grace and hush.

Occasionally you might catch a glimpse of yourself, unrecognized at first, in one of the resplendent mirrors. The clothes, the face, seemed for an instant to belong to someone else, someone familiar and incredibly grand; someone perhaps stepped off that silver screen? It was only you – but who would admit it? The spine stiffened ever so slightly. The feet set down with confidence into that deep carpet. A youth of noble bearing, touched with humility, handed his ticket to the usher with a kindly smile. Everyone, after all, had a place in this great world.

The Robe starring Richard Burton and Jean Simmons was showing that day. Such a film, in the parents' terms, was suitable; and I must confess, it suited me very well. To this day I cannot distinguish between the glorious sensuality of Jean Simmons' yellow robe as she stood near a marble bench gazing out over the Mediterranean, and the glorious sensuality of herself. All those elegant folds, draped so that the eye swept up and down; that lovely face, so full of innocent longing for Richard. Of course, when he appeared – who could resist those magnetic, wobbling eyes, all dolor and sincerity; that voice intoned with prophecy. But sexuality had no place in such a movie. It was all elevated from base thought as the two stars, draped and folded in Italian sun, their eyes filled with olive oil, walked nobly to a martyr's death my parents would certainly have

approved of. Oh, and they were right. I walked out of that theatre, my heart in Christ's hand; the resplendent mirrors carried no reflection.

But there were other movies, X movies. To say that Ireland is an unsophisticated land would be to wrong it. Long before the United States ever thought of rating their movies, the Irish scuffled about with their scissors and X's. X is such an unfortunate letter for a censor to have chosen. Why not the pleasant and frank O, or the stately, well-balanced Y? Why X, with all its dreadful connotations of cancelled, failed, rejected; the sign of crucifixion? How effectively it muddles the issue!

I heard a conversation the grown-ups had concerning some American cousins who were visiting. The man and his wife, affable and debonaire people, had gone to see an American film which carried an X rating. Now the Irish take the business of being hosts very seriously. Hand towels, for example, always appear in the bathroom when visitors arrive, even though no one ever uses them. "They've been to that dreadful movie," my mother's friend kept saying. "Now what'll they think of the Irish. They'll tell everybody in America!"

The American version of censorship, Hollywood's delicate code, caused little stir in Ireland. Indeed the Irish movie-goer has such a lust for fantasy, there's not much questioning of anything, let alone the invincible "realism" of the camera. Whatever hit that screen simply *was* America.

Consequently, when movie stars, even married ones, climbed into those softly lighted twin beds (the code forbade a double bed), it seemed the very soul of true sophistication. As a result, my mother longed most of her married life for twin beds, even in Ireland where the bedrooms are unheated, and one of the few comforts against the cold and dark is to cling to human flesh until time comes to light the kitchen fire before breakfast.

As I entered my teens, the pace of my movie-going speeded up, and it wasn't long before I discovered that element the parents found "unsuit-

able." Two movies, two gloriously "suitable" movies, aided and abetted me.

The first was *Captain Horatio Hornblower*, starring Gregory Peck and Virginia Mayo. What a clean movie! The sky, the seas, the ship, everything was clean. One scene will be imprinted on my mind forever. The Captain – and what a clean man Gregory Peck is – arrives home in his immaculate dress uniform. It was a long voyage, and he finds the lovely, silk-clad Lady Barbara waiting for him with a son. A son! Gregory Peck's sun-tanned fingers reach, in close-up, for the baby's frail, pink hand. The Lady Barbara coos. The baby coos. Did Gregory Peck coo? Was this immaculate conception? Oh, no doubt there was some explanation, some schedule which permitted this. But where was sex, just any hint of it in the middle of all this polished life? Something was missing – I didn't quite know what – but I was getting warmer.

The second glorious movie was Shaw's *St. Joan*, starring Ingrid Bergman. My mother had decided this was a movie I *should* see. Shaw, after all, was Shaw, and St. Joan was a saint.

Off we went to Belfast. I was dragging along, peering in shop windows as we passed. It all seemed so suitable, I dreaded it; it smelled of school.

St. Joan was condemned and fastened to the stake. Sex, its armored splendor, suddenly revealed itself as Ingrid Bergman's lovely face was going up in smoke. My mother shuddered, and glancing from the screen, I saw her stare in horror as a limp, lacey brassiere, tugged by a heavy hand, emerged from the collar of a young girl's coat. In a flash it crumpled into the hand and disappeared. The couple took up their inseparable clutch.

The secret was suddenly revealed. A life the grown-ups had carefully concealed by jerking on the reins, leading us this way and that. How swiftly the blinkers fell away; and there was a vast, midnight blue terrain.

My friends and I, we talked of little else but sex, the strange forms it took, the places it popped up in. We piled up piecemeal our wisps of

scavenged information. Great haystacks of half-truths and rumor; now and then a tidbit of experience. It was *our* secret now, and our teens were given over to its exploration.

We still piled into the cinema, dating now that we knew why. As fingers intertwined, thigh pressed on thigh, images of America flowed through our numbed brains. Images of splendor, wealth, terrain, and gorgeous women who cavorted with handsome men. It was simple and secure.

II

Then, with all the breezy confidence of going to a well-reviewed movie, I found myself going to America. I stood on the deck of the "Queen Elizabeth" as she steamed into New York Harbor on a bright May morning. Passengers, hundreds of them, lined the ship's rail to watch the fabled Manhattan skyline draw near.

And the skyline – it was *almost* there. Lounging on the rail, feeling ridiculously like Cary Grant, I reran his appearance in a movie where he sailed up this very channel, watching this very view. The sense of *déjà vu* was inescapable. But worst of all – even on this clear day when the skyscrapers pierced the sky like shining swords – what I had seen on film three thousand miles away was far more interesting. My present version was devoid of plot and poorly edited, while around me surged a bunch of extras, gesticulating, waving crumpled handkerchiefs, shouting in half a dozen languages I didn't know.

As the "Queen Elizabeth" turned gigantically, tugged bow and stern into her berth, Manhattan paid not the slightest attention. The skyscrapers came to rest, and I found myself alone, gazing at this immense movie set, directorless, lost in a sea of clichéd images.

How fine it would be if we were blessed with the voices of the great wits. Oscar Wilde, finding himself disappointed with the Atlantic Ocean, stepped ashore and announced, "I have nothing to declare but my genius." Dylan Thomas, on one of his libidinous romps, suggested that he came to America "looking for naked girls in wet mackintoshes."

As for me? I was speechless, waiting with dread certainty for the reels to run out, for the sun to set redly down, and the camera to dolly back as THE END floated above the glittering lights in the skyscrapers.

I looked down the channel past the Statue of Liberty to the Atlantic. There was nothing on the horizon; no small green hump of land in the distance. Ireland had gone, slipped away down the greasy face of the globe. The horses, the farms hedged into fields of brown and green, hills peppered with yellow-flowered gorse bushes; they only existed on a screen in my imagination.

Without ever having anticipated this might happen, I was suddenly without a country, devoid of home, floating between two great screens, playing no part on either one. I had seen so many movies that I was familiar with everything; it was an insidious familiarity, for it left me ill-equipped to grapple with anything new. I thought I knew so much about human experience, but all I really knew was that good would triumph during the final reel of a movie.

I began to touch things, to feel the iron side of the ship, the rough canvas on the life rings hanging by the rail. Over the side, hawsers, inches thick, swung in slack arcs to the rusty bollards on the dock. I was moored to America.

I had to go ashore; walk onto the movie set. I began to look more closely at the city etched around the ship. The traffic by the Hudson River, red, yellow and white cars, bucking and swerving from lane to lane. The sound of their horns and engines became distinguishable from the general wall of noise flooding the city. There was a tangible sense about those cars, blasting ahead, going a hundred places quite independent of any director's design. They implied a life, a real confused life, that I might have a part in.

Of course my relatives in California, my destination, would also have cars – long and luxurious. Or possibly convertibles with scream-

ing tires; maybe sedans, black and polished, purring outside a bank waiting for Humphrey Bogart to appear. There was something to be discovered in America; more than what was ordained by the scriptwriter and acted out by serene, human images. Something to be alive in.

That thought buoyed me up enough to shuffle through the customs line, produce my papers, money, health certificate and vaccination scar, and then balance my one large suitcase down the gangway onto American soil. Well, not soil exactly; cement, American cement. I felt it hard and ungiving under my foot.

Perhaps it was sentimental of me, but I wanted some element of celebration. I had reached the New World a little late in its development to cause a stir, but some token was called for. I had no thought of Indians appearing with roasted turkey; nor had I any impulse to drop thankfully to my knees and kiss the concrete. But it was, in my brief history, a significant moment. Some welcoming arm would have helped.

As it was, the ship had arrived earlier than expected, and I knew my distant cousin, an elderly woman who planned to meet me wearing a white carnation for identification, could not yet have arrived. There was nothing for it but to wait and light a cigarette. Two minutes later, just as the continent was beginning to settle under my feet, a large hand gripped my shoulder. I looked up into the narrow eyes of a policeman.

"Put out that cigarette. You're breaking the law," he said, and nodded to a NO SMOKING sign hanging high in the rafters of the dock building.

I squashed the tobacco, American tobacco at that, into a black and brown semi-circle on the dock. The cop strode off, his holstered gun scraping on his hip.

A few minutes later my distant cousin arrived carrying a whole bouquet of carnations. "You look just like your father," she said. "What do you think of America?"

The city of New York whirled by, unedited. My cousin, who was mighty sprightly in a car, cut in and out of traffic en route to Idlewild Airport. "This is a country for teenagers," she announced, "and women. Everything's geared for them, and in that order. The men work hard and die of heart attacks."

I didn't much care for the sound of that. I was almost twenty.

"There goes the United Nations! Pizza," she said, "you'll love it. In New York City you can see anything, anything at all."

At that moment we were paused for a traffic light, and I watched a bus draw away from the sidewalk, a snozzle of black smoke gushing from its exhaust pipe. A cripple, a middle-aged fellow on two crutches, was paddling along as quickly as he could trying to catch the bus. As it edged into the traffic lane, he tucked his crutches under his arm and dashed full pelt off the sidewalk, through the open door of the bus.

"See what I mean!" my distant cousin said.

On the flight to Los Angeles, I sat beside Ava Gardner. We didn't recognize each other.

I didn't recognize Hollywood either. "Where is it?" I kept asking my relatives who met me at the airport. The car whipped from lane to lane, gliding through intersections, enormous loops of concrete which seemed to lead directly back to where we had come from. "Where is it? Are we there now?"

"In a minute. In a few miles you'll see it."

They had thoughtfully brought me a pair of dark glasses to help ward off the smog, but it worked its way behind them, turning my eyeballs acid-red. The city bounced in tears as though distorted by a fish-eyed lens.

"Where is it? Are we there yet?"

"Take a look over there. That's part of it."

I pulled the glasses off and sponged out my eyes. To my left, where they had pointed, was a row of palm trees, their crowns a greenish-grey in the cotton air. Beyond the palms was a freeway curling out of sight. To my right, another row of palms, another freeway curling out of sight.

I lighted a cigarette and dragged on it. "Are we there yet?"

"Oh," they said. "We're past it."

"You shouldn't have brought that heavy coat," my aunt said.

"But what if it rains?"

"It doesn't."

"But sometimes."

"Just use the car."

I did. I purchased for eighty bucks an ancient, yellow De Soto convertible. I liked the image of a convertible, particularly since the roof rolled itself away at the touch of a button. In fact that very detail encouraged me to buy the car. But my aunt was wrong. It did rain; quite unexpectedly. I got soaked heaving and pulling on that wretched roof, while pools of water gathered on the leather seats and cascaded down the back of my neck.

But the car allowed me to search for Hollywood; the illusive, mythic beast which the whole world dreamed of in warm orange light. I set off on the freeways, and after my initial fear, I fell in love with them.

There's something quite magnificent about spurting off an on-ramp into the tiny space of air between two bumpers; wedging from lane to lane at sixty and seventy miles an hour. Since everyone else is charging along at the same speed, the sense of danger is reduced. Once in the fast lane, with my De Soto snorting and skipping along, the white stitches separating traffic led me on and on. Cars dashed up, fell back, and blinkers flicked. The magical Spanish names flowed by – El Camino Real, La Cienega, Sepulveda. I sped on and on into the night, chanting the city's original name, El Pueblo De Nuestra Senora La Reina De Los Angeles. And in the midst of this, Hollywood.

My problem was that I kept overshooting. No sooner did I spot a sign for Hollywood and start wedging over to the exit lane, than some great truck and trailer would hoot and roar alongside, leaving me headed for San Fernando or Ventura.

I finally hit it right, crawling into the breakdown lane and sneaking off onto Hollywood Boulevard. It was Saturday night and the road was jammed with cars, bumper to bumper, start and stop. Each car had its radio blaring, while four or five teenagers leaned out the windows, yelling, squirting water pistols at the teenagers in the cars coming toward them.

The sidewalks were crowded, mostly with teenagers, here and there a group of servicemen. I had crawled along for several blocks before it dawned on me that the kids in the cars watched the kids on the sidewalks, and the kids on the sidewalks watched the kids in the cars.

They observed each other with some dull-eyed hope that someone, somewhere, would be worth looking at. All of this glancing made for a certain tension, and I began to look around myself in case a movie star should suddenly appear; or credits might flash on the night sky whereupon everyone would settle down on the sidewalks to watch Hollywood take form.

But no! The traffic stuttered forward until it had progressed beyond the neon lights flickering on the theatre marquees. I had kept an eye on the films being shown, thinking I might go to one, but I had seen them all before leaving Ireland. The kids, it turned out, weren't going to the movies either. Where the boulevard darkened, they peeled off to right and left, circling the block, and joining the caravan of teenagers headed the opposite direction.

I parked the car a few blocks off the boulevard; it was a residential area on a steep road leading up into the Hollywood Hills. It was quiet there. A sense of darkness and suspense gathered around the hills; something old and patient. Walking down toward the lights, the boulevard glowed like a decorated set, flimsy, propped with poles. The camera was not meant to peer behind it.

I wandered slowly from block to block, pacing the gold stars set in the sidewalk, each one labeled with a star's name. Other people, doing the same thing, glanced up as we met; a vaguely hopeful stare which shifted quickly back to the pavement. I kept hearing my great-aunt's voice; her tiny soprano echoing when she knocked on the door: "It's only me. It's only me." But what

did we expect, we somnambulists – a burst of song? Doris Day dancing down the road in blue? Yes? Yes! That's exactly what I wanted; I'd been led to look for that.

And then I stumbled upon Grauman's Chinese Theatre. I'd seen those bulbous turrets and gigantic griffins on half a dozen newsreels when the great stars crashed onto their hands and knees to leave their imprints in the wet concrete and a message of undying gratitude to Sid Grauman.

I entered the landscaped courtyard with the same sense of awe I felt in the Tower of London. Here, in this tiny chapel, Richard II was assassinated; there Bette Davis sank for half an inch in stone. They, the celestial ones, had soiled themselves with grit from this place. I touched the handprint of Gregory Peck and thought of the immaculate conception. I looked with adoration at the dimpled marks of Audrey Hepburn. I wondered did it matter to them, this pilgrimage to Grauman's Chinese, crawling on the ground to be immortalized? Was the flickering image on the screen too impermanent? Kilroy was here. Is that what really counts?

I turned and noticed Shirley Temple's tiny hands and feet marks. Underneath was scrawled in big abandoned letters: I LOVE YOU ALL.

During the next few weeks I flailed around the Los Angeles basin, inspecting studios in Glendale, houses of movie stars in Bel Air, the beach colony at Malibu. The image of Hollywood which shone so surely in Holywood, Ireland refused to coalesce. The physical city resisted me; it failed to deliver its juices.

One morning, the *Los Angeles Times* provided a flicker of hope. An advertisement in the job column read: "Young man wanted. Training for Executive Position. Only serious need apply." The phone number to call had a Hollywood prefix.

The voice which answered me was grave and direct. I was told to appear the next day at 10 a.m. sharp, wearing a business suit. The address was Hollywood and Vine.

Hollywood and Vine – the most famous of all intersections. I shuddered with delight and hit the freeways. It was clear, after all, Hollywood did exist; business was being conducted. Of course I hadn't seen it before; the sound stages were closed to the general public. It was a glorious day; the smog had rolled out to sea and stayed there. The mountains were purple and sharp.

I found the building and was shown by a secretary to a waiting room. Presently she showed several more young men in. No one spoke. There was a deal of throat clearing and glancing at watches. An eye might meet and quickly shift. Were they the competition? All after this one position? Most of them wore the makings of business suits; jackets, ties knotted uncomfortably around ill-fitting collars. Some of them had pressed creases into their blue jeans and polished their loafers. More and more of these applicants kept arriving until the room was packed, standing room only. The air was full of tension and after-shave lotion.

The door opened again. This time the secretary entered the room and pulled the door completely open. In strode a man of perhaps thirty. He paused on the threshold, tucked some papers under his arm, and looked slowly around the room. Without having been quite conscious of having done so, we were all standing, quiet with anticipation.

If it is permissible in these days of American English to use the word "scoundrel," then this man, dressed in the latest color-coordinated style, a welt of ruffles on his shirtfront and a hank of teased hair hanging over his forehead, was surely that. He appeared without antecedents; he walked among us; he was baked in confidence as though he smeared it like tanning butter over his body.

"Gentlemen," he said, through perfectly wonderful teeth. "Come in and be seated."

There was a quick jostling and elbowing as we leapt to be first through the door. He paused, stiffened, and when he glanced back over his

shoulder, the crew of us had fallen into an amiable line, filtering into the conference room.

Then we were seated, we motleys, feeling ill-clothed and shifty in the eyes of this immaculate fellow. He took his time. He adjusted the air-conditioning control; he glanced from a window over the city, and turned away as though he were personally responsible for the entire metropolis. It was a great weight, one could see that. He made sure we could see *that* as he tugged his gold cufflinks. And then he smiled – such teeth – a smile so totally devoid of mirth that I felt my mouth go dry.

"Gentlemen," he began, almost in a whisper so we had to hold our breath to hear. "Here you are at Hollywood and Vine. You have come from all over this country; and here you are, at the center." He raised his hand and touched the ruffles on his shirt. "We all know what Hollywood and Vine means. I too came here; five years ago I had five dollars in my pocket." He bowed slightly so that our eyes were directed to his clothes before he paced the room, moving between us so that no one could possibly escape the vision of success he embodied.

As he paced, he talked of capitalism, of the great stake we all had in American society, of its rewards for the courageous. He turned, he smiled; he knew exactly who we were, he said, for he was one of us.

He asked rhetorical questions and answered them with the utmost simplicity. He drew us out; he received answers with all the modesty of a star acknowledging an Academy Award. We were too kind; he had nothing to do with it.

He quickened his pace; the pitch of his monologue rose. "What is it makes the world go round? Is it love? That's what the song-writers tell us, isn't it? But is it love? You know that's possibly not true. I can see that. You gentlemen are sophisticates. You know about love, don't you? You've had it in your time.

"So what, then, makes the world go round? It's not love. No one ever died for love, did they? Think about that. Think what people die for. They die for money, don't they? What they *love*

is money. That's what you're here for, isn't it? You want money."

He paused. He unbuttoned his jacket. He plunged his hands deep into his pockets and began to jingle coins. "Think about money. How are you going to get it? Good businessmen make money, don't they?"

The group gave a few scattered grunts.

He suddenly crouched into a tackle position. "You're going to make good businessmen, aren't you?"

Three or four boys muttered positively.

"Louder, louder, do you hear?"

"Yeah! Yes!"

"Good. Remember, that's the best you can get. Never forget that."

He plucked a thread from his sleeve, twirled it in his fingers and flicked it on the floor. None of us moved.

"All right, gentlemen. Now for the million dollar question. Let's see who's the bright one who can get the answer.

"What is it makes a good businessman. There you sit, dressed in rags. Don't you have any idea? What? None of you?"

One lone hand went up across the room. He waved it away.

"I'm going to tell you what it is; and don't forget it. It's greed.

"GREED makes a good businessman. The greedier you are, the better businessmen you'll make."

He began pacing the room again, moving among us. "If you're not greedy, I don't want you. I want the greedy ones, the ones like me – they're the ones who'll work and get somewhere.

"Are you greedy?" He pushed his face close to the boy to my right. Those teeth were leading a life of their own. "Are you greedy?"

The boy nodded, quickly.

"Then let me hear it from you. Are you greedy?"

"Yes."

"Let me hear it from all of you."

"Yes, yes."

"Yes, what!"

"Yes, Sir."

"That's better. I expect discipline in this outfit. You don't make money without discipline.

"Now take a look at these." He handed out a series of color photographs. There he was in a Jaguar sportscar; there he was alighting from a jet plane. There was a blonde leaning seductively against the Jaguar. In the next shot he had one hand on the Jag, the other on the blonde.

"Isn't she something," he said in a voice which might have referred to the girl, the plane or the car. "See that chick. Ever see her in the movies? She's mine.

"But don't think boobs like that come cheap. I got her because of greed. She loves my money and she *loves* me. Me and my money."

Even though the room was air-conditioned, I began to feel sweat creep around my collar and start from my scalp. About half the group leaned forward, taking in every word, their faces filled with light. A few of them still scrutinized the snapshots, tilting them this way and that.

"Okay. Lunch. You've got thirty minutes precisely. This is your first test. If you're late, you're out."

The intersection of Hollywood and Vine was dazzlingly hot. I joined several of the others for a hamburger in a coffee shop.

"He's some operator," one of them said.

"Yeah, he's really got it made."

"What do you think he's after?" I asked. No one answered. Everybody was suddenly busy with their food. "But he hasn't told us a thing."

"So what! Didn't you see that posh place he's got his office in? And that car?"

"It's the way this town is. You gotta get in there when you see a chance."

"They got front men working like this."

"Who?" I asked.

"Jesus man. The studios, that's who. Come on, we'd better get back."

We picked up our checks and paid the cashier. The streets were crowded with people. A hustler was standing near the intersection watching himself and passers-by reflected in a bank window. Across the street, an old man dressed up as Buffalo Bill waved to passing cars.

"Are you really going back in there?" I asked the guy nearest me.

"Listen," he said. "I'm looking for a break. I need some bucks. I'm holed up in a motel, and it ain't cheap."

"But he's a swizzler. It's a put-on. God knows what he's after."

"Yeah. That's what I like about it. I've heard of a lot of kids getting breaks this way. There ain't no other way to the top in this town."

"Are you from here?"

"Nope. Montana."

"Been here long?"

"Couple of weeks."

He was standing in the conference room, looking at his watch as we entered. At exactly the half hour, he closed the door and began.

"Okay. This afternoon you get your second test. On paper this time.

"Now you guys have already spent the morning here. You got up early, cleaned up, put on your best clothes, and drove from all over the place. You probably had to pay for parking; now you've paid for your lunch. In other words — in business terms – you've got a sizeable investment here already.

"And let me tell you. You don't want to lose it. There's a lot of kids in this town from all over. If you can't cut it here, an ad in the paper brings them rolling in. They're all here looking for the same thing. Remember that. You're dispensable.

"I'll give it to you straight. You can make a fortune doing this if you have your wits about you, and if you work. A kid I started last week has made five hundred bucks already. All you've got to do is ask yourself, what do people value most apart from money. Eh? It's education, isn't it? And why? 'Cause that's the way to get into business.

"Now, just ask yourself. What home is complete without an encyclopedia. I mean, the kids have to get a good start . . ."

So that was it. Another shyster salesman. A

door to door Johnny peddling books. I got up quietly and made for the door.

"Hey, wait a minute there."

"No thanks. Not interested."

He grabbed his pictures of the car and the girl. "What's the matter with you? You think you're not greedy like the rest of us? Look at this guy, fellas. He's a quitter."

"That's me," I said, closing the door behind me. I waited to see if anyone else would follow. No one did. I could hear that scoundrel's voice through the door. "See, not everybody can make it in this town. That guy, he'll never make it. You've got to *need* to get somewhere.

"Listen. Life on the big screen's got to start somewhere. You meet a lot of people in this job. Who knows where it'll get you. And look at that car; look at that chick . . ."

I got a job, looking after dogs in an animal hospital. It wasn't a glamorous profession, but it was honest; and I liked the animals, the ones that didn't bite.

Animal medicine is one of those jobs where you get your hands dirty – sometimes very dirty; and in the great scheme of human affairs, the profession doesn't rate high in glamour. The doctor who owned the hospital had made a good deal of money, and he was careful to keep his hands very clean. He spent most of his time golfing and cavorting around country clubs in his Thunderbird.

Much of our business involved boarding animals whose owners were on vacation or whatever. The doctors never handled these animals; that was left to the kennel boys. When their owners called to pick them up, we would check them over, comb and fluff them up a bit, and take them up front to their owners.

So it was that a poodle owned by Greer Garson fell into my hands. I got a call to pick up a dog from the front office, and headed up the corridor by the doctor's office and the examining rooms. I had just passed the office when something soft and white swept by, throwing me against the wall. There was a sound of rubber squeaking on the floor, and by the time I gained my balance the doctor had already reached the waiting room.

To call her beautiful would draw attention to something scarcely relevant. She exuded an aura which stilled the entire hospital. She was dressed in black – black high heels, black stockings, a black coat over a black dress; black glasses and a black scarf from under which some red hair strayed. She stood close to the wall – perhaps her shoulder was even touching it – trying to conduct her dog's business as quietly and demurely as possible. Had she walked in under spotlights, dressed only in G-string and pasties, she could not have caused a greater stir.

The waiting room was crowded with owners and pets, all of whom, human and canine, were silent, frozen in their respective places, their eyes glued to this famous apparition. In fact the only living thing which seemed immune to all this was the Garson dog. The good Doctor held it in his arms, fondling and petting it while it lolled and licked his face. Knowing how he hated to be licked, I extended my hand to take the dog from him. "That will be all right," he said quickly, and turning his head from the light, shot me such a glance that I knew surely I was out of a job.

For at least five minutes the most animated of conversations took place; one little pleasantry after another producing side-splitting convulsions in the Doctor, while the dog licked one side of his face and then the other.

She left as quietly as she had come. The door clicked closed with a crack of thunder. A babble of conversation broke out; dogs growled; typewriters clicked. "Yes," said the Doctor to one of his clients, "That was her. That was Greer Garson." He clutched her poodle to him and moved past the spot she had occupied as though the air were sacred.

But if I laughed so readily at the good Doctor, I was soon to get my own comeuppance. I met Christopher Isherwood on the beach near Santa Monica.

I recognized him in a flash – those improba-

ble stiff-haired eyebrows; Herr Issyvoo. Had he been sitting on the beach surrounded by piles of manuscript, a writing desk, and all the characters from *The Berlin Stories* gathered at his knee, I could not have been more abashed.

Isherwood occasionally taught at the college I attended; I was with some of his former students, and they were quick to join him, babbling away about motor bikes. I was introduced and heard my voice rumble out an octave deeper, fraught with British vowels. It was hopeless. I had just touched the hand that touched Virginia Woolf's, a proven hand in the great tradition of English letters. On the beach, yet.

How I wanted to talk to him; to tell him I had read his books, and the books they grew from; to say, Here I am, and I have an inkling of what matters to you. I couldn't. I didn't know where to begin. What could I say? I've published some poems and they're too compressed to be readable? How I could imagine him secretly writhing as yet another clumsy-egoed young writer began to trample ignorant and unheeding around this remarkable and humble man. In short, I knew that if I said one word, he would be decent and kind to me. I couldn't stand it.

Instead I dug my toes into the warm sand and thought about the artists, the expatriots, who had come to Hollywood during its early years. Stravinsky, Huxley, Rachmaninoff, a host of others, fleeing political machinations in Europe. How strange that they should live here, know each other, and one by one depart, without ever having affected the motion picture industry in any profound way. Here I was, sitting on the beach, speechless, beside one of the last survivors of that extraordinary group. If only the visual and technical brilliance of the industry had been matched by its content; if only these men had had a greater stake in it.

We got up; we brushed the sand from our bodies, and set off for the freeways. "I wish you'd get rid of those motorcycles," Isherwood said. "You'll get killed."

A few years and jobs later, I finally made contact with the great causer of fantasies, the fabled beast of Hollywood. It was inevitable, I suppose, that it didn't reveal itself directly; it didn't come in legal-size envelopes or humming limousines, or massive studio lots; it wasn't mentioned in the pages of *Variety*.

In fact, I bumped into it at a Fourth of July party in Sierra Madre, a small town lingering in the foothills about an hour's drive from Hollywood. I met two Swedish cameramen who had recently arrived in California to make a movie, an independently produced movie, pulled together on a shoestring by a friend of theirs.

They had gladly taken the opportunity to come from Sweden for very little money; it was a chance to see the States and Hollywood in particular. Their degree of interest surprised me a little. I had thought of the Swedish film industry as sophisticated and successful in ways Hollywood was not; and furthermore, these two had worked in big Swedish studios, even for a time with Bergman.

"But Bergman loves Hollywood movies," they told me, and referred to his admiration for the opening sequence from *West Side Story*. They spoke of film with exquisite familiarity, always from the camera's point of view. They would often hold their hands at arm's length, extending their thumbs and forefingers to suggest a frame they peered through.

"Ah, that shot from *Judgment at Nuremberg*, that great circular shot in the courtroom. That is genius."

Hollywood's technical achievements – I can't recall them speaking of much else – delighted them. "No one in this country," they insisted, "seems to have any thought of Hollywood's technique. It is marvelous. Even in Japan, they give the Mitchell camera a place in their parades. That camera, it made all the difference."

"You mean George Mitchell's camera?" I asked.

"At least you know of it."

"Know of it! I've met him. Sailed on his

boat "Beagle." And we talked about that camera, how it works. I had no notion it was so important."

"But you will. You will. You will work with us, right? We need help; we're looking for people. We'll introduce you to the producer."

What we did – it must have been the way the first film makers worked in those early days. Crazy men, alive with the thrill of their new toys, aiming those cameras at anything that moved, picking up from the streets anyone who would take direction for a dollar until the sun went down. Inventors, tinkerers, men mad with imagination, squinting through miles of exposed film in editing machines. What we did in Sierra Madre that summer must have been very much the way it was back in the twenties.

We had a beat-up green Chevy sedan to haul our gear around – the lights, the sound equipment, booms, a dolly, and one precious camera which we carried everywhere. I was hired as grip, assistant to the cameramen, character actor, extra, lunch boy, and the guy whose muscles ached holding the sound boom and microphone perfectly still and clear of the camera's range while shooting. Two months we labored on that film, day and night, and it was bloody marvelous.

One night we mobilized half the population of Sierra Madre for a crowd scene; the next morning we were up at dawn, shooting in the ashes left from a forest fire – on film it looked like the pit of hell. For two wearisome nights, miles from our base, we shot beach scenes. We used the days to set campfires and rehearse; then shooting swiftly in the dark before the fires got too low to show on film. Except that someone had forgotten to bring the cameraman – he was fifty miles away. They were horrendous days. The leading man fought with the director who claimed he hated actors and showed it. The leading man got drunk, and staggered through his scenes for take after take. The fires went out. The girls who had to appear in bikinis got cold, and when they went to their cars for clothes, found that everything had been stolen. We

finally finished the sequence and dragged our equipment home at dawn.

The rushes arrived the next day – entirely blank. By some dreadful accident, the shutter had slipped down behind the camera's bleak eye, and it had seen nothing for two days; not an inch of film was exposed. The cameraman tore his beard; the director wept and rolled on the floor. We had to do the whole thing over again.

We worked fast – the way surgeons did before anaesthesia was discovered. There wasn't enough money to take much time. Once, in a scene of mine, the director called out "Print it" before I realized they'd done a take. There was little time for images, at least the more glamorous variety.

During casting we had some; it involved the selection of our leading lady. Our base of operations was a house, a shack, toppling on a sandy cliff near the foothills. That was our address and there was our telephone. It was there we stored equipment too precious to be locked in the car.

A cliff path, narrow and crumbling, bordered with weeds and cactus, made four or five zig-zags between the road and the shack. Twice and three times a day, we had to skitter up and down that treacherous path, the heavy camera weighing us into the sand, making us lurch like elephants. And up that same path came half a dozen leading ladies, all ingenues.

They had come, these starlets, from all over the Mid-west and set up apartments in Hollywood; apartments typically littered with clothes, make-up and empty yogurt cartons. There they lived and waited for their telephones to ring. Days on end waiting for the shrill bell and the voice to tell them they were wanted for a try-out, a screen test, a call-back.

We called them to make screen tests. (Where in God's name is Sierra Madre? You could feel them vibrate with that thought.) Yes, of course, they said. Of course they could be there at three o'clock. And under their cool professional tones, under their calm notation of freeways and turn-offs, under all this the thought was winking – Oh, of course we've all read the industry is di-

versifying; independent companies all over the place. And they would reorganize their fantasies. The great grey studio would blow away, and the breath-taking swiftness of the Sierra Madre mountains came into focus.

They stepped from their cars, dressed to perfection, while the sun flogged their shoulders, and beat up from the earth into their faces. They adjusted their sunglasses and gazed with dismay at our shack shimmering in heat waves above their heads. They rechecked the address, tucked the paper into their purses and, one by one, day after day, started up the crumbling pathway.

Their shoes were pointed and clean, their nylons unsnagged; the make-up on their eyelashes held against the heat. Up they came, stately young princesses, screwing all the professionalism their dreadful trade had taught them into one great commandment: Thou shalt not sweat. The path swayed; their shoes picked up a circle of dust; they paused; they raised their heads to the shack, and on they came. The six queens attending the death of King Arthur would have been hard pressed to match this grace, this courage. They arrived at the door, a tattered screen door; their pale knuckles tapped. They were offered a glass of fairly cool Coca-Cola and sent back down again. The screen tests were made in the basement of a nearby house.

One of those starlets provided me a hint of real illusion. She arrived at the screen door, cool as a cucumber, in a light green suit. Her ascent must have been terrific; she was utterly unruffled. And her eyes. Her eyes matched the green of her suit. Never before or since have I seen such eyes; they were green the way glazes are green; they were green with the mythical green of Ireland. They were everything green and they glowed. At me!

She had no idea who I was; what my position was. I didn't tell her. I said we were expecting her, and we must go to another building for the test. She cooed; she pressed lightly on my arm as we descended, gratefully fumbling down that goat-path. She was so pleased, she said, to have a chance to test for the film. She was

honored. The snakes wriggling in the undergrowth stilled their rattles as she went by.

We tested her, and asked her to come the following day for a further scene. She arrived in that dark basement, its walls dusty and infested with malevolent black widow spiders. She crossed the room, and even in that half-light, her eyes were the most radiant blue! Blue – I thought I was mad with love, or sick from it. Blue the way cornflowers are blue. Blue the way David Lean made Peter O'Toole's eyes look in the desert when he played Lawrence.

The director greeted her. She stood before him poised, elegant, humble. The effort didn't show. I took her to the make-up room.

"Hey," I whispered. "I think I'm going cuckoo. Yesterday I swore your eyes were green."

By now she knew I was a nobody, so she winked and said nothing until we were out of earshot of the crew. She put her hand to her mouth and burst out laughing. "They're contact lenses. What's the matter with you. You want me to look like a mouse?"

She didn't get the part. But then, to my amazement, she was perfectly happy to work on the set as a script girl for twenty bucks a week. Her eyes were brown; she wore blue jeans and worked day and night with the rest of us.

It was September before we finished shooting. The final scene involved the leading man staggering out of a bar into the dawn, and it had to be setup before the sun was near the horizon.

I shared an apartment with the sound man and the assistant cameraman. We set the alarm clock for four in the morning and fell asleep. A pounding at the door and the most incredible cursing I have ever in my life heard – its speed and density were awesome – woke us. It was the producer, and we were already over an hour late.

To make it worse, the location was twenty miles away, on the edge of the desert. The green Chevy sagged and swayed and hit a frightening ninety miles an hour. The producer cursed; the car fled beneath us.

We set up as quickly as possible. The director and the cameraman stood looking at the

swiftly whitening horizon. We did an interior in one take, and left a second shot for later. We had made it just in time. But the bloody leading man kept fluffing on a line. He couldn't remember it. We did three takes – all of them unprintable. The sun wouldn't be still. We rewrote the line to make it easier. We begged him to say anything at all, improvise something that seemed right. We'd dub it later. We'd slit his throat.

The producer pounded his fists on the wall. The director was icy calm. The cameraman kept glancing at his light meter. The leading man was trembling, close to tears.

It was too late. Like the arrows which pierced the body of St. Anthony, the sun's first rays struck the set. That same sun which drew the film industry to California. Hopeless.

The producer, perhaps inspired by the image of even more money slipping through his bruised and swollen fists, located an enormous roll of roofing felt, some four feet wide. There was one chance left. We stapled sheets of it together, making a great blind supported on two poles. It blocked out the sun; the indirect rays were almost like dawn. In thirty seconds the take was complete, word-perfect. "Print it," the director said, and went for coffee.

And then I was dancing with Maggie Phillips. We were at a party in the Hollywood Hills. She wore a tight black dress and sailed in circles to keep the wispiest, frail white scarf twirling about her slender throat.

"I hate, hate, hate Hollywood, California," Maggie said, letting her arm float through the air so that her drink performed an exquisite arabesque. She balanced her other arm on my shoulder and leaned backward until the boney protuberances of our pelvises bumped.

"And why do, do, do you keep coming here then?" I asked. There was a wave of perfume as her ear whizzed past my nose; the merest brush of her scarf across my shaven beard, and she disappeared through the dancers. I toppled backwards onto a couch beside Florence MacMichael.

"Well, what was all that about?" I asked, swigging down my drink.

"We've been friends for years," Flo said, using her throatiest voice.

"Why all the hate, hate, hate?"

"She's wonderfully talented. New York's been tough on her."

"She says she's Welsh."

"You know she did *Summer and Smoke* in Dallas and New York. It was perfectly marvelous."

"I want to meet an American who admits it."

"And then Geraldine Page made a huge smash with it later, off-Broadway."

"It's wonderfully fashionable to hate this place, isn't it?"

"She's here for a pilot film. They pay wonderfully, you know. Three days with Audrey Hepburn in *The Children's Hour* and I lived well for a month. Of course, I landed on the cutting room floor," she laughed.

"How can you stand it? The whole business."

"I love it, doing character work, working in a character way. The other thing – " She waved her hand in front of her face.

"You know," she went on. "When I was beginning, Barbara Bel Geddes and I were playing in New York. Our first Broadway show, *Out of the Frying Pan*. We were silly – you know – a bit giddy. We'd go home in the subway with our stage make-up on. Barbara used to say, 'I want to get to the top in this business.' And I used to ask her, 'What are you going to do when you get there?'"

The dancers had stopped and were selecting more records. In the center of the floor, a middle-aged man was standing on his head. I nudged Flo and nodded in his direction.

"Oh dear," she whispered. "He's in my acting class."

"Is he drunk?"

"He can balance, it seems."

"It's all so like bullfighting. Leap into the big ring and maybe you're famous overnight."

"Well, yes; a bit. But the people who work

over and over again, they know their business."

As I went off to the kitchen for another drink, the man was still standing on his head, the veins fairly pulsing and blue in his neck.

"Hi," he said.

"How do you do." I held up my glass. "I'm on my way to get a drink."

"Good," he said. "Good. You enjoy it."

A girl was standing by the ice bucket, talking to no one in particular. "Richard Chamberlain. What a man," she giggled. "Just think – he gets to wash himself every day."

"Well, what about *that*," a woman with a Mid-western accent said. "The first agent I ever talked to – it was at a party, and he'd seen me in that showcase thing." She raised her long cigarette holder and blew the ash off her cigarette. "He saw me in *that*, and then I ran into him at a party. He was this funny little fellow, built like a penny-farthing bicycle – you know, all round below . . . so he said – I mean we were talking about my career – he said, 'Honey, do you swing?' And I thought . . . " She was shrieking with laughter. "I thought he meant – did I swing on trees? And so I said, 'What, at my age?'

"Darlings, I haven't got an agent yet!"

I took my drink into the other room, looking for Florence. The hostess met me by the door. She was a middle-aged woman; her hair streaked with grey, straggling from the pins which held it up. When she put her arms around my shoulders, I realized she was drunk.

"Do you want to sit down?" I asked.

"You artists," she said, beginning to cry. "I'm sick of all of you. You have nothing. Nothing, do you hear? Nothing but talk. Talk about what you're going to do, about what you want to do; talk about everything. And you never have a fucking penny; you don't have a pot to piss in. Day to day, clawing. You've got nothing.

"Listen," she said, pushing me back against the door. Her eyes were blazing. "I used to have money. I used to open my closet. I had fifty pair of shoes, you hear me? Fifty pair. Sitting right there. Right on the floor for me. To choose from.

And now? What have I, tell me? I've got sneakers on my feet and this shack sliding down the hill. I'm sick of you artists. You've nothing but images in your heads. You're selfish, every last one of you. Selfish bastards.

"Why did I give it up? I had money, security. I didn't know it. I ran off with a no-good actor. Look at us. We have nothing. When I wake up dead in the morning – no one, not one of you, will give a shit." She staggered off towards the kitchen.

I went out onto the veranda. It was covered with wisteria, and the air was filled with the scent of night-blooming jasmine. The babble of voices at my back pushed me on out into the garden. It was a cactus garden. Here and there a tall yucca stood like a dimly glowing candle. There was a stillness in the hills, as though someone were sleeping and should not be disturbed. I lay down on the sandy soil, listening to the scattered barks of coyotes as they moved down through the canyons in search of water. The chill glimmer of a howl lay on the night air.

The real, alive, suffering people. The achievers and the self-destroyers. Somehow, from the interaction of them all, all the myths, all the energies plunged into this valley, was a great flux, a spiral of silver wind which had blown across the face of the earth. It had come from here; from this inexplicable place.

Hollywood – what we understand by Hollywood – could not have happened anywhere else. A motion picture industry might have sprung up in another place, but it would not have been seared with the same baffling luminance.

People were getting into their cars in the driveway, talking, saying goodnight. I got up and wandered closer to the hills.

The power of Hollywood is undeniable; and yet, for all its talent, productivity, imagination, the very word suggests a fantasy which skips across the water like a flat stone. Where is the philosophy which can describe this power, this frippery? How do we know so surely that this intractable name will live in legend?

Standing here amid the cactus, close to the

hills overlooking the city, I think of the land, of the deserts and mountains, the chaparral. It has not been tamed and settled, merely built upon. At night you can hear the land breathe. The hills roll up against the night sky like great dromedaries slumbering on their knees while the city plays.

Think of the early film makers who burst into this valley in search of eternal sunlight; how they must have opened their arms to this semi-paradise, free from smog and concrete. How they must have stood in silence near these hills and heard the deep muffled breathing of the beast. At what instant would it rise up and lumber into another age? How they must have turned their cameras from this dark, troubled sleep with a sense of frenzy and escape.

I escaped – at least I thought I did – to a city on the East Coast. And for a while I fooled myself that I was clear of the star-spangled images.

A local television station had an eye out for a critic-at-large, and that same eye happened to scan some of my articles. I was asked to come and have a talk.

I arrived at the station to meet one of the big shots, and was received by his secretary, a coy young thing. Her tone was tinged with anticipation bordering on hysteria as though something of tremendous importance were taking place; or perhaps she feared her boss might descend on us *ex machina* in a large balloon.

I was kept waiting for quite sometime, and I had the distinct impression this was a matter of form. The big shot had to give the impression of importance. At any rate, his secretary twittered prepared statements over the telephone, and ran to and fro between file cabinets, seemingly checking and rechecking the same folder half a dozen times. It was a put-up job.

A buzzer buzzed, and I was led through a series of corridors to the very heart of the television station. Linoleum gave way to carpeting. A door was opened, and there was the boss. He

was a gross mountain of a man – he might have been a ride at Disneyland – sitting behind a mighty desk, all white shirt and hoops of flesh hanging over the collar.

He nodded for me to sit down, which I did, a little baffled since he was talking continually, barking out directives, and there was no one else in the room. It turned out he was having a telephone conversation, except that he didn't use a telephone, but a special mike with buttons on his desk. Across from him was a stack of televisions, three or four like a layer cake, all winking and flickering with the sound turned down.

At that point he hung up, or unbuttoned, and observed my puzzle over the layers of televisions, each one tuned to a different station.

"Keeping an eye on the competition," he informed me, and launched into an expansive lecture on the power of the media, the brilliant uniformity of the writing style in *Time*; all without taking his eye off those televisions at my back.

What he was after, it turned out, was a gimmick – he called it an element of prestige the competition didn't have. A slick fast-talking critic to do two-minute spots, movie reviews at $15 a whack. I allowed that I wasn't too interested.

"Listen kid," he said, rolling his cigar across his lip. "You don't know what I'm offering you. You don't know the power of this media. People around here would turn and look at you on the streets. If you were any good, you might make it to a national network."

I indicated, quite respectfully, that such might be the case.

"Listen kid," he said. "You don't understand what I'm telling you. We could make a big star out of you."

"But I don't want to be a star," I blurted out. "I want to be a writer."

"Kid," he said. "In their hearts, EVERYBODY wants to be a *star!*"

Part I

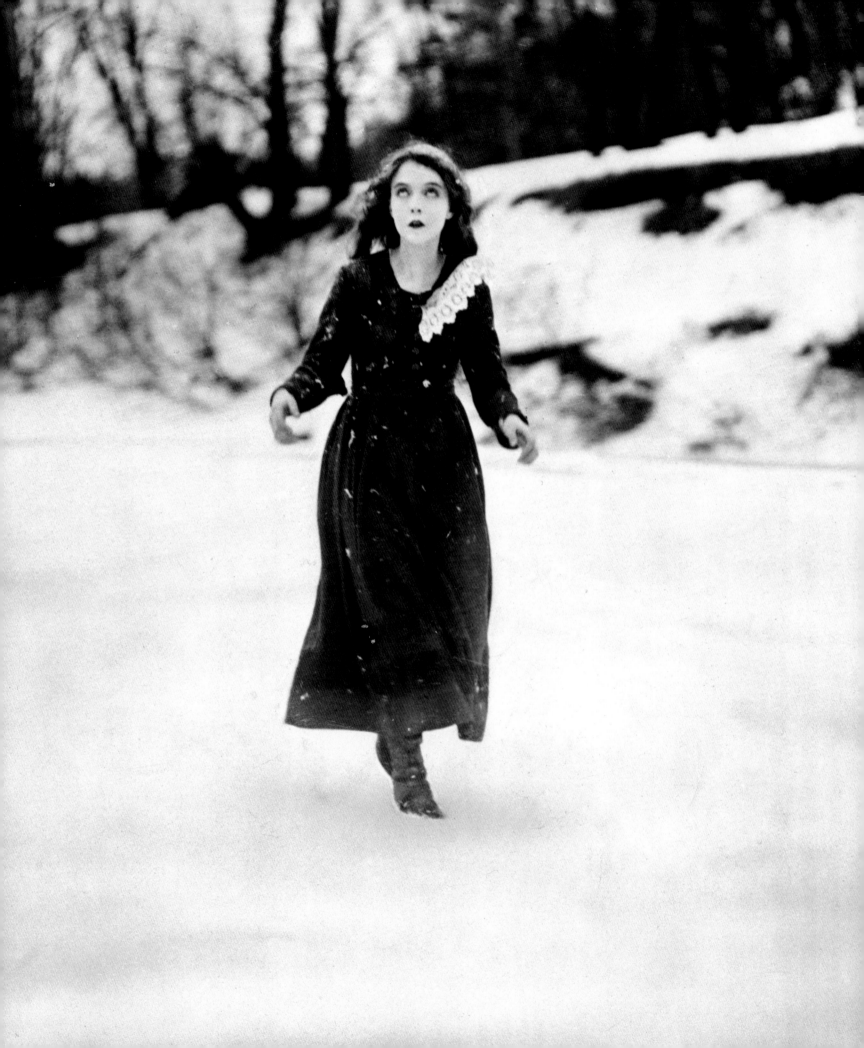

The Twenties and Before

OPPOSITE Mae Murray and John Gilbert in *The Merry Widow*, 1925

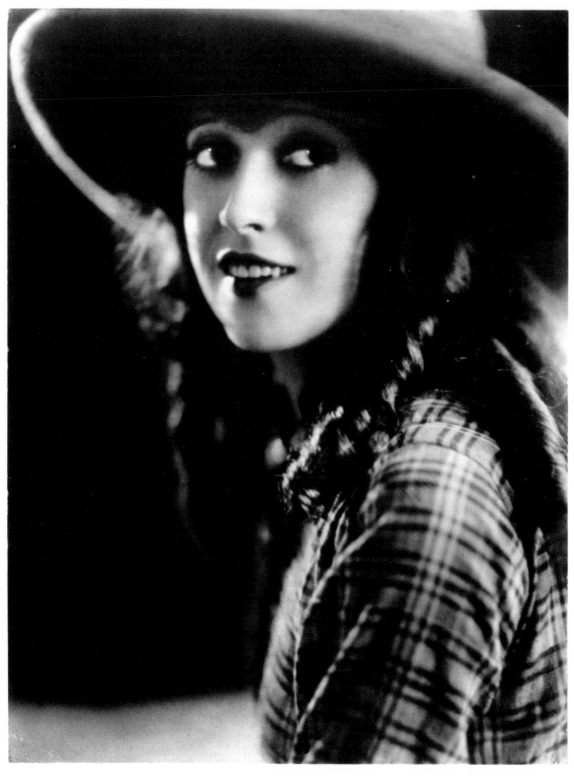

Mabel Normand, 1919

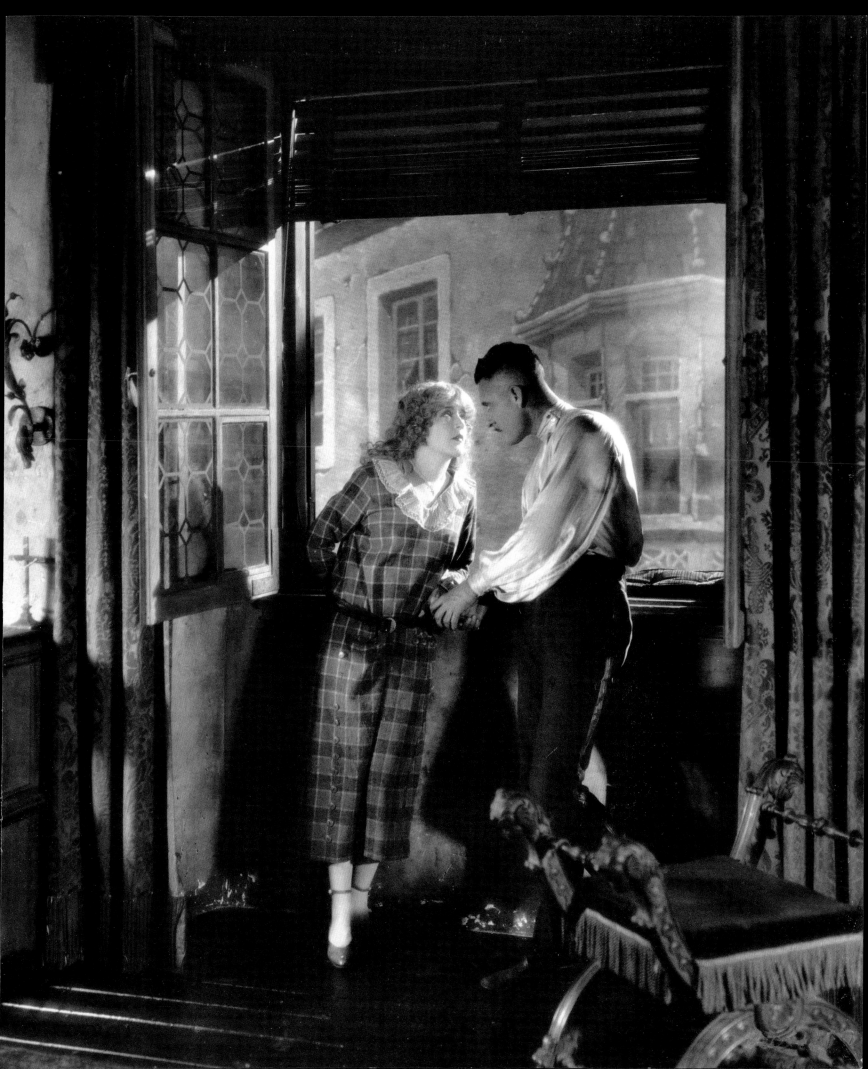

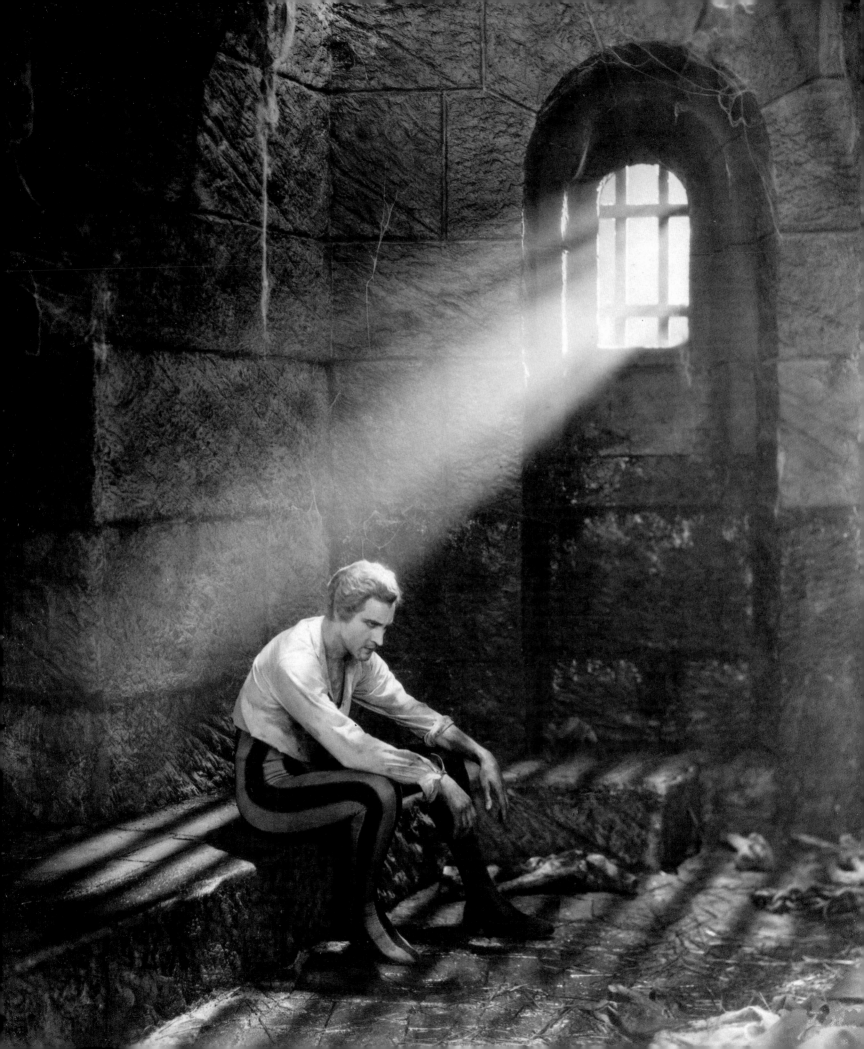

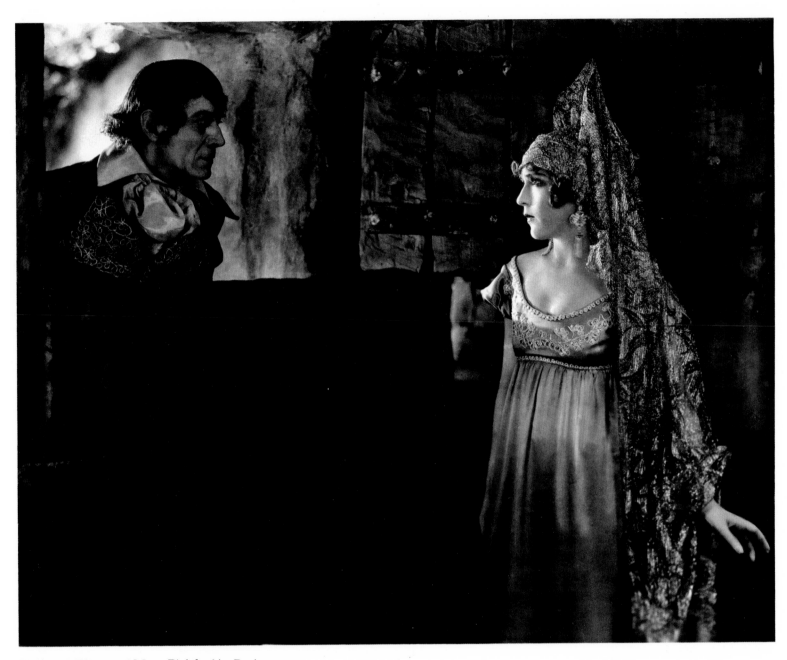

Holbrook Blinn and Mary Pickford in *Rosita*, 1923

OPPOSITE John Barrymore in *Don Juan*, 1926

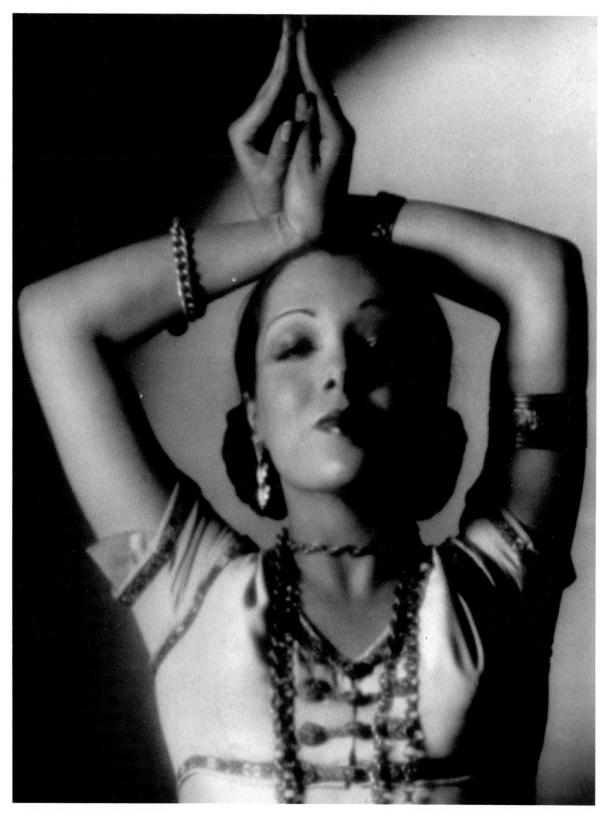

Lupe Velez in *Where East Is East*, 1929

OPPOSITE Gary Cooper in *The Virginian*, 1929

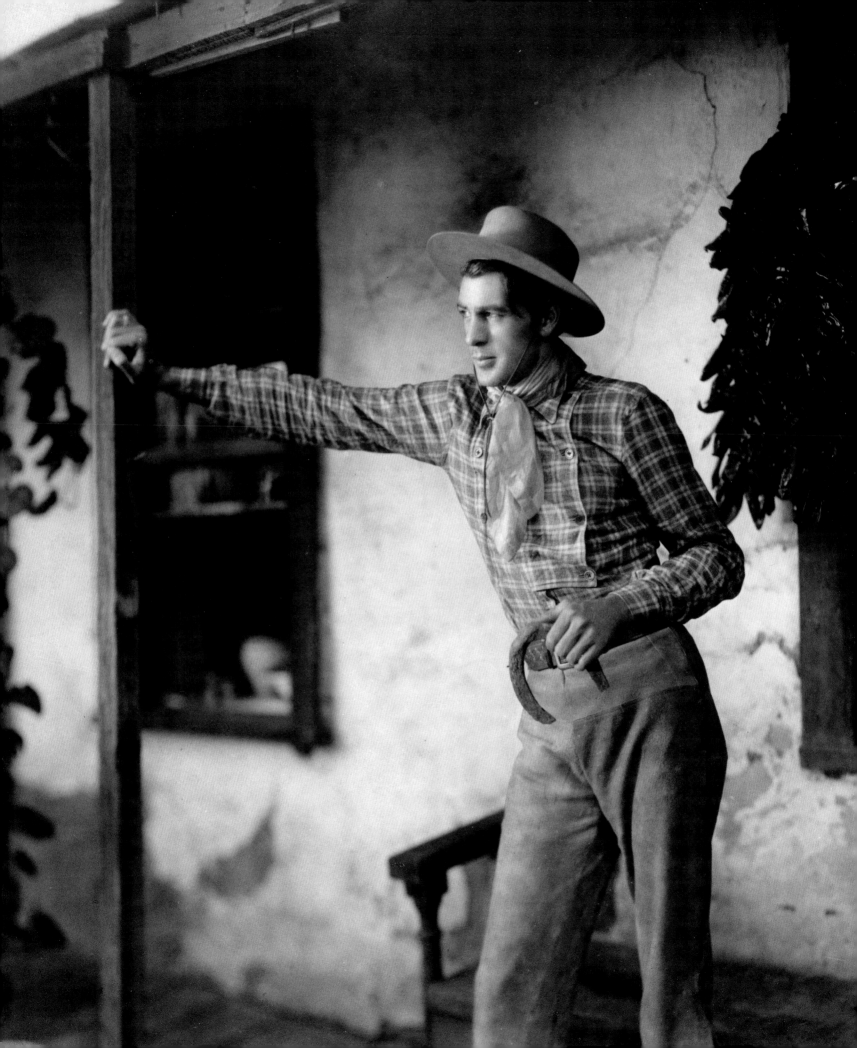

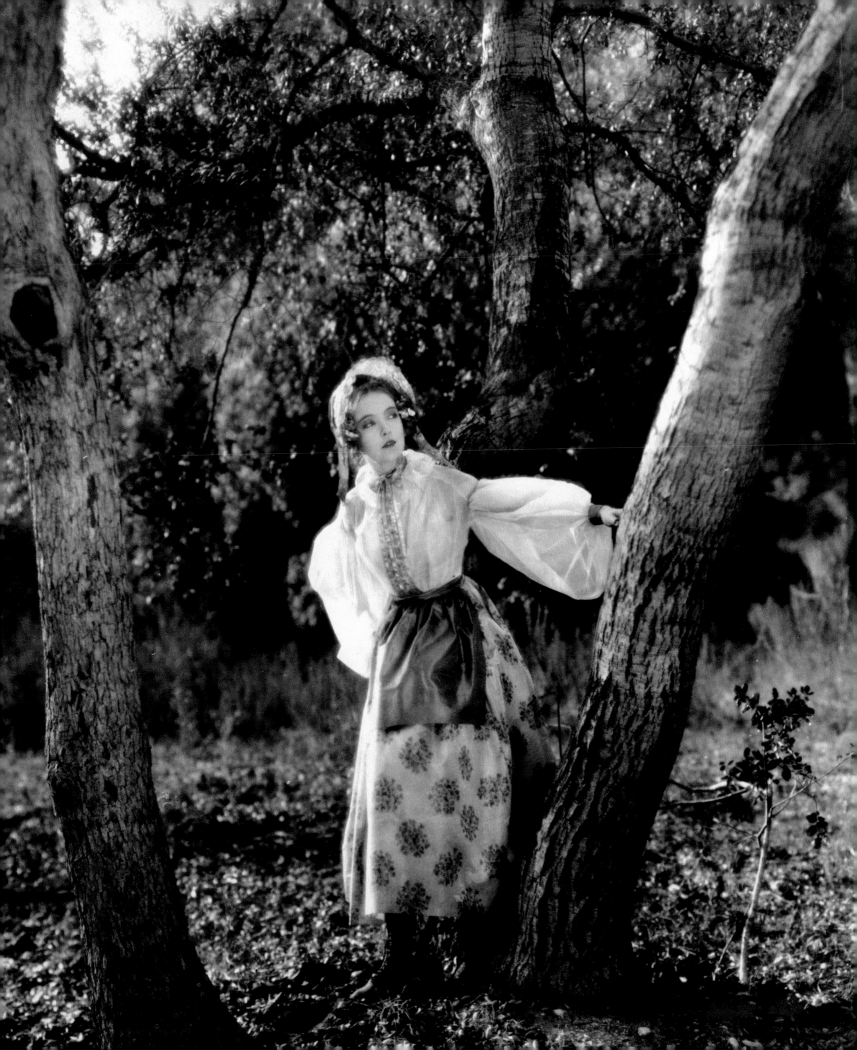

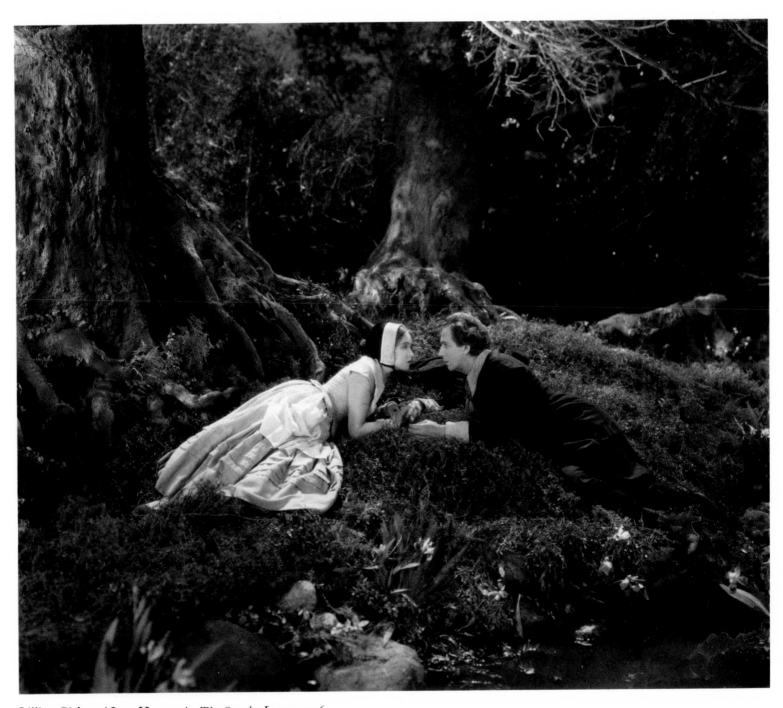

Lillian Gish and Lars Hanson in *The Scarlet Letter*, 1926

OPPOSITE Lillian Gish in *La Boheme*, 1926

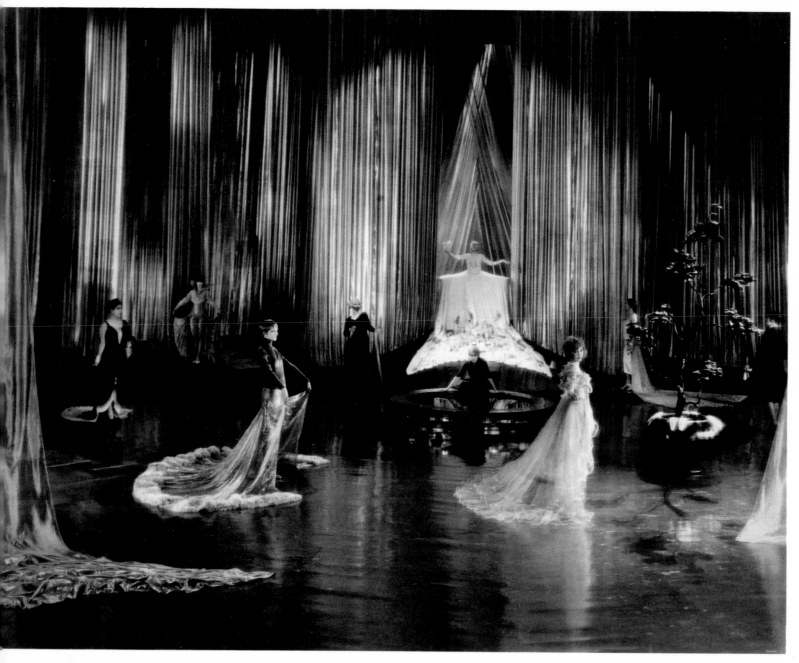

Myrna Loy (left) in *What Price Beauty*, 1927

OPPOSITE Greta Nissen, 1927

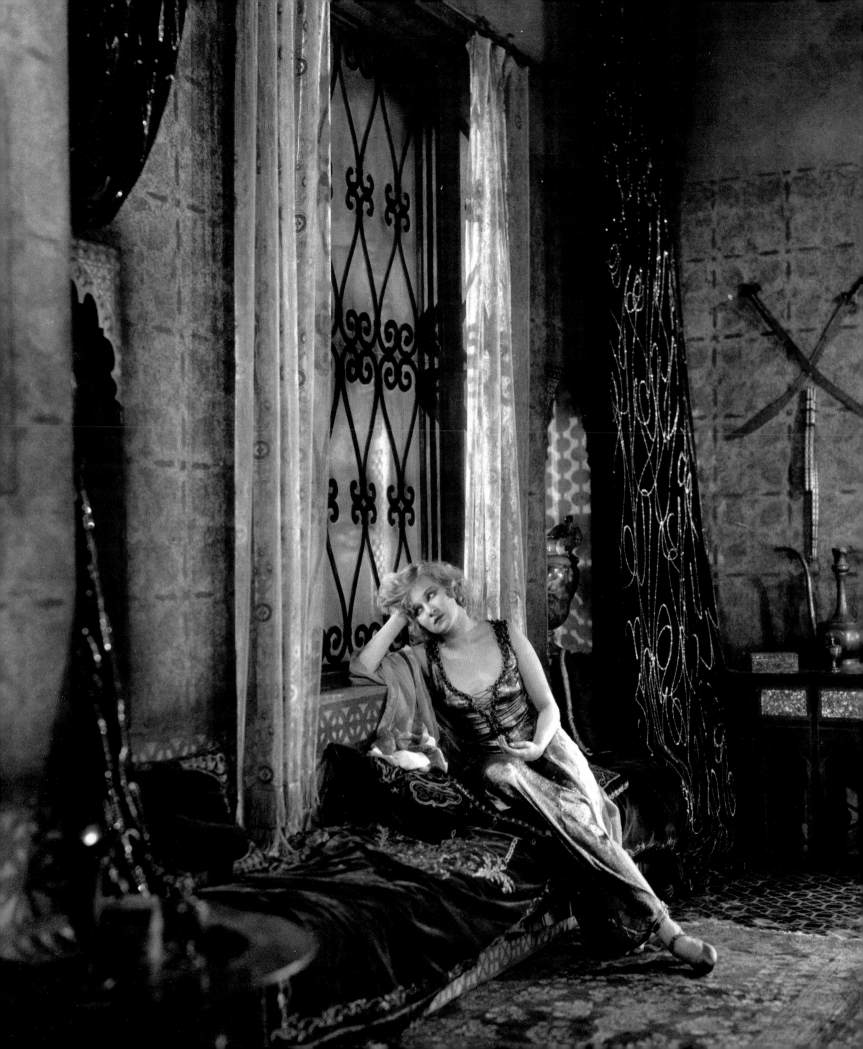

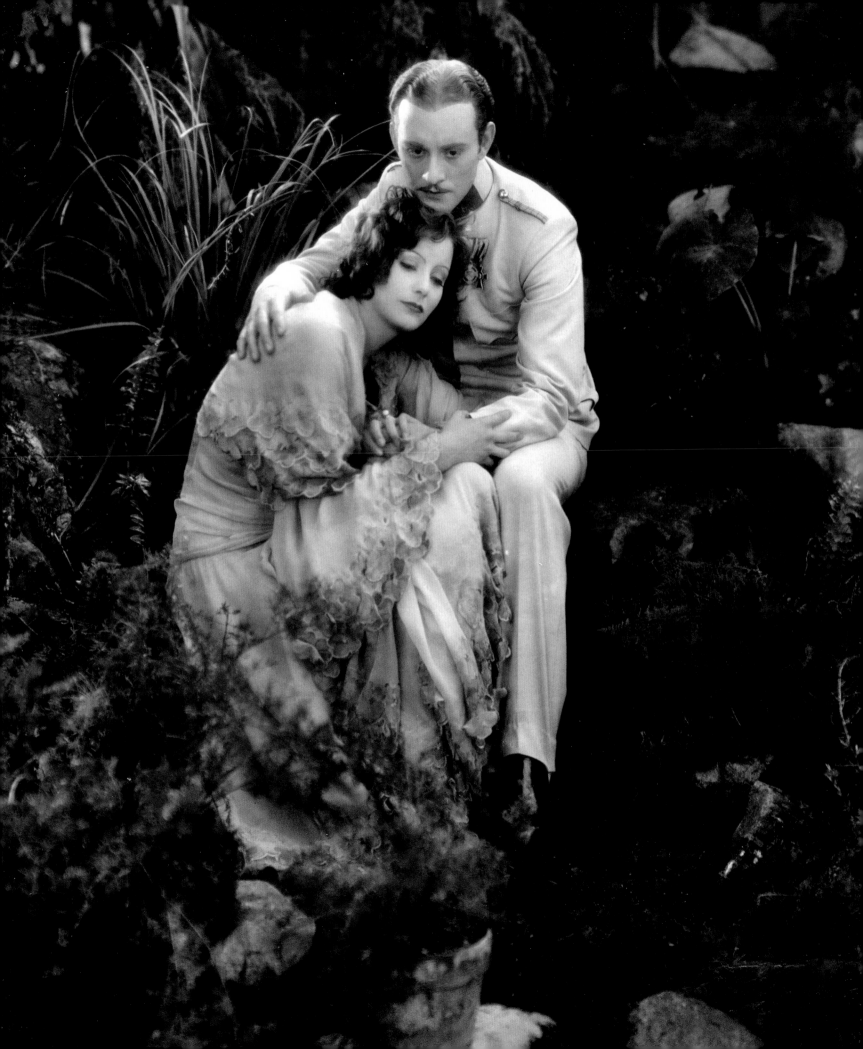

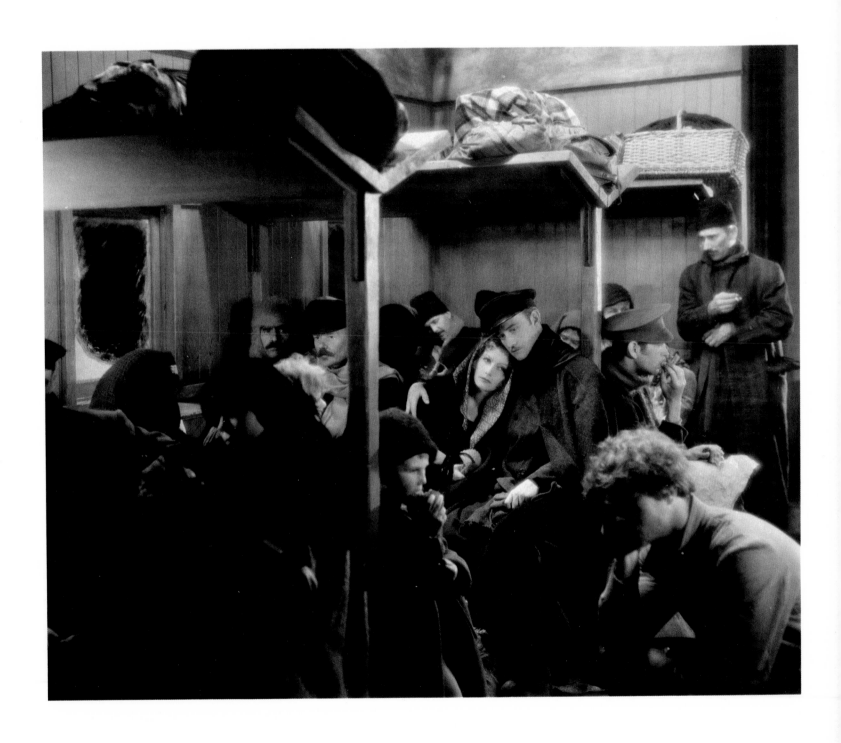

Greta Garbo and Conrad Nagel in *The Mysterious Lady*, 1928

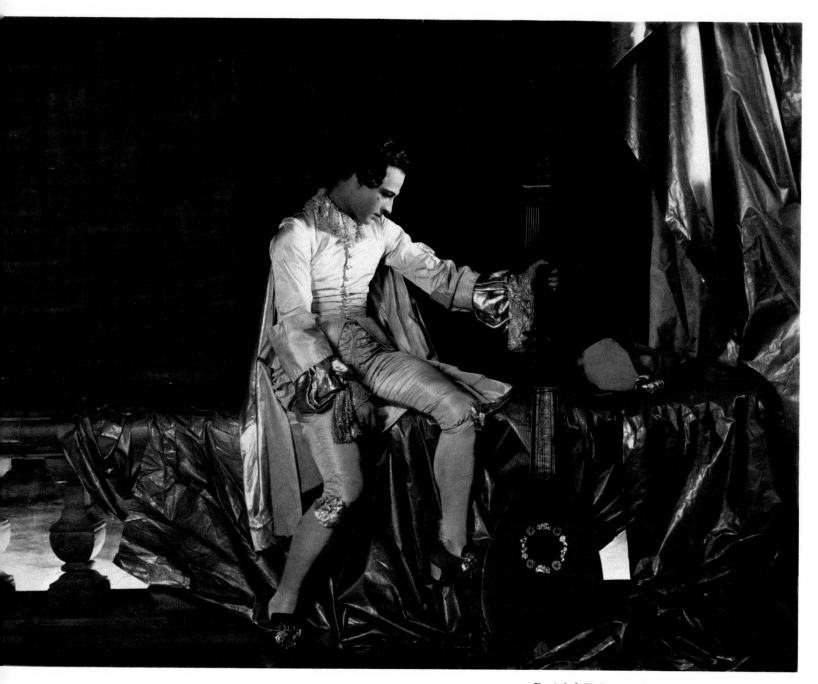

Rudolph Valentino in *Monsieur Beaucaire*, 1924

OPPOSITE Pola Negri in *Woman of the World*, 1925

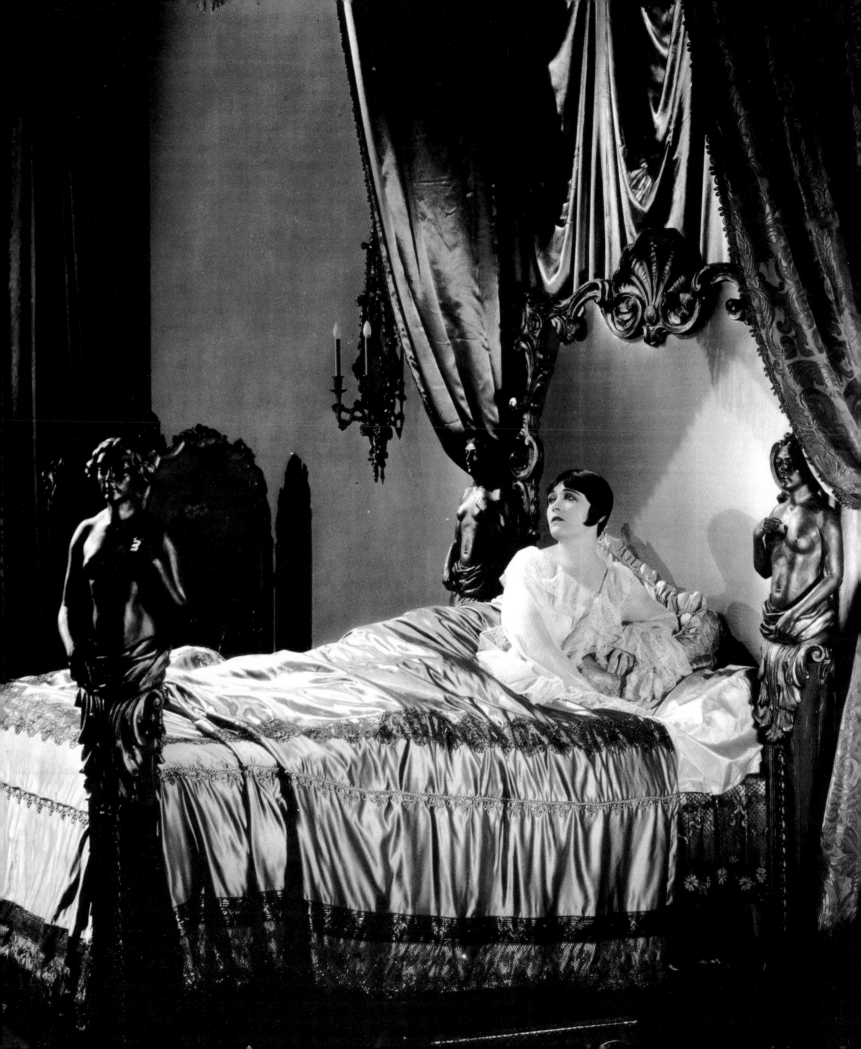

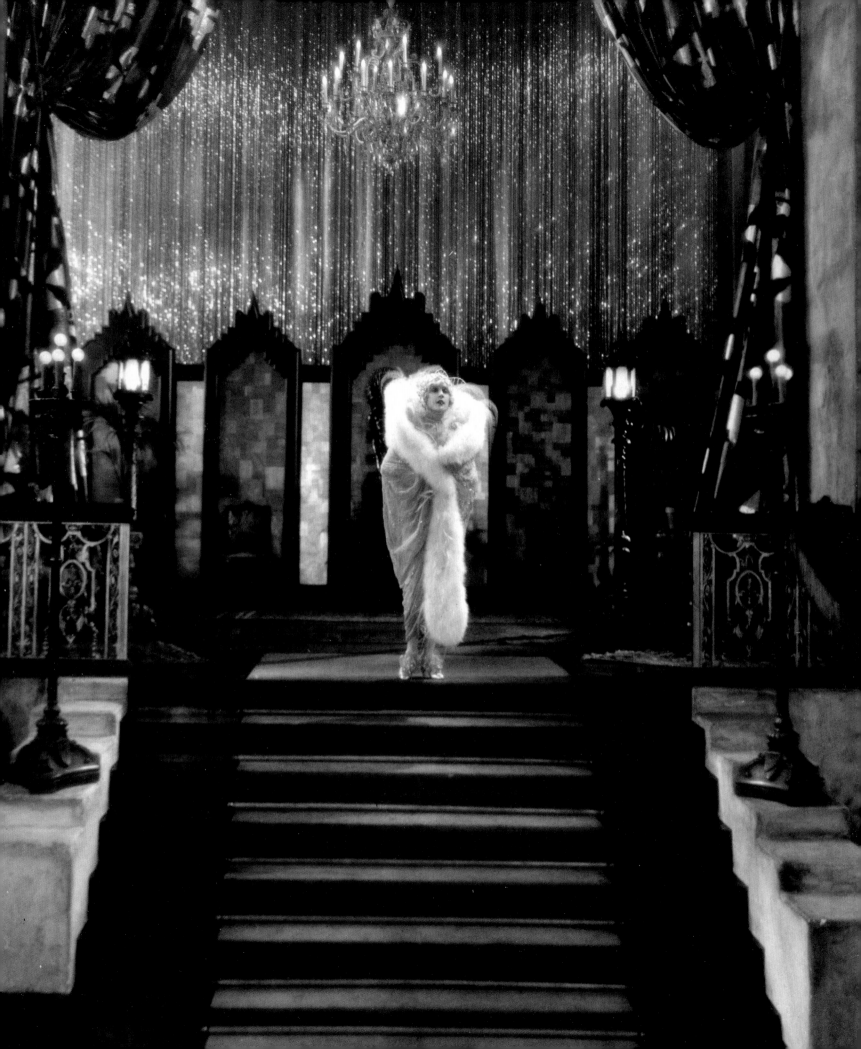

OPPOSITE Mae Murray in *The Merry Widow*, 1925

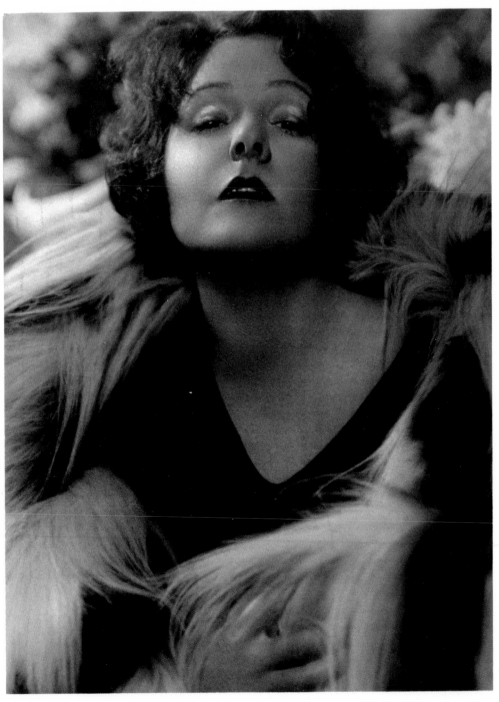

Norma Talmadge, 1927

OPPOSITE Marion Davies, 1921

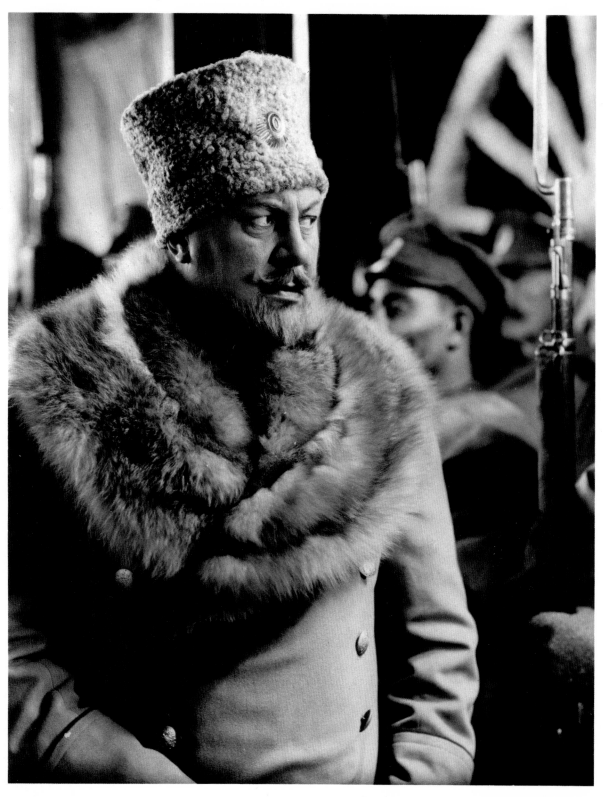

Emil Jannings in *The Last Command*, 1928

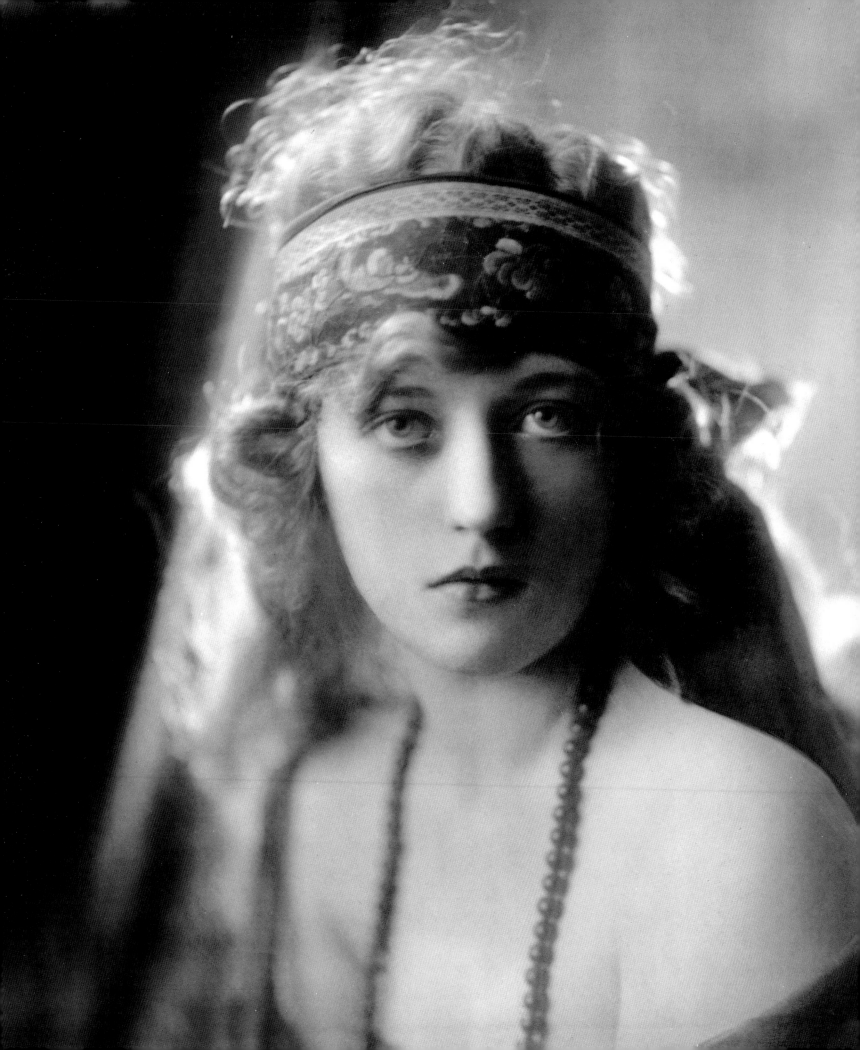

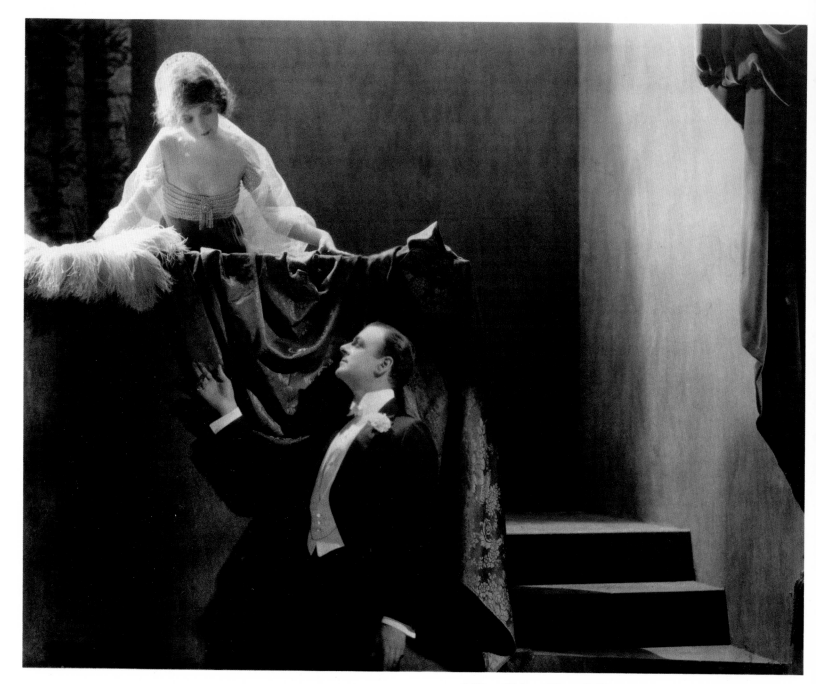

Lillian Gish and Lowell Sherman in *Way Down East*, 1920

OPPOSITE June Collyer, 1926

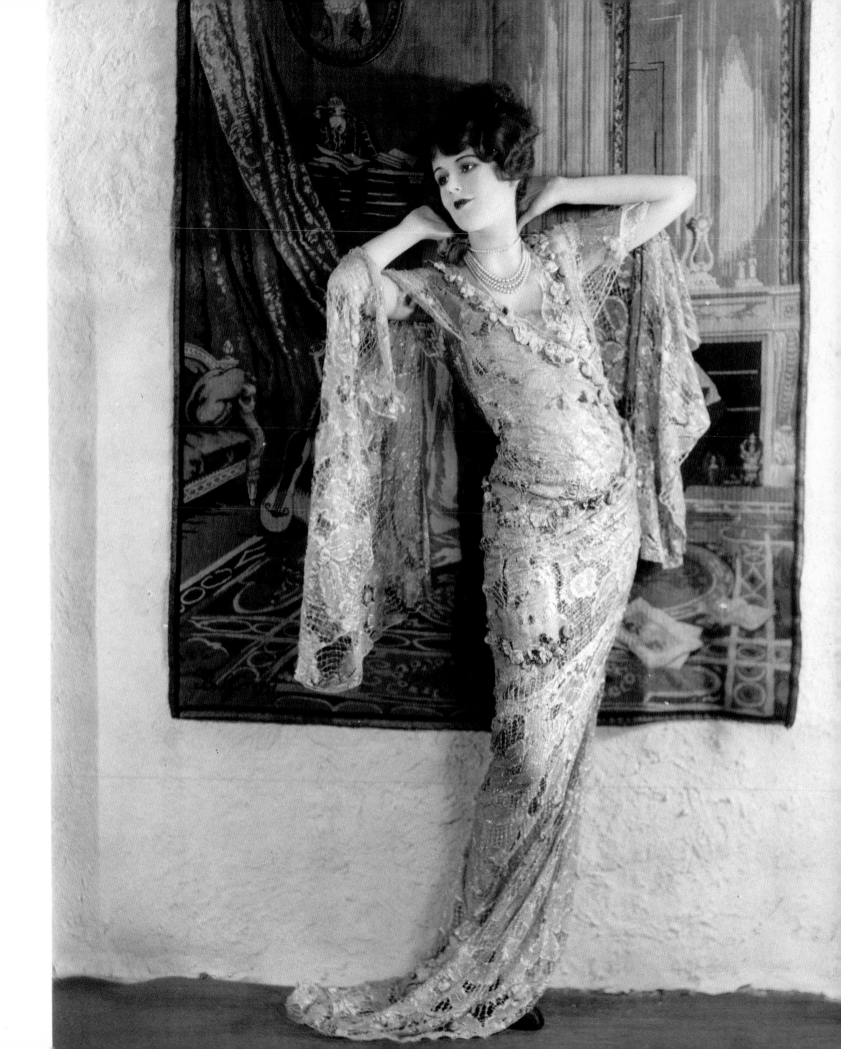

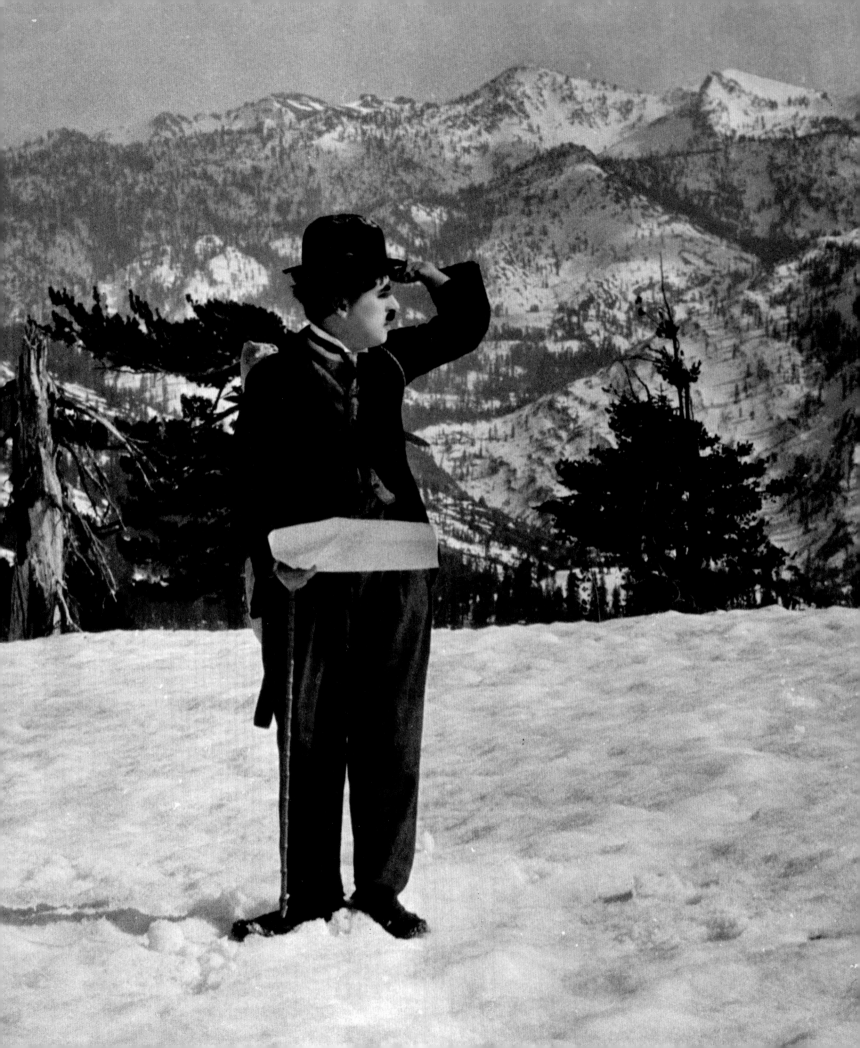

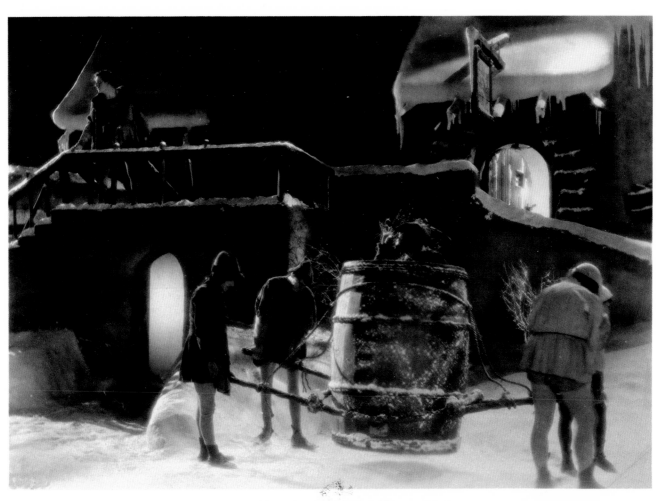

ABOVE John Barrymore (head appearing from barrel) in *The Beloved Rogue*, 1927

RIGHT Charlie Chaplin in *The Gold Rush*, 1925

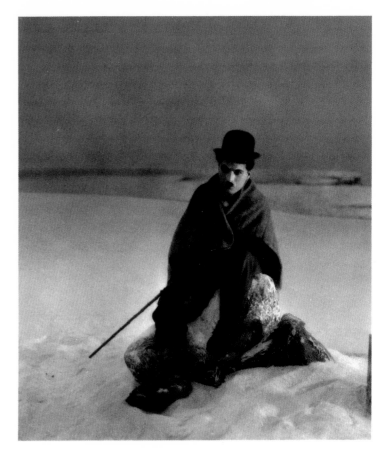

OPPOSITE Charlie Chaplin in *The Gold Rush*, 1925

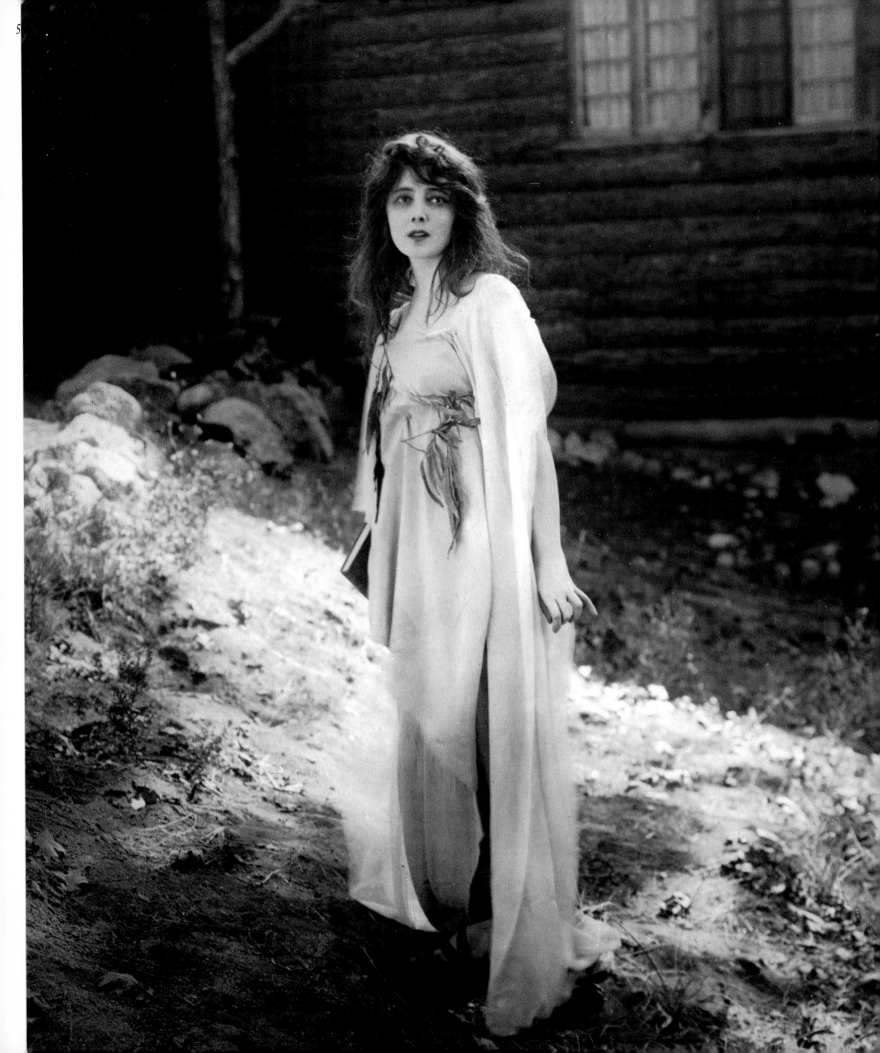

OPPOSITE Marie Doro in *The Wood Nymph*, 1915

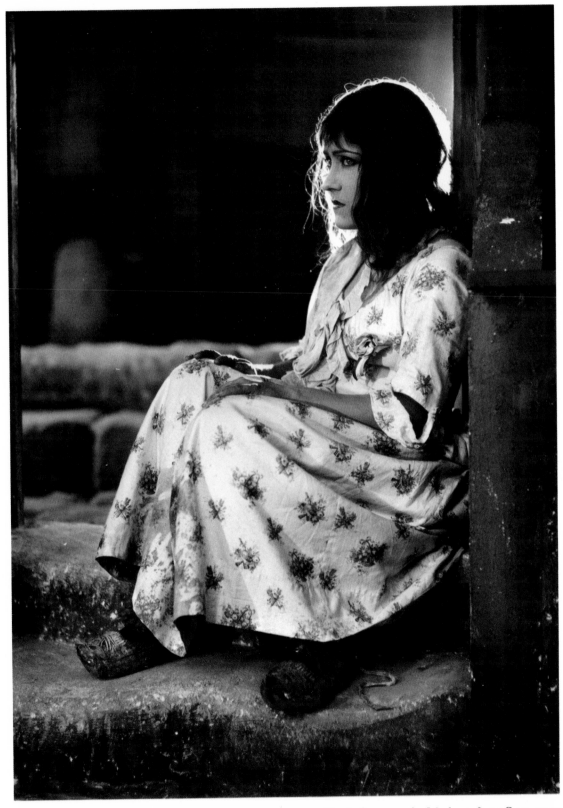

Gloria Swanson in *Madame Sans Gene*, 1925

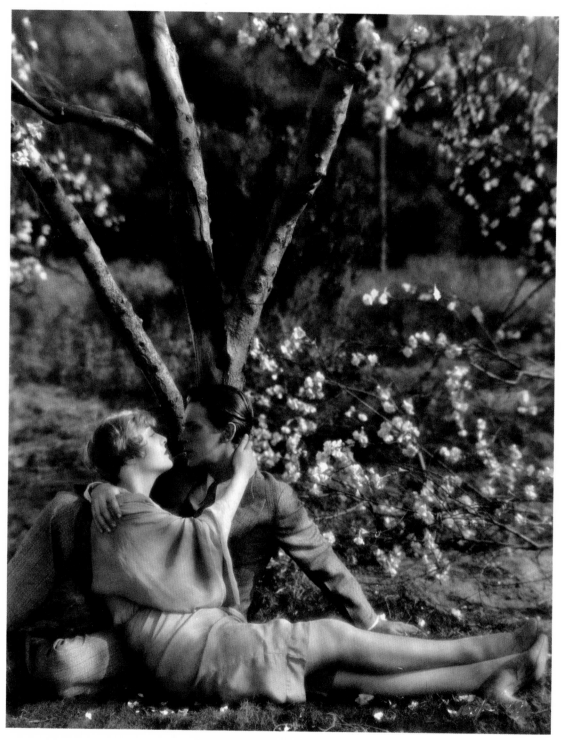

Dorothy Mackail and Douglas Fairbanks Jr. in *The Barker, 1929*

OPPOSITE Conrad Nagel and Greta Garbo in *The Mysterious Lady, 1928*

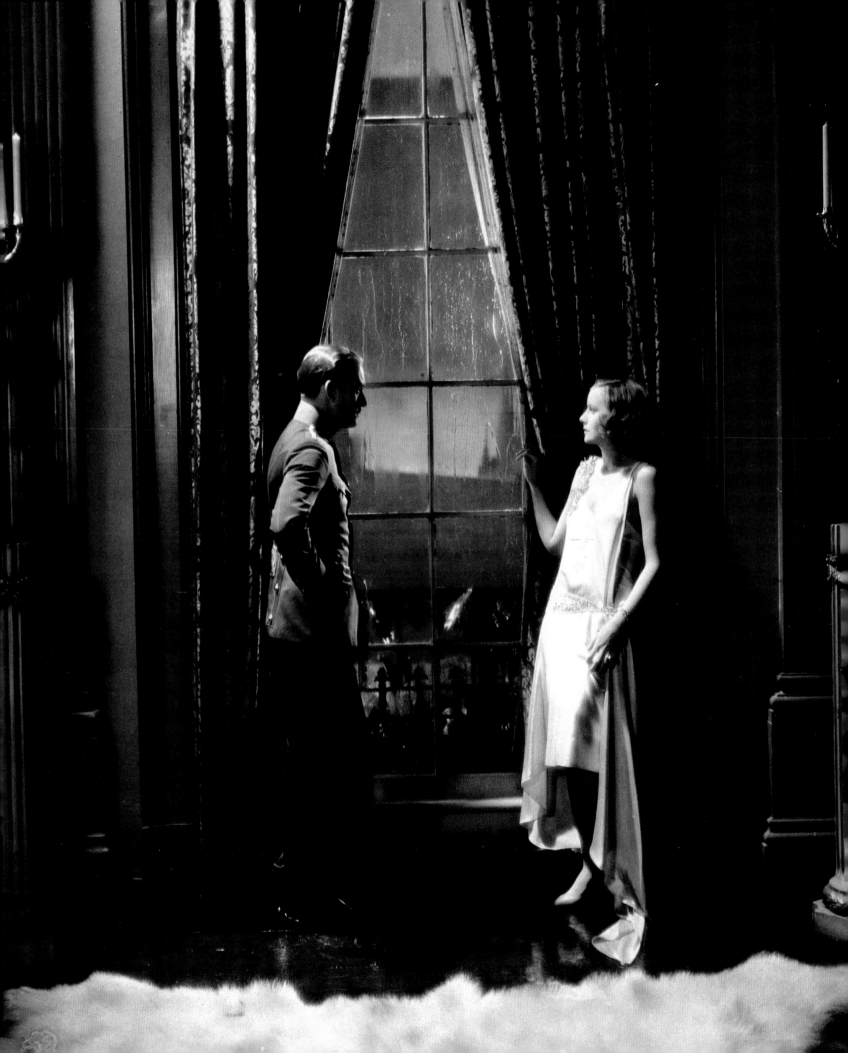

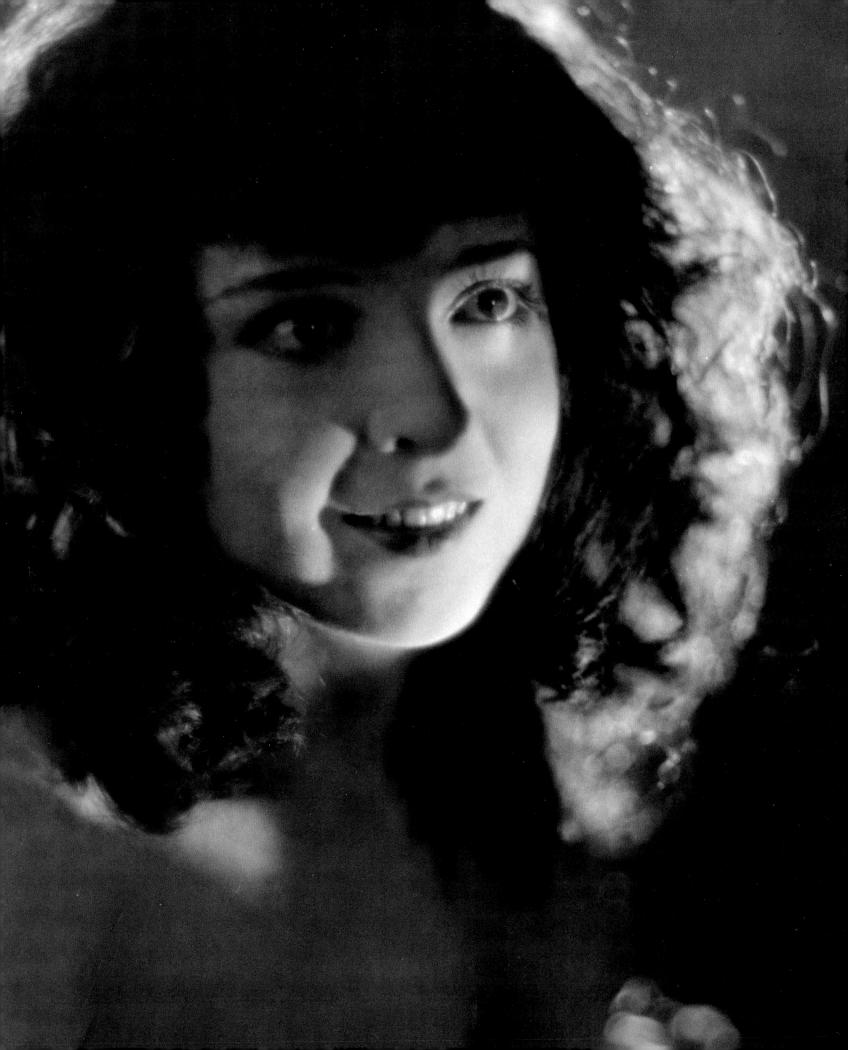

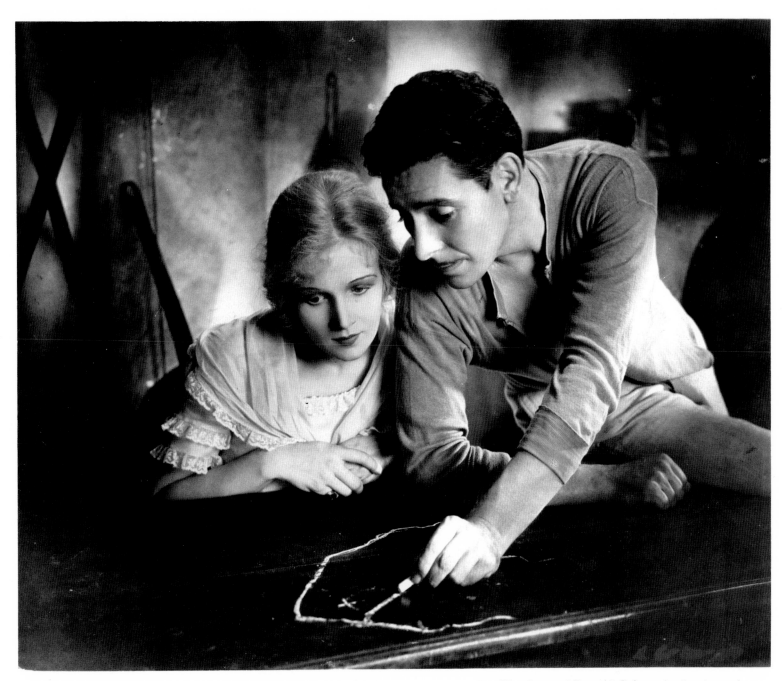

Ann Harding and Ronald Colman in *Condemned*, 1929

OPPOSITE Colleen Moore, 1922

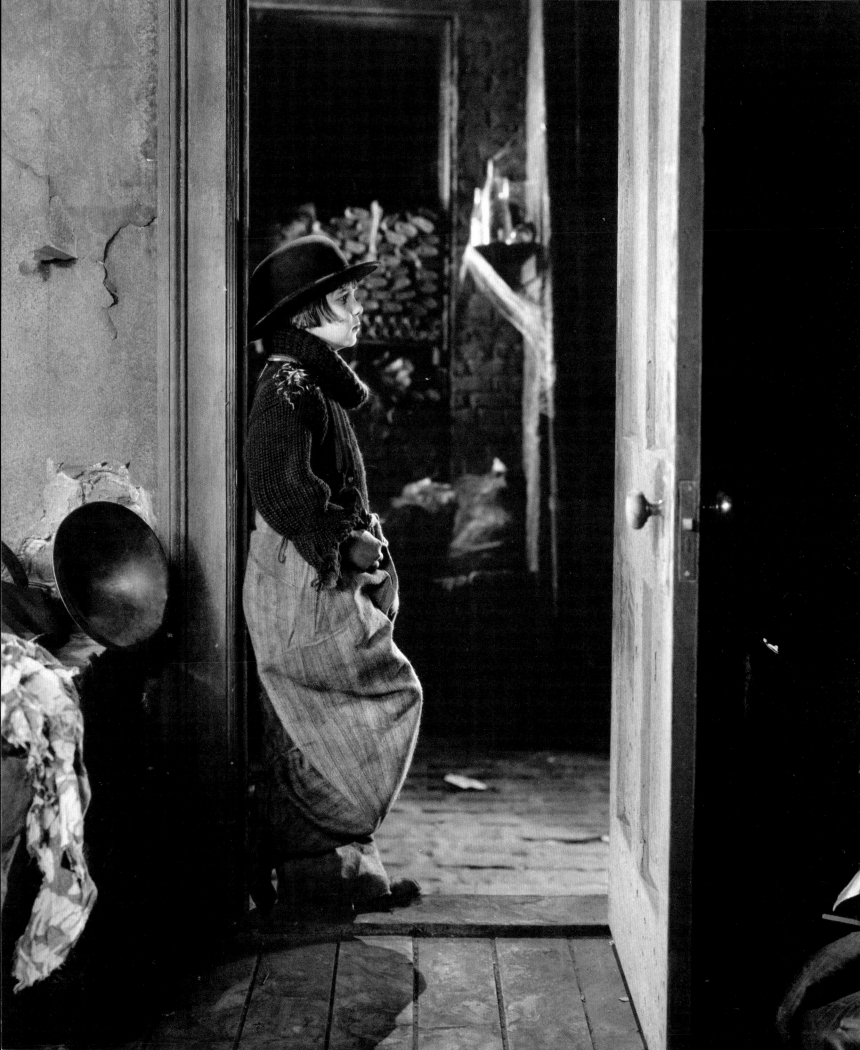

Lillian Gish and Blanche Payson in *La Boheme*, 1926

OPPOSITE Jackie Coogan in *The Rag Man*, 1925

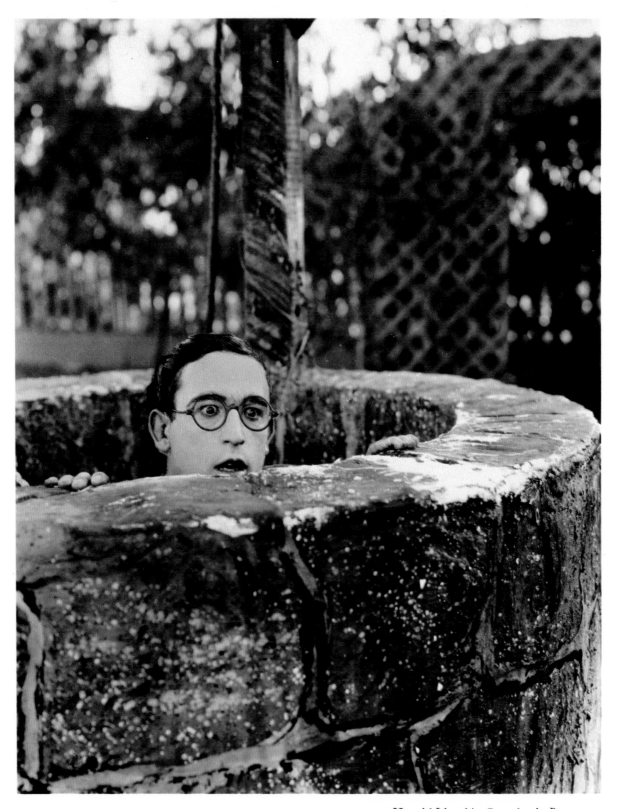

Harold Lloyd in *Grandma's Boy*, 1922

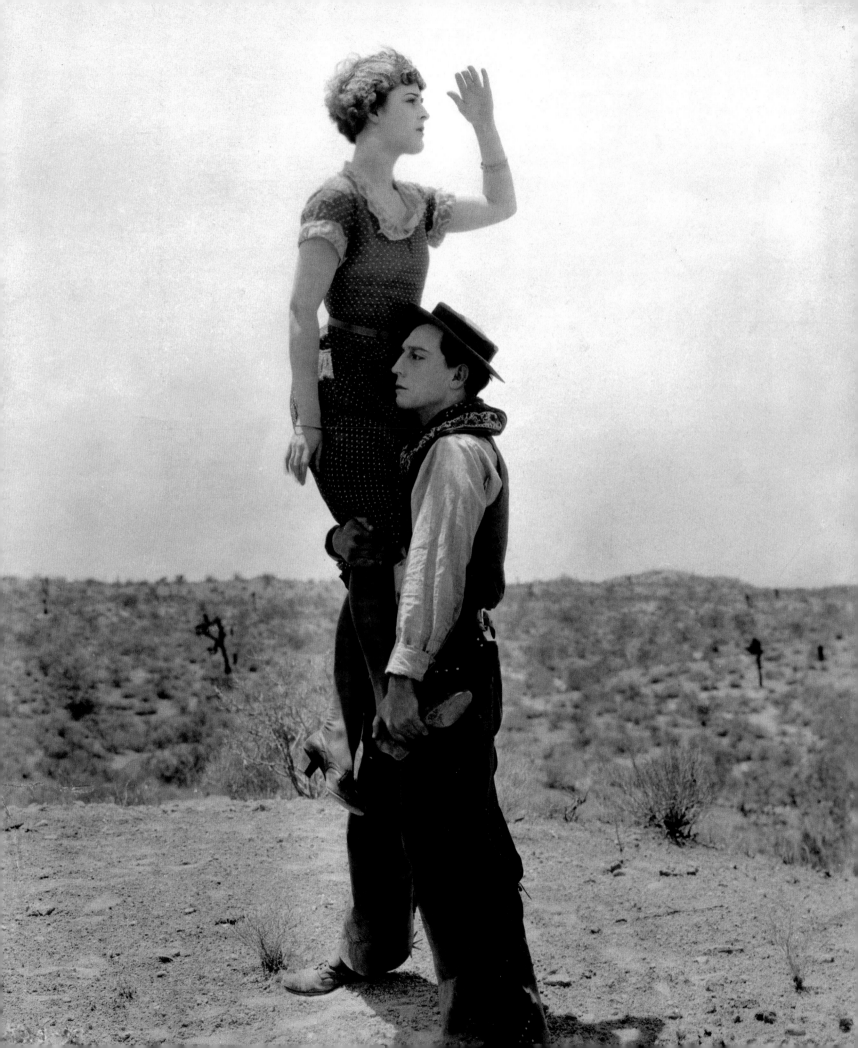

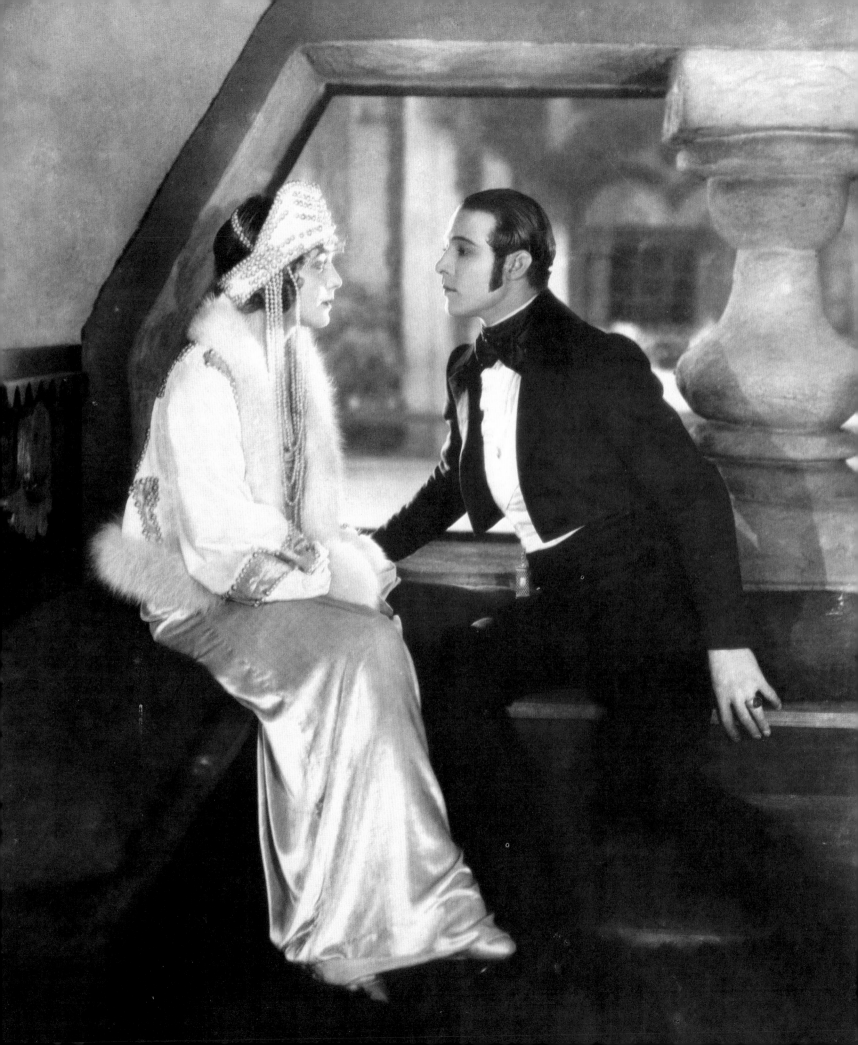

OPPOSITE Vilma Banky and Rudolph Valentino in *The Eagle*, 1925

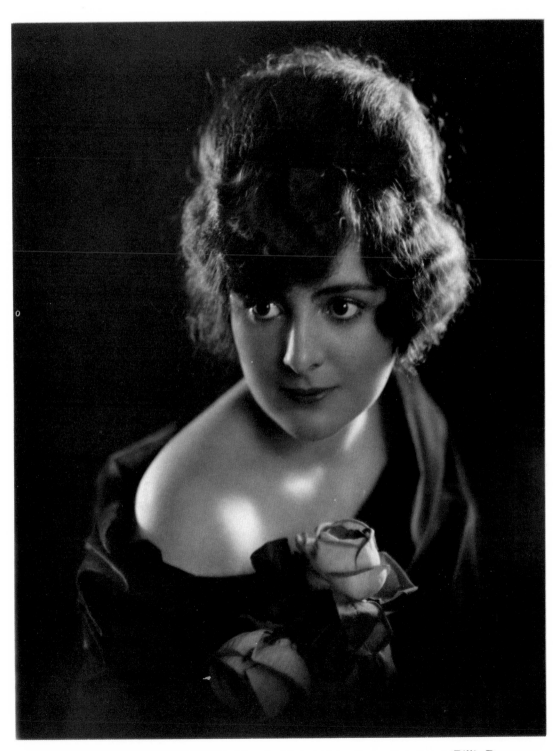

Billie Dove, 1922

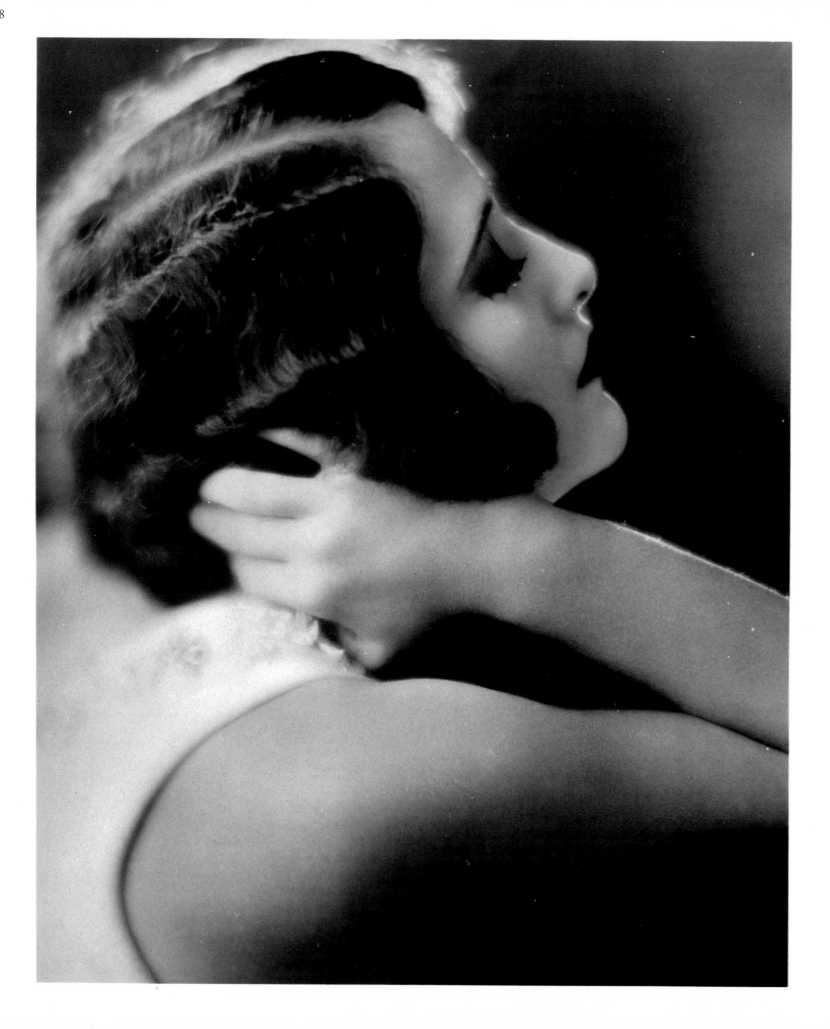

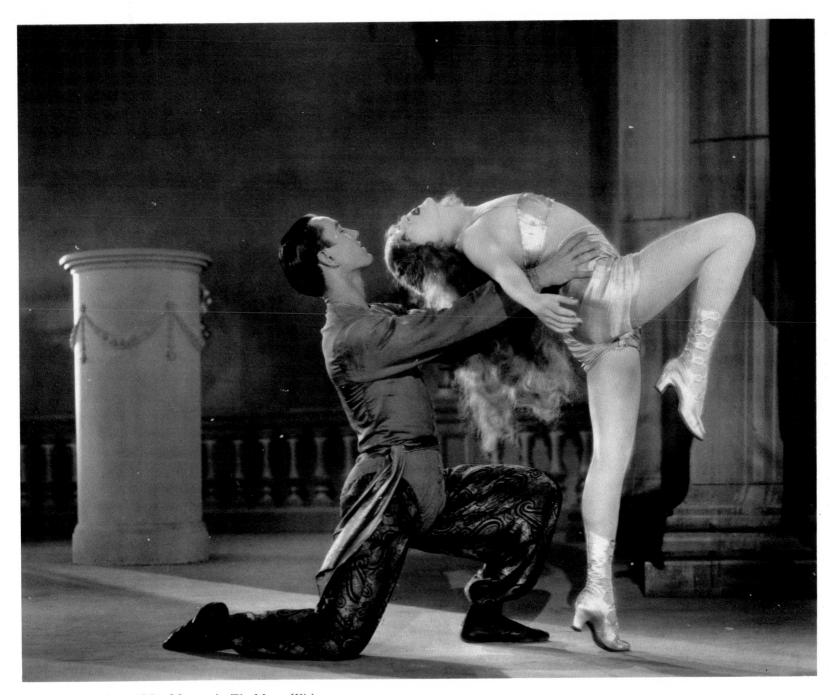

Harvey Karelt and Mae Murray in *The Merry Widow*, 1925

OPPOSITE Joan Crawford, 1926

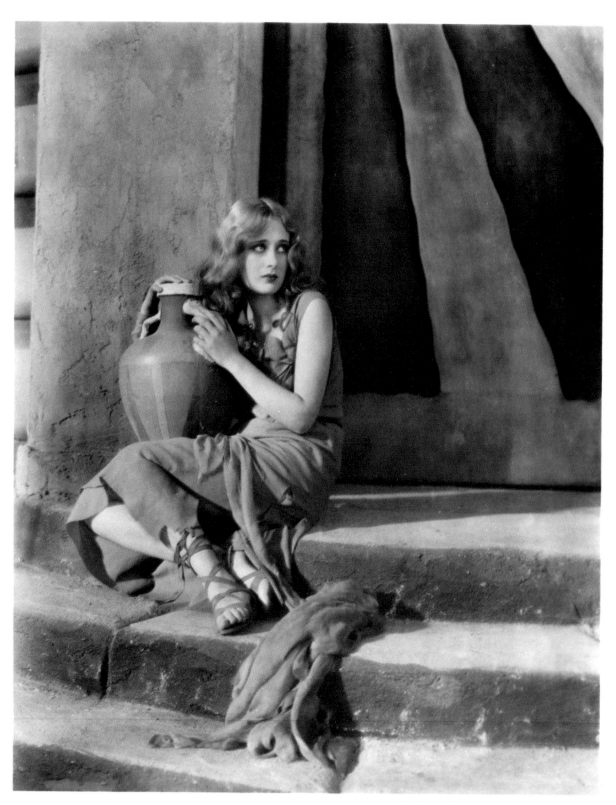

Dolores Costello in *Noah's Ark*, 1929

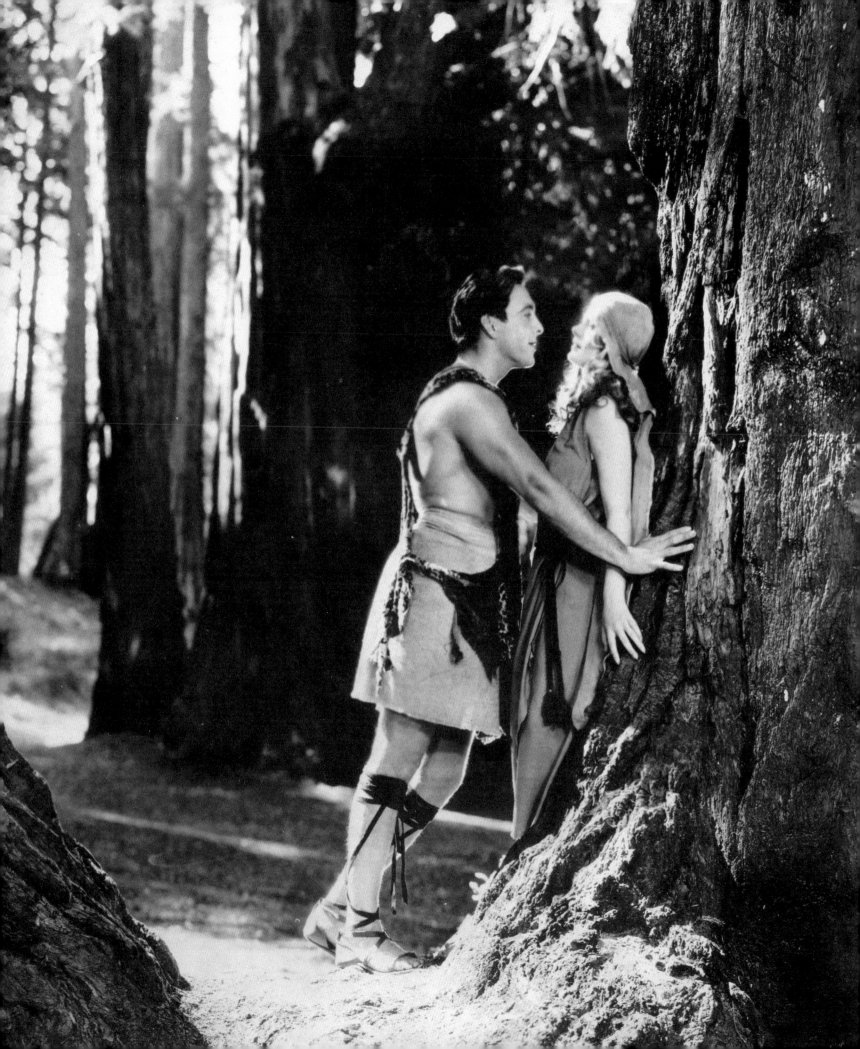

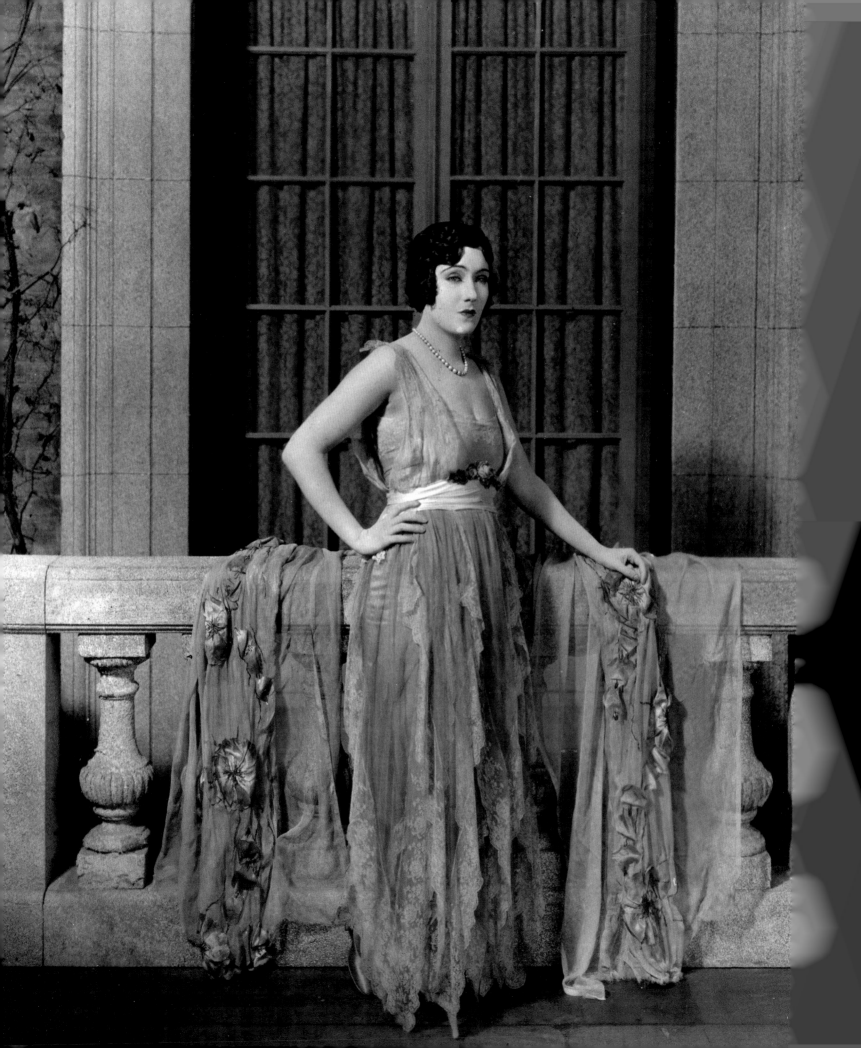

OPPOSITE Gloria Swanson in *The Humming Bird*, 1924

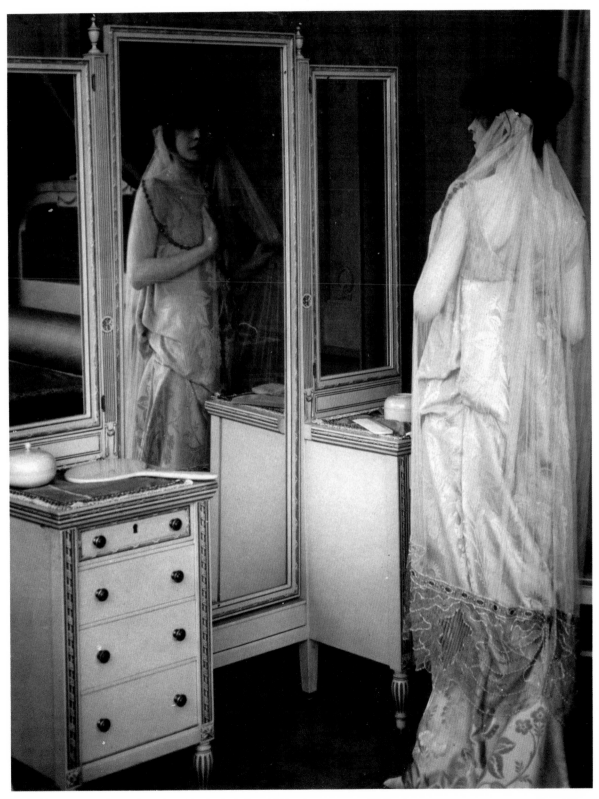

Lillian Gish in *The Lily and the Rose*, 1915

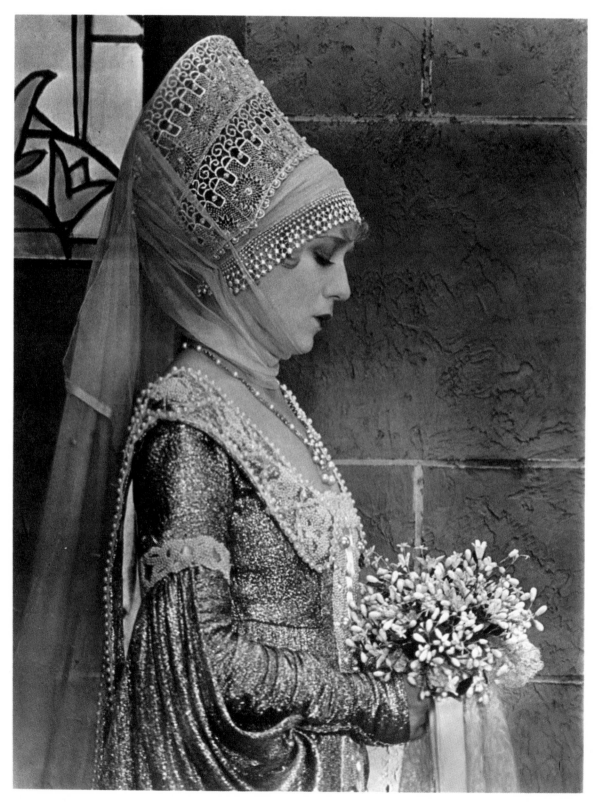

Mary Pickford in *The Taming of the Shrew*, 1929

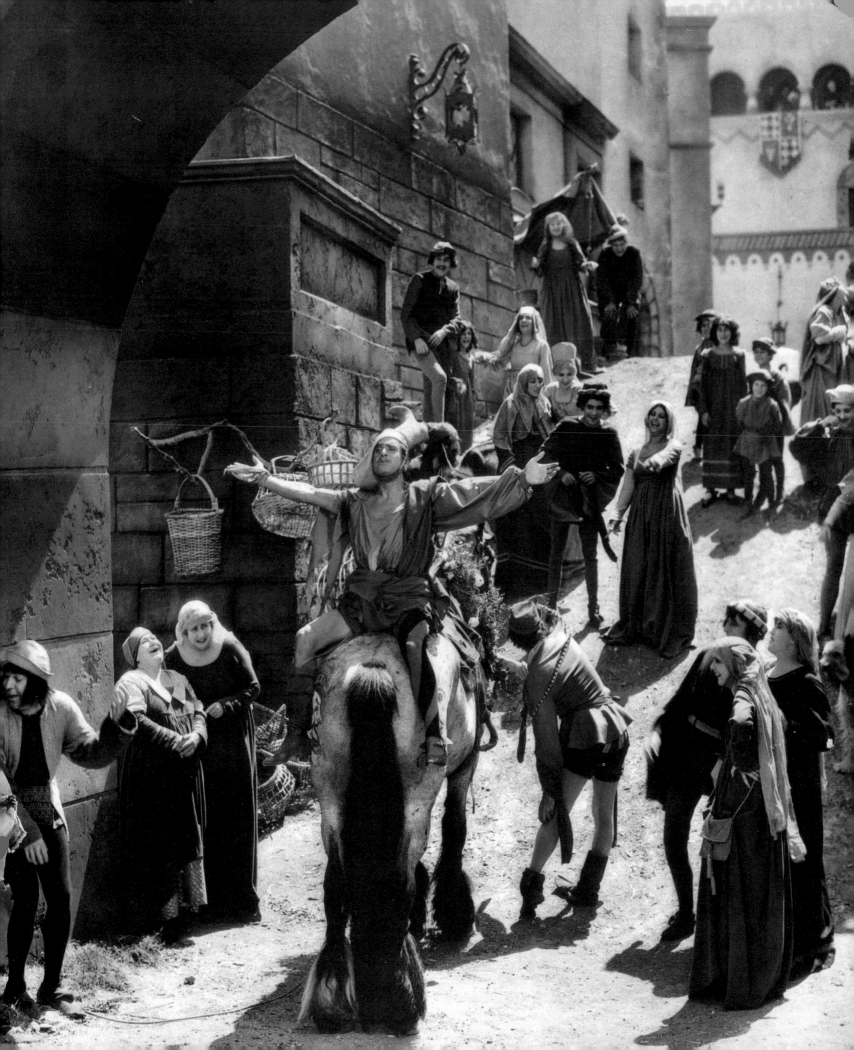

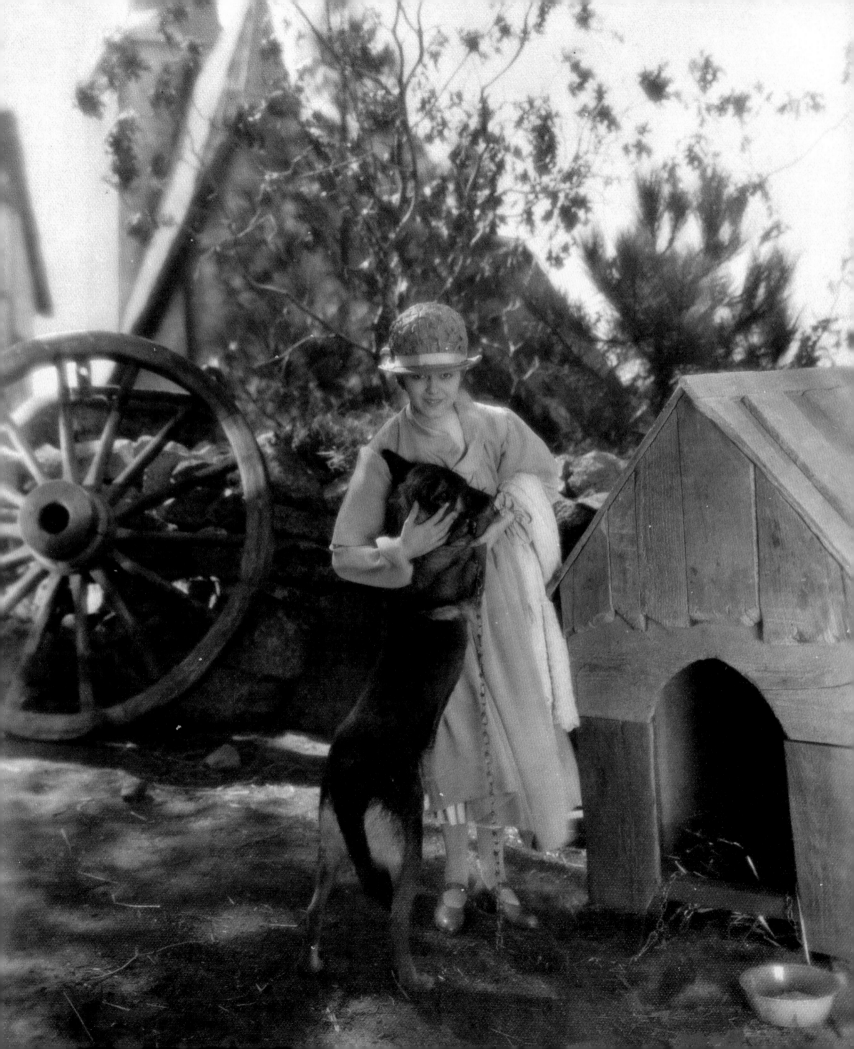

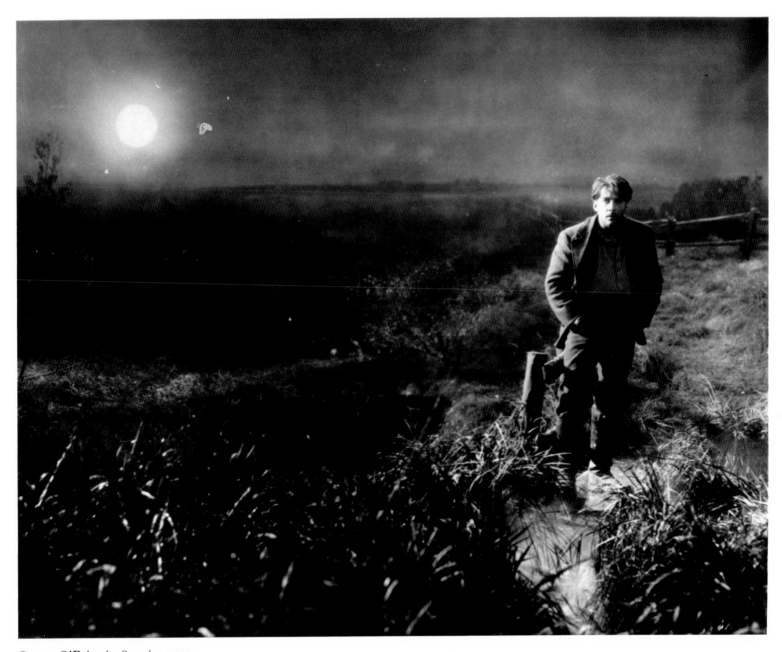

George O'Brien in *Sunrise*, 1927

OPPOSITE Janet Gaynor in *Sunrise*, 1927

OPPOSITE Lon Chaney and Mary Nolan in *West of Zanzibar*, 1929

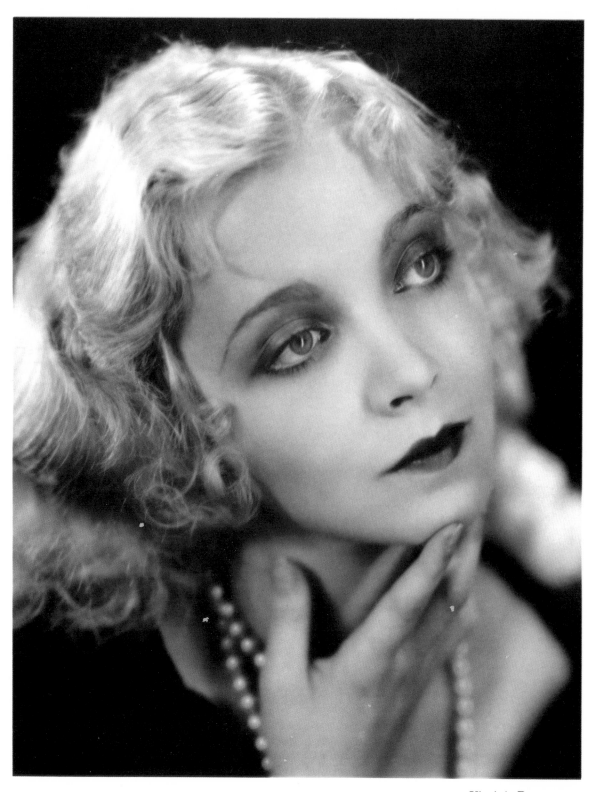

Virginia Bruce, 1929

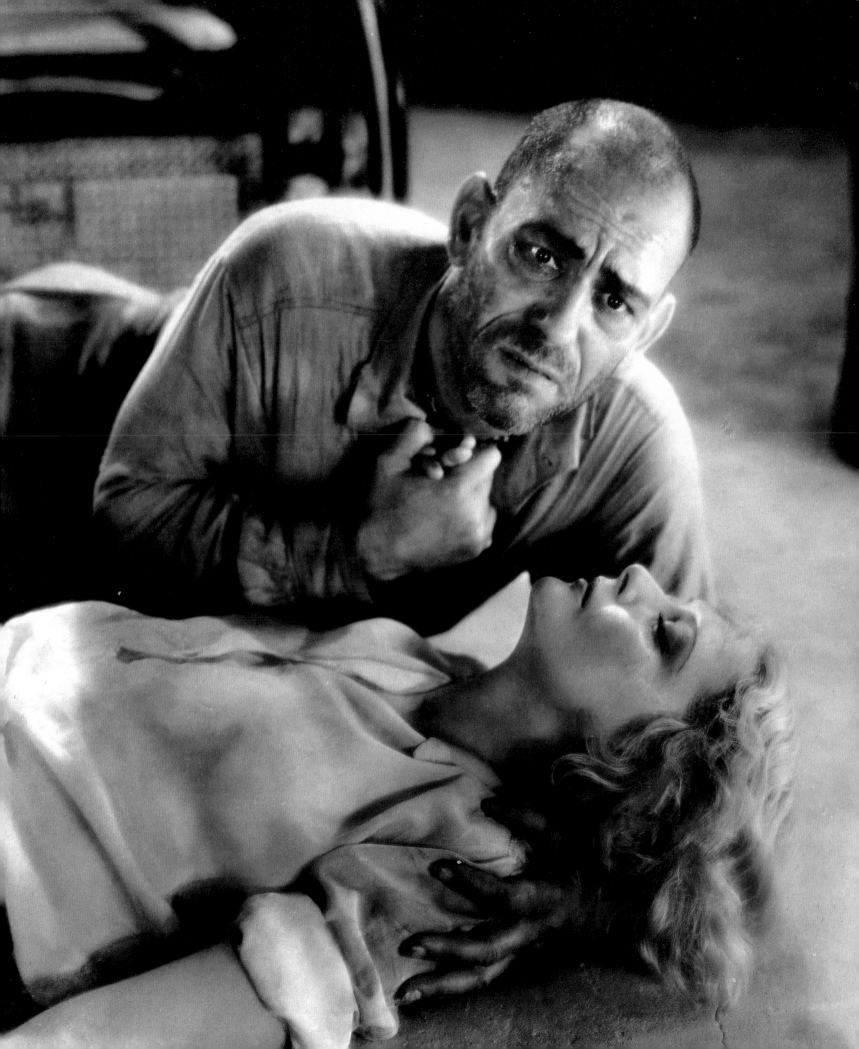

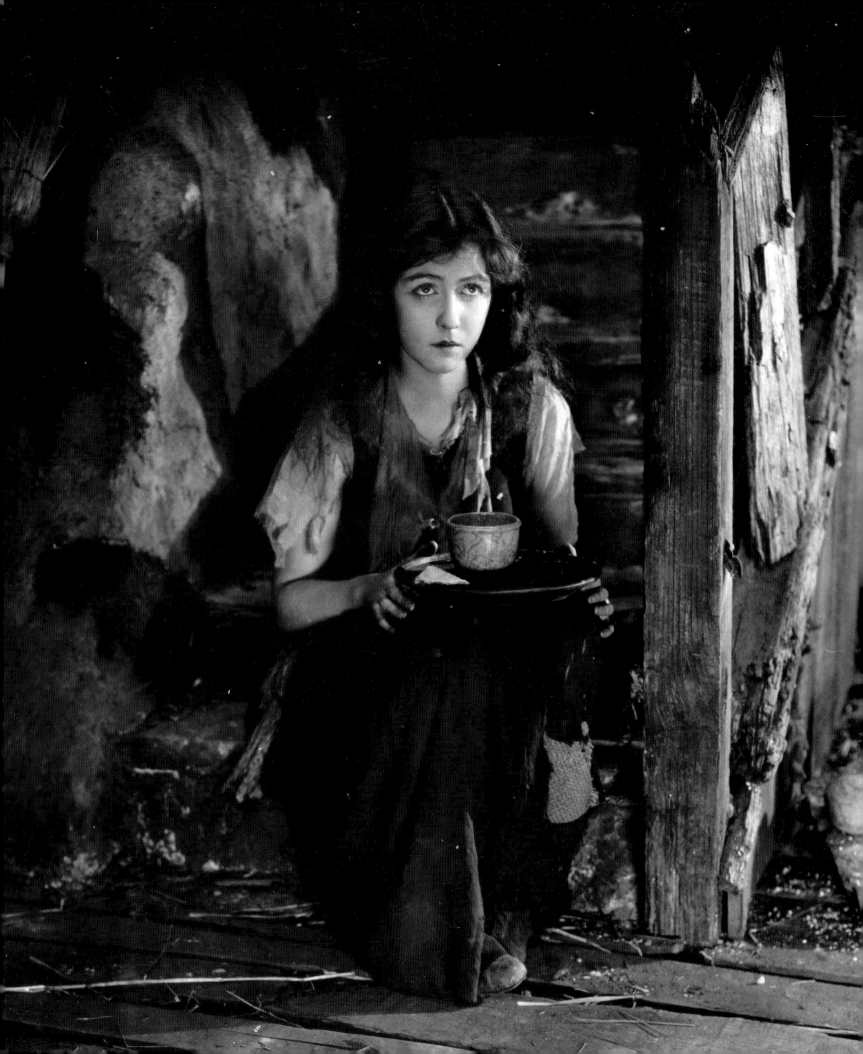

Enid Bennett, 1916

OPPOSITE Dorothy Gish in *Orphans of the Storm*, 1922

Mae Murray in *Fashion Row*, 1924

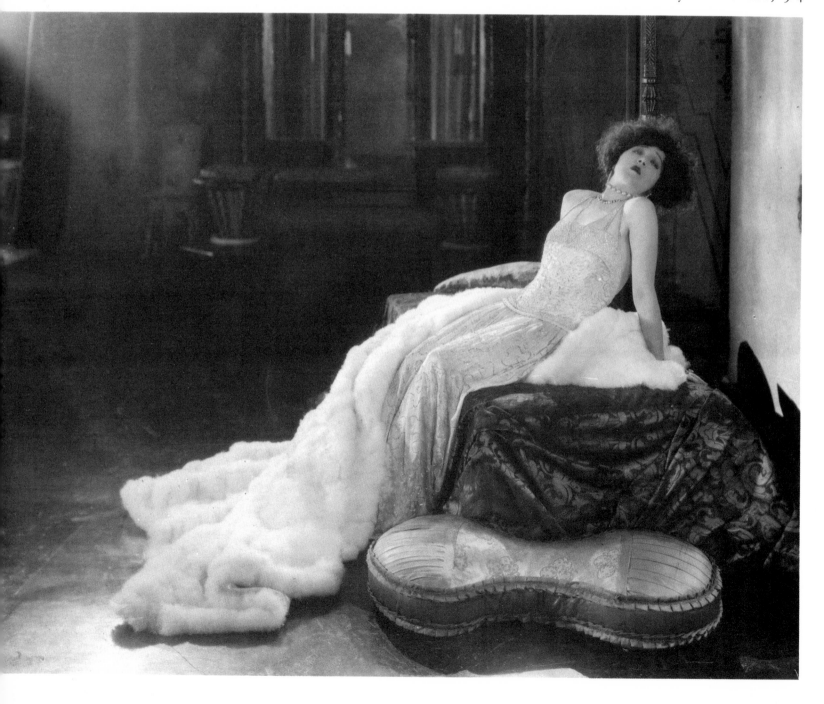

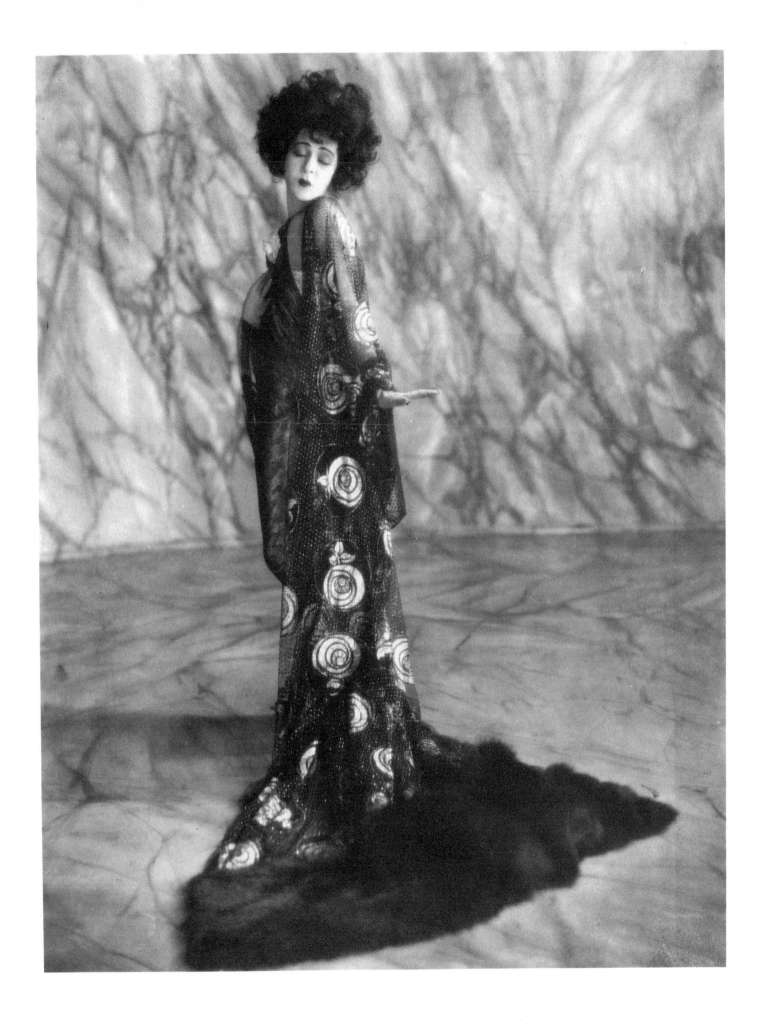

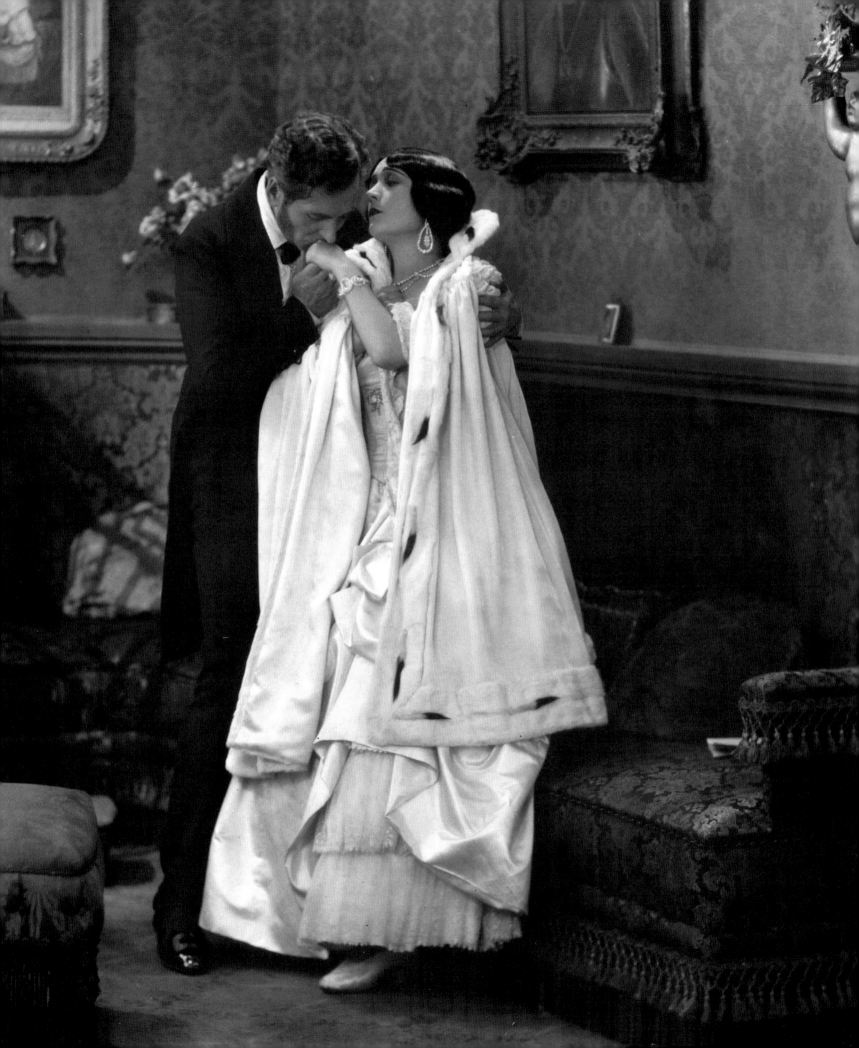

OPPOSITE Pola Negri with unidentified player, 1926

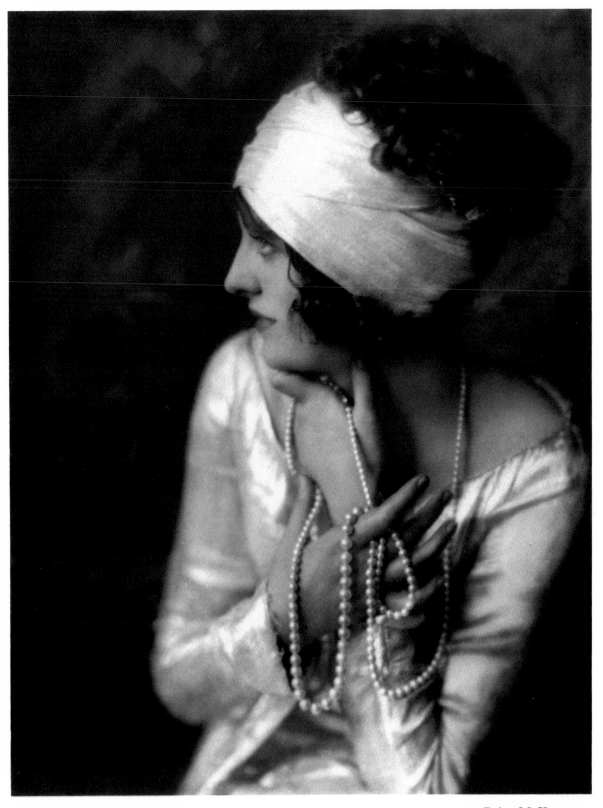

Belva McKay, 1925

OPPOSITE Joan Crawford and Johnny Mack Brown in *Our Dancing Daughters*, 1928

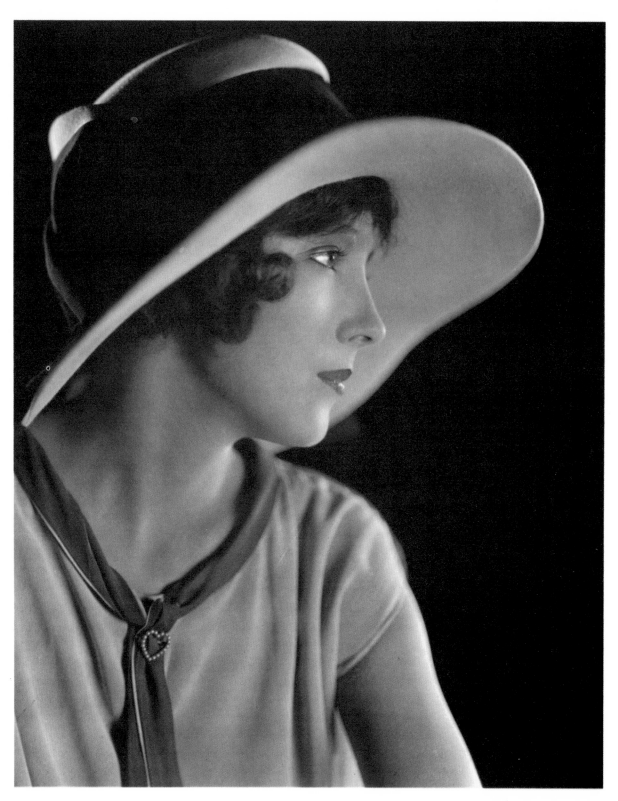

Betty Bronson, 1927

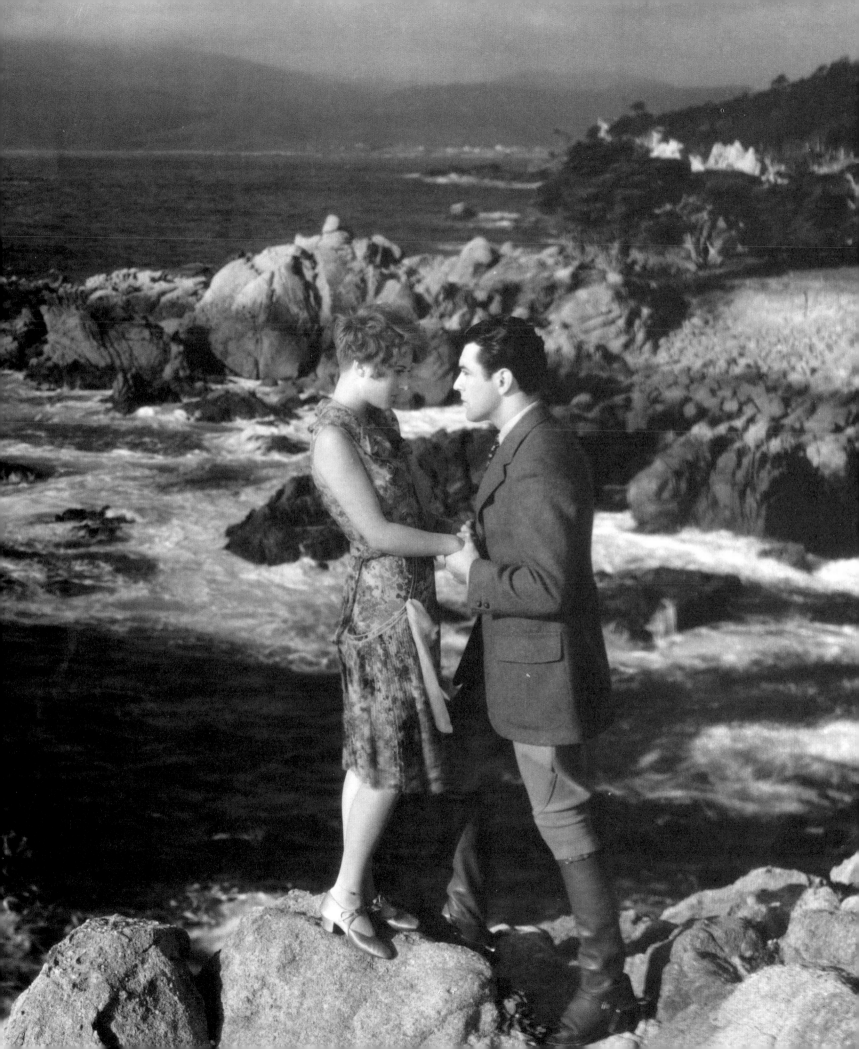

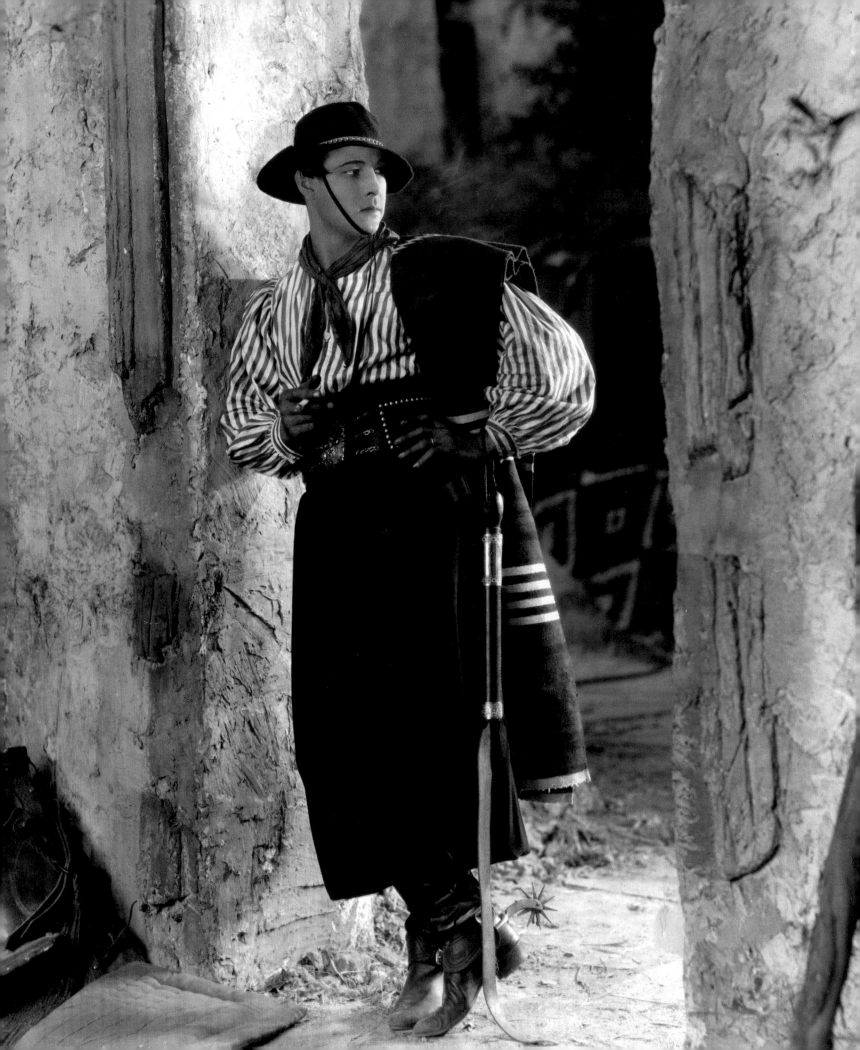

89

OPPOSITE Rudolph Valentino in *A Sainted Devil*, 1924

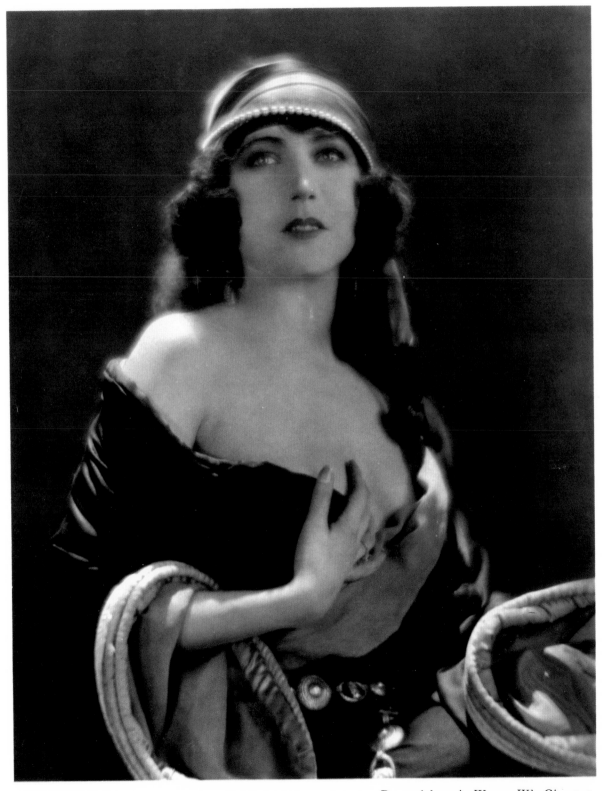

Renee Adoree in *Women Who Give*, 1924

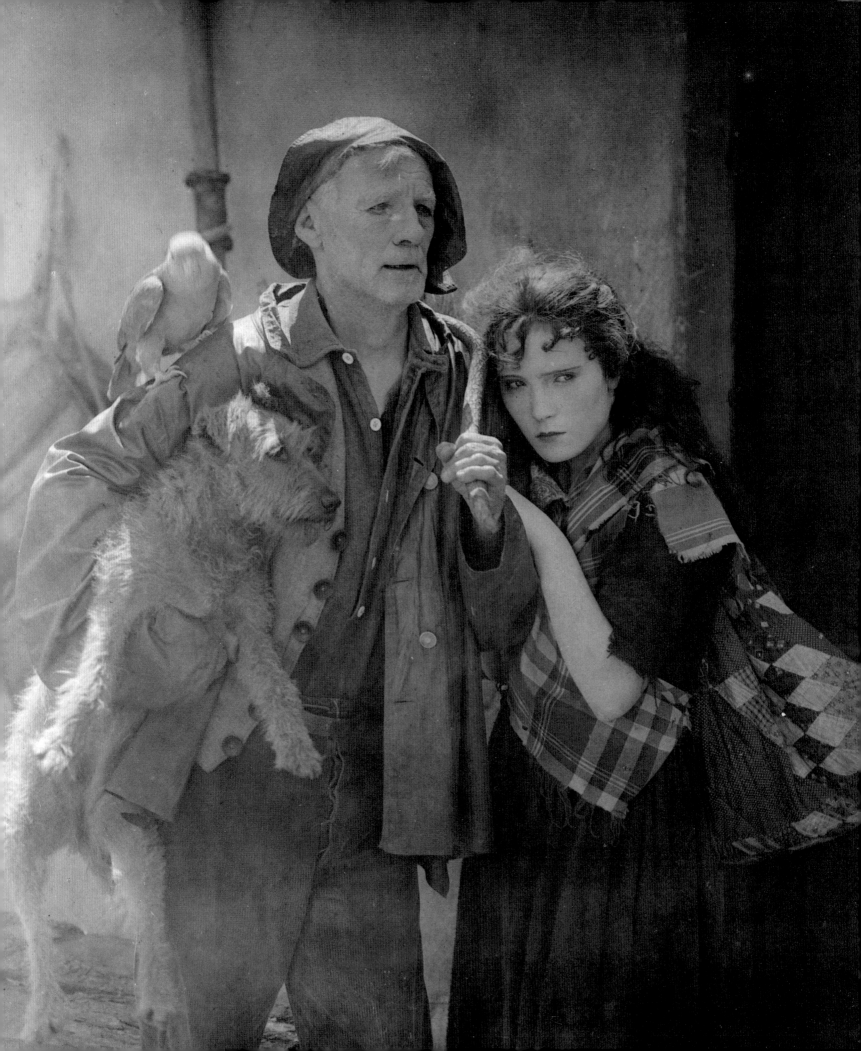

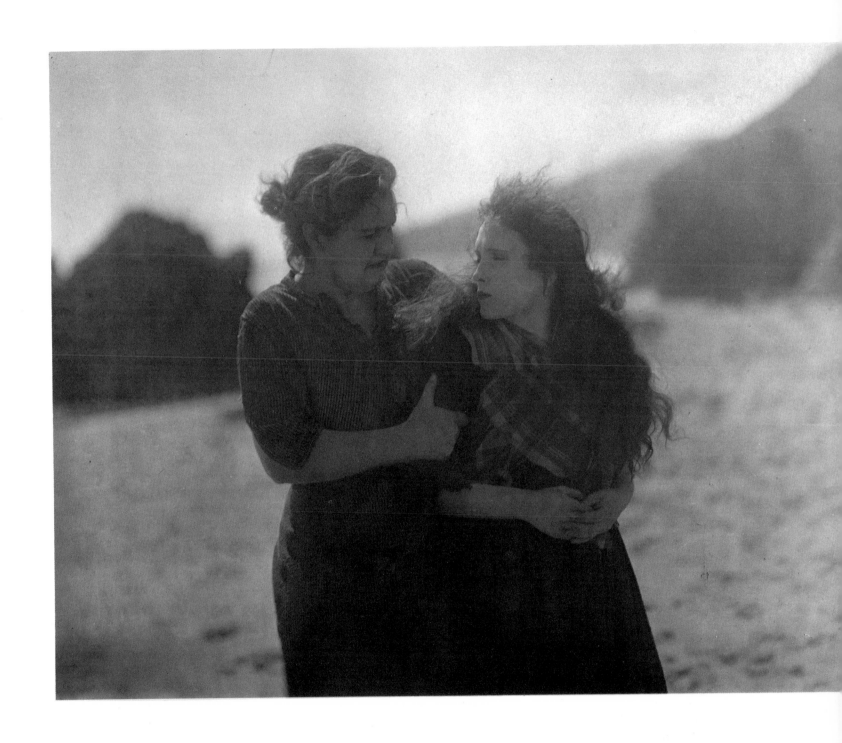

Pauline Starke with unidentified players in *Irish Eyes*, 1918

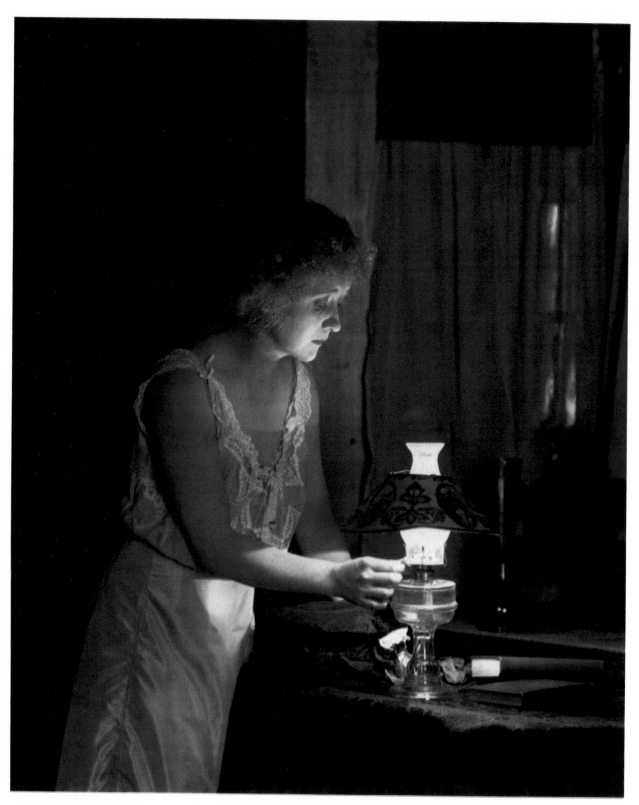

Bessie Barriscale in *I Love You*, 1917

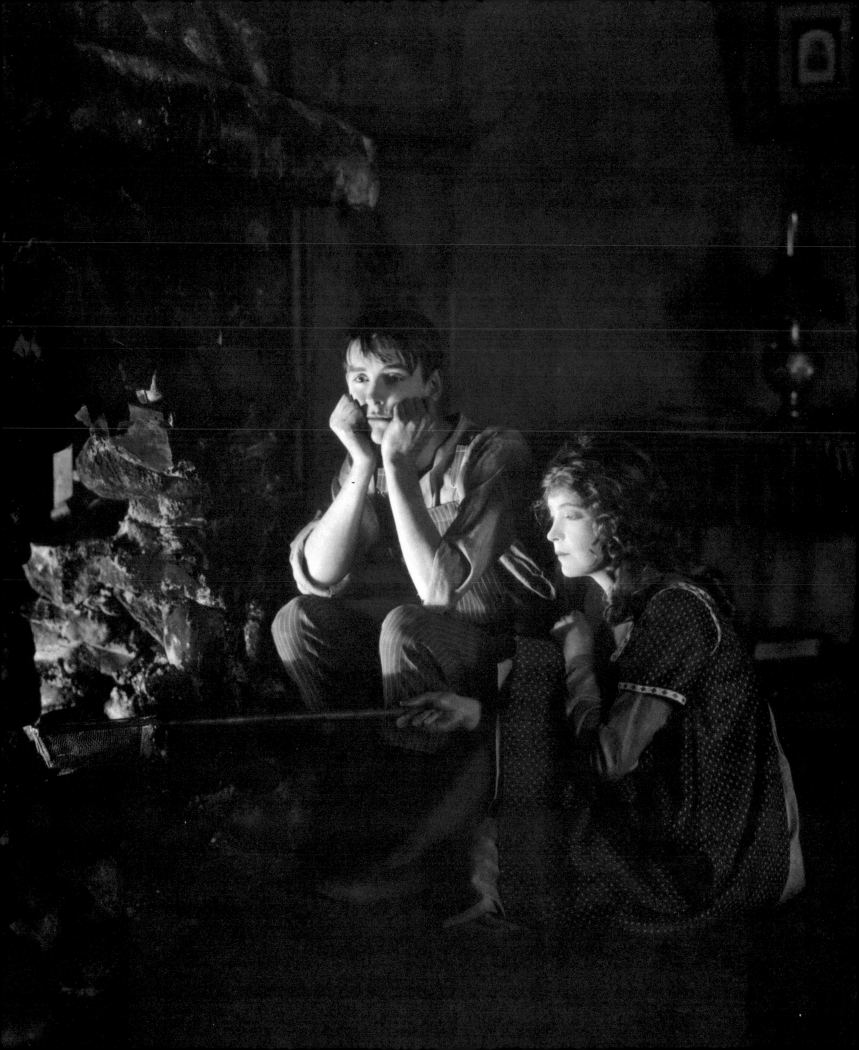

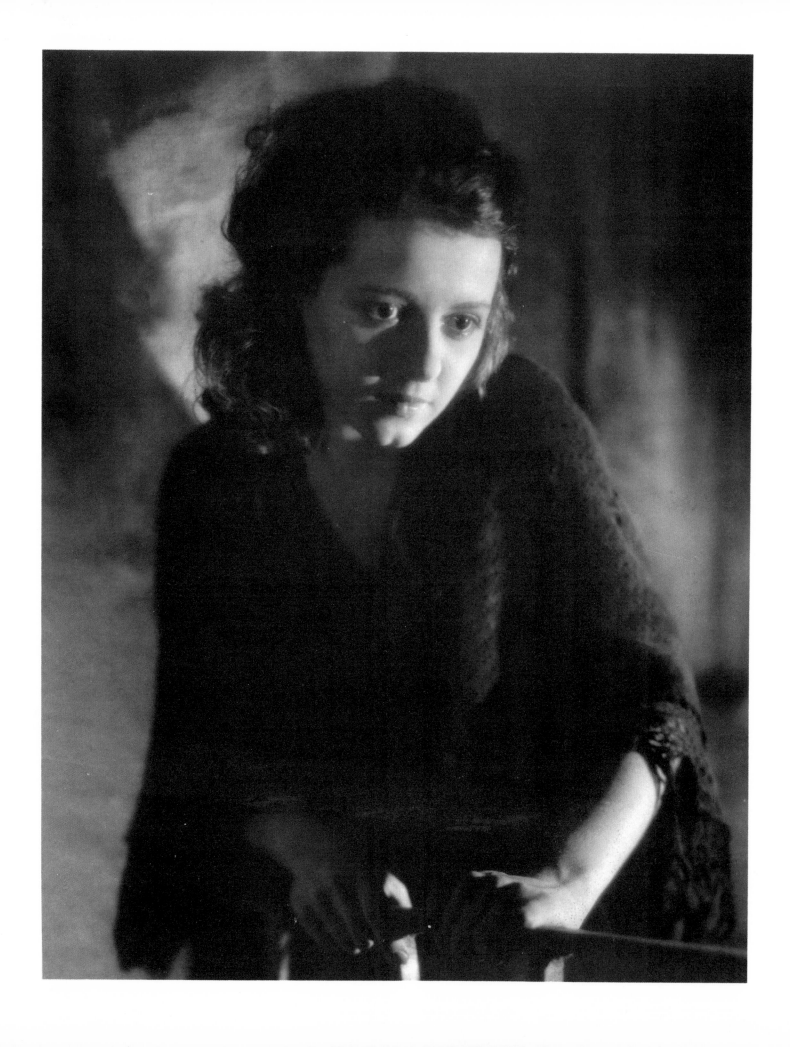

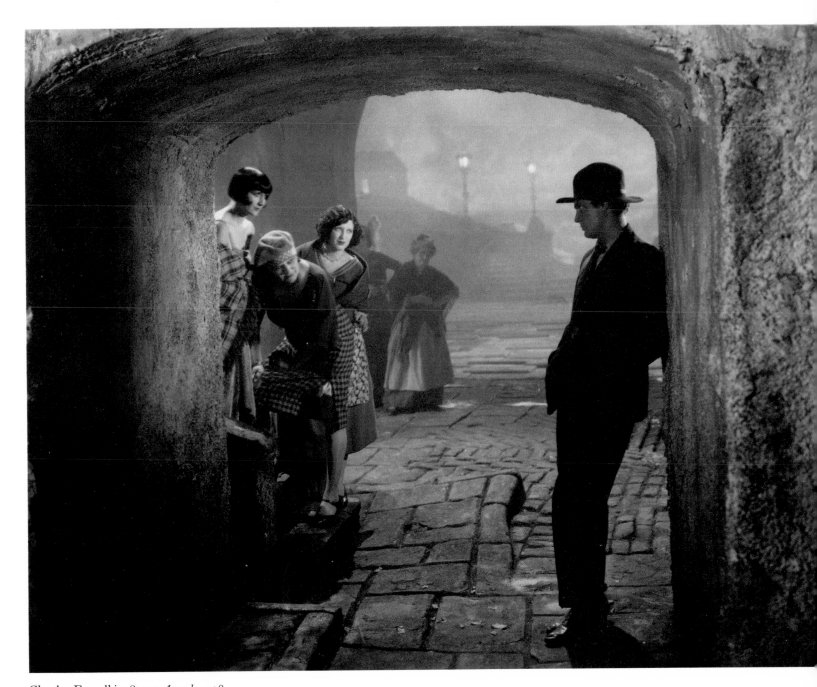

Charles Farrell in *Street Angel*, 1928

OPPOSITE Janet Gaynor in *Seventh Heaven*, 1927

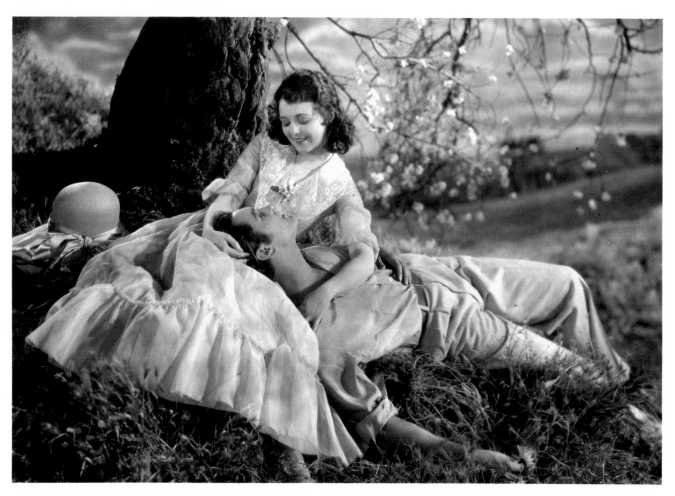

ABOVE Janet Gaynor and Charles Morton in *4 Devils*, 1928

LEFT Gary Cooper and Colleen Moore in *Lilac Time*, 1928

OPPOSITE Colleen Moore in *Lilac Time*, 1928

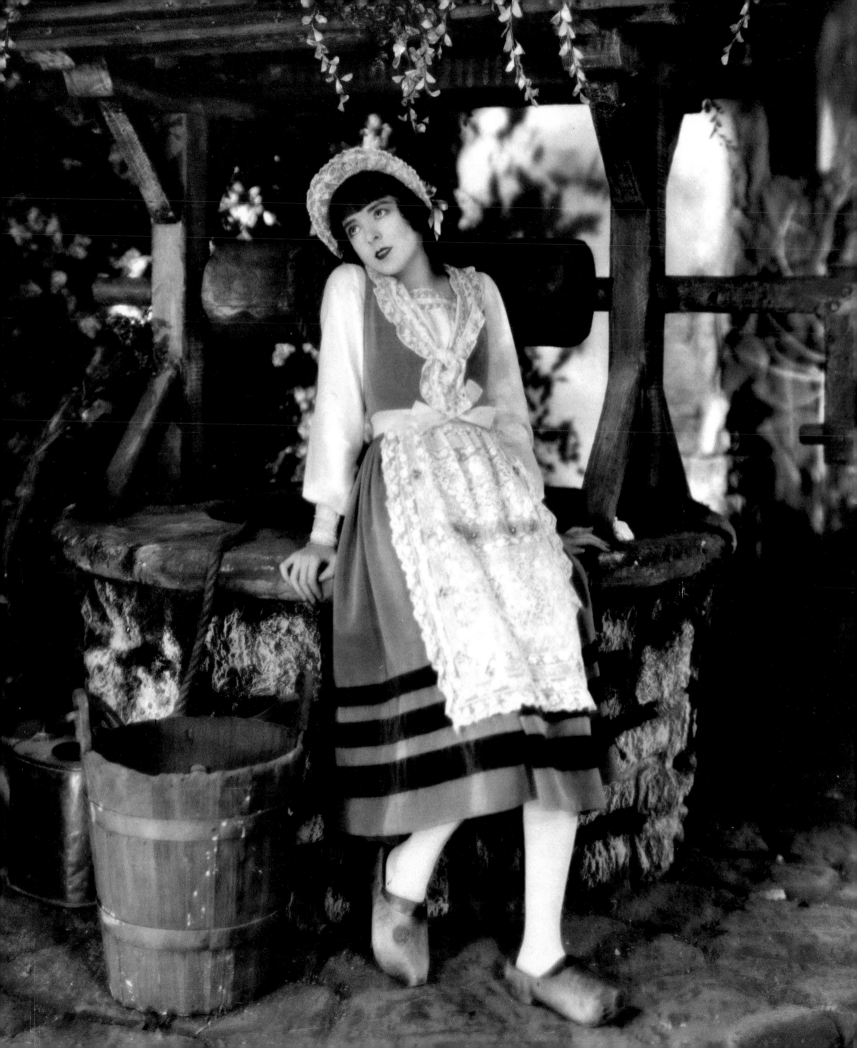

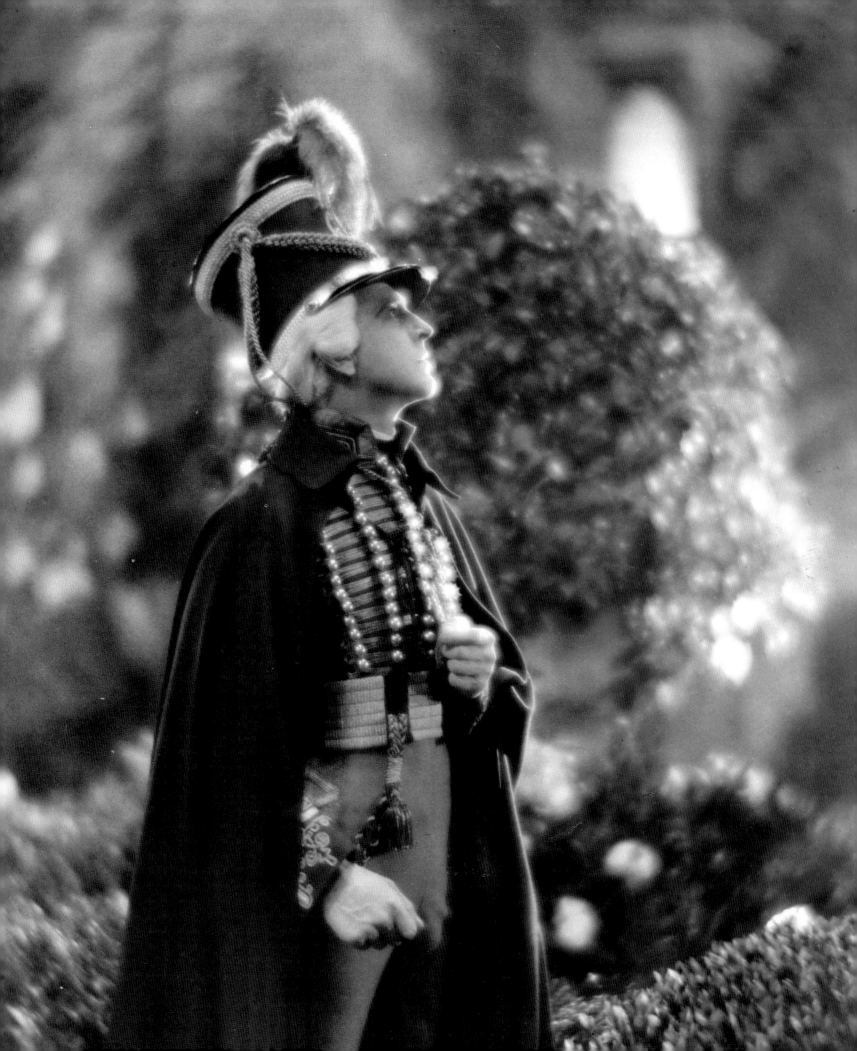

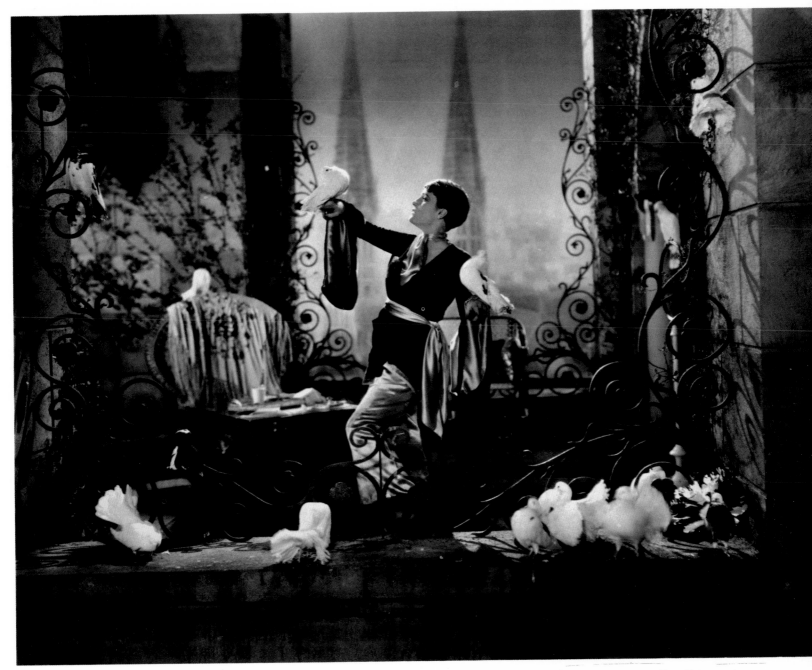

Pauline Starke in *Women Love Diamonds*, 1927

OPPOSITE John Barrymore in *Beau Brummel*, 1924

ABOVE Douglas Fairbanks (center) in *The Thief of Bagdad*, 1924

LEFT Mary Astor, 1923

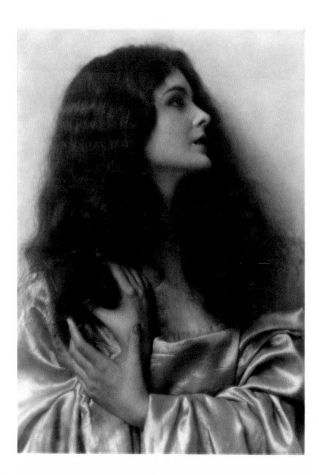

OPPOSITE Lillian Gish in *Romola*, 1924

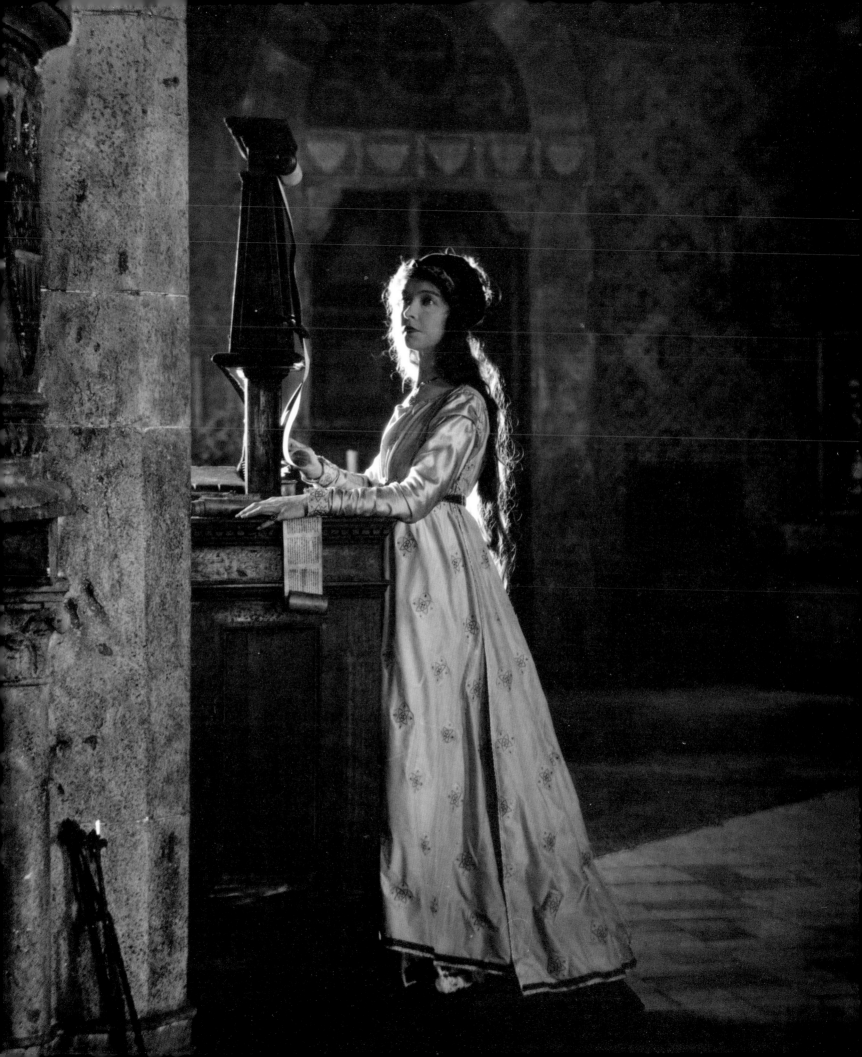

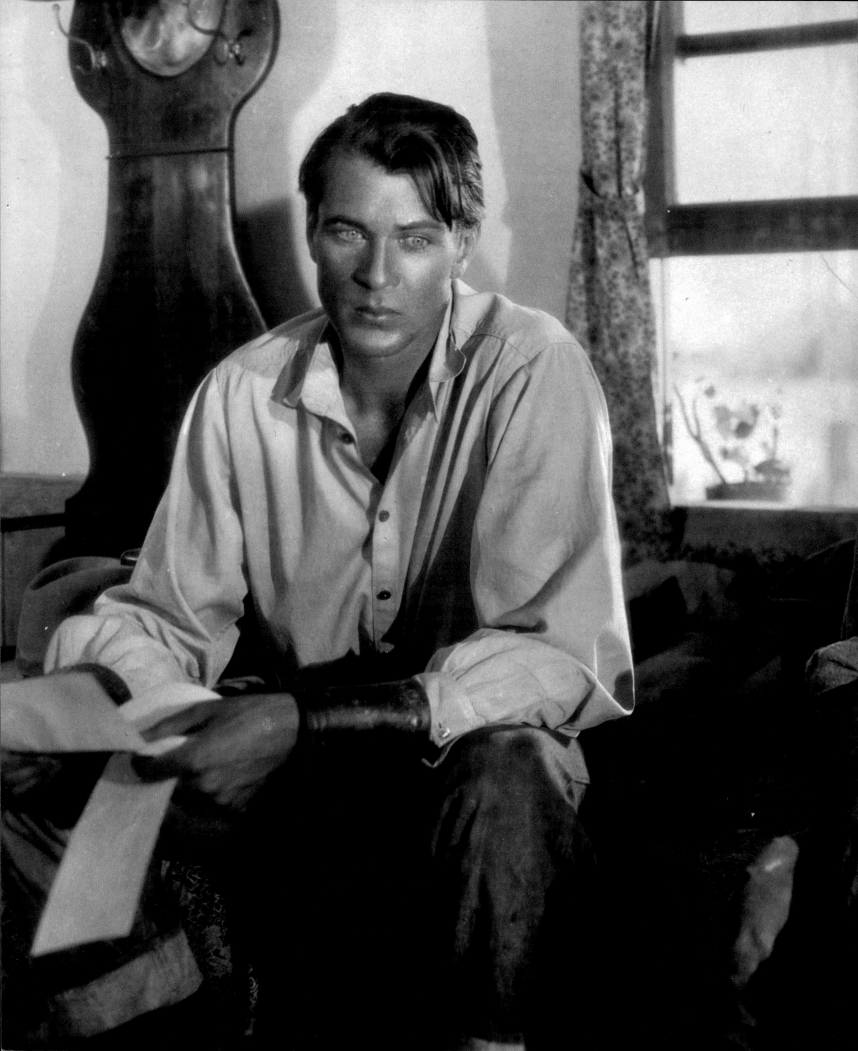

OPPOSITE Gary Cooper in *The Winning of Barbara Worth*, 1926

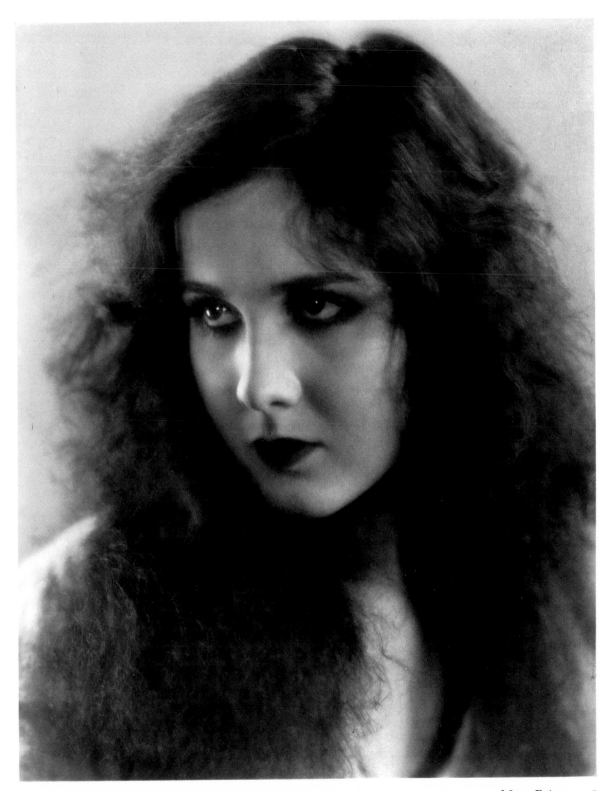

Mary Brian, 1928

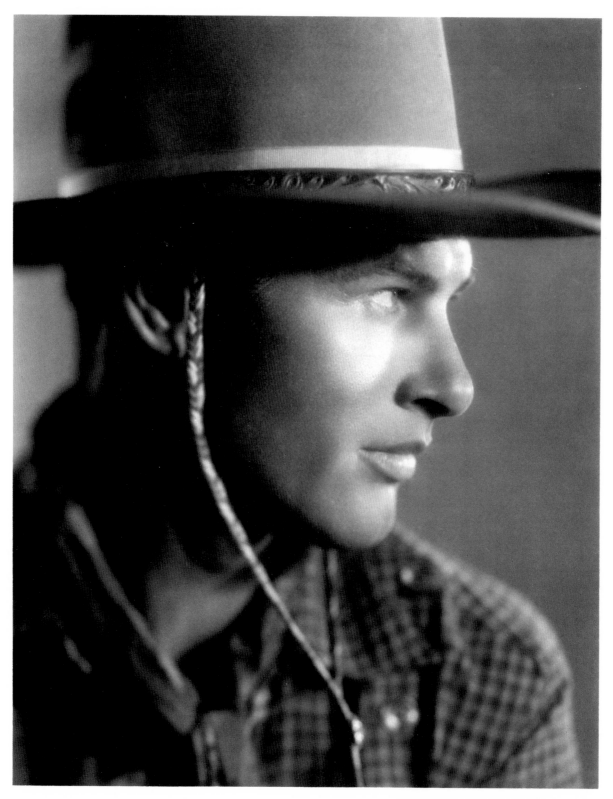

Richard Arlen in *The Virginian*, 1929

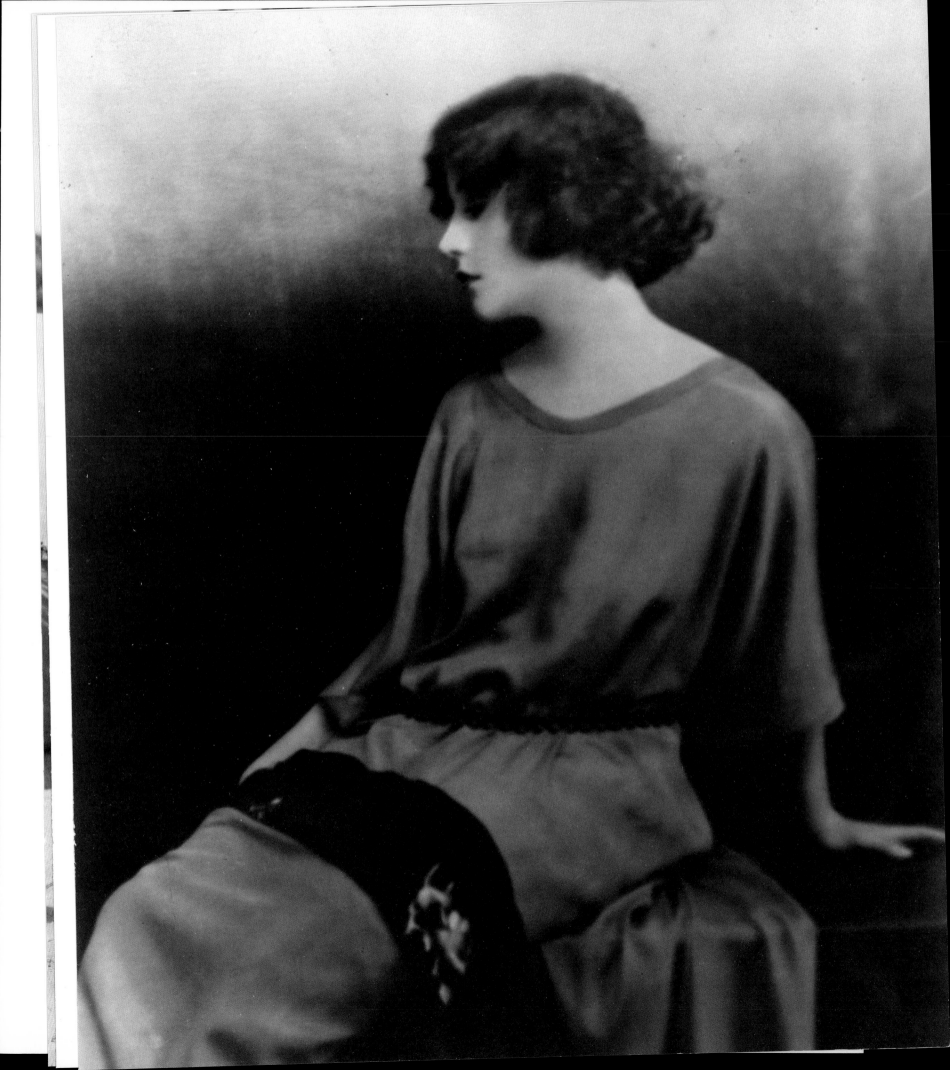

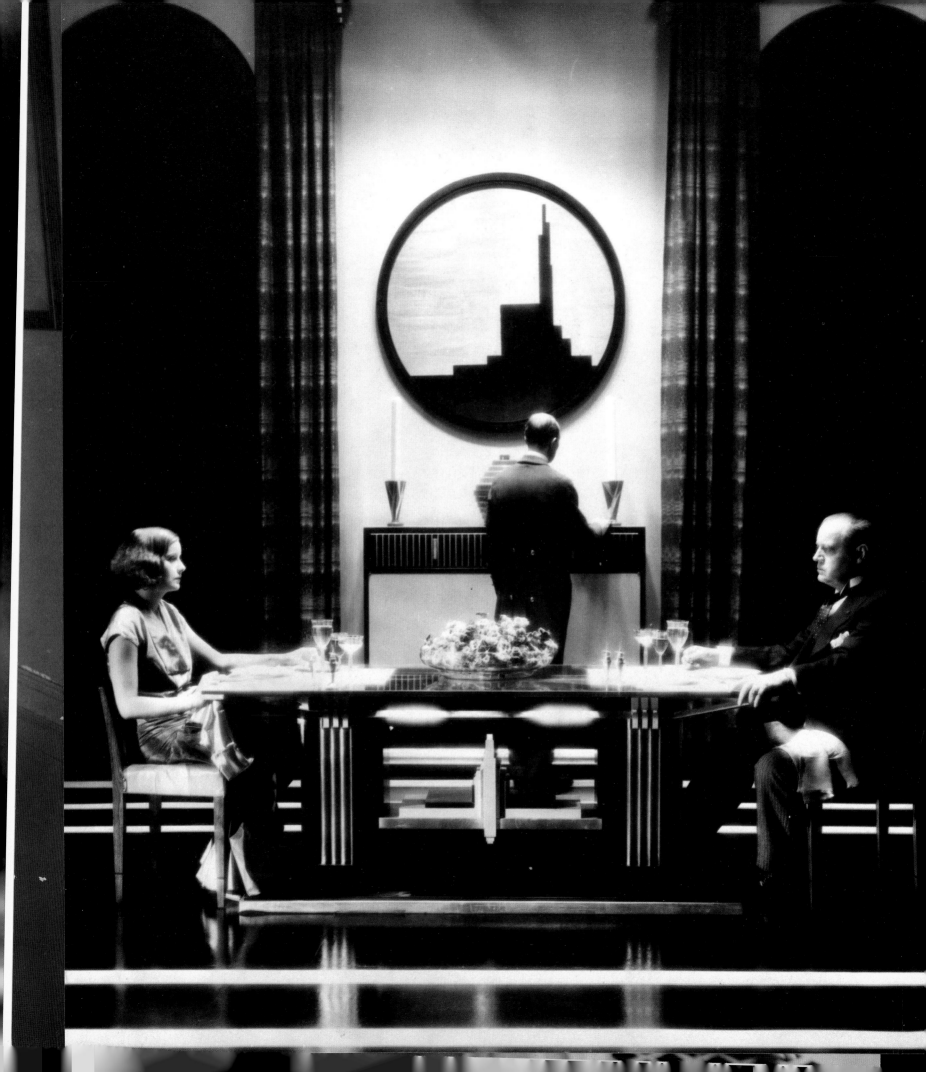

Part II

OPPOSITE Greta Garbo and Anders Randolph in *The Kiss*, 1929

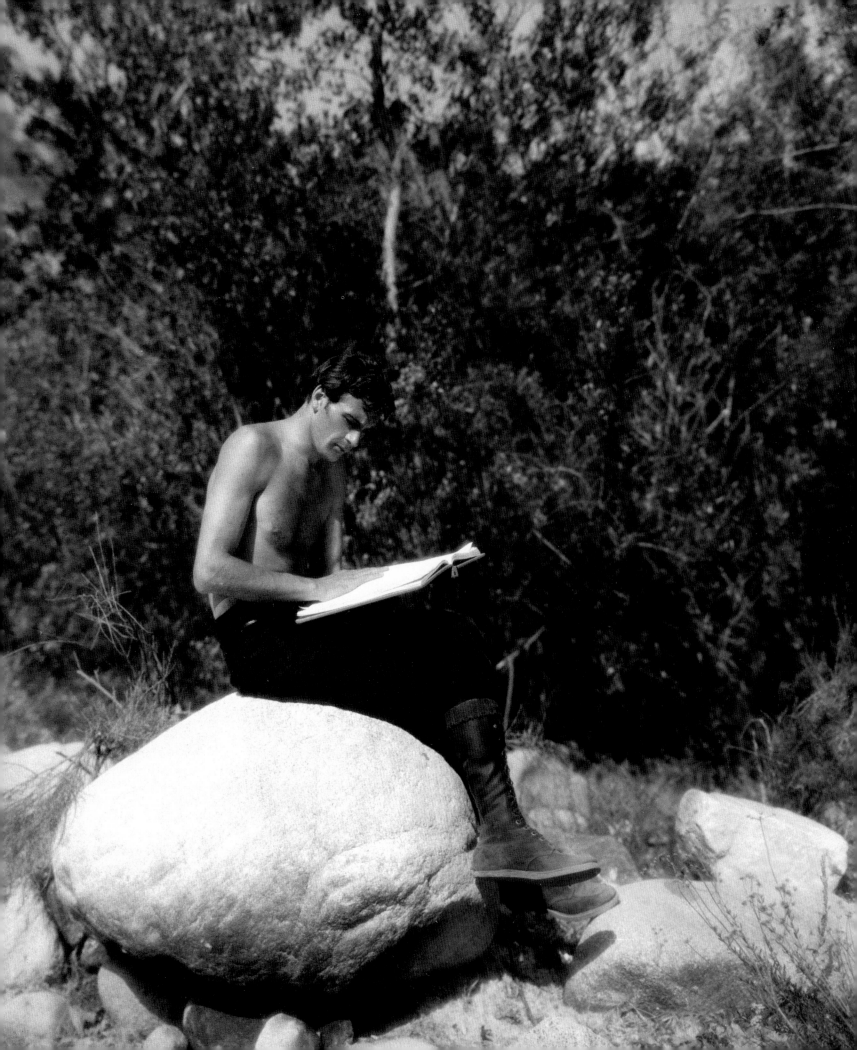

The Thirties

OPPOSITE Gary Cooper, 1930

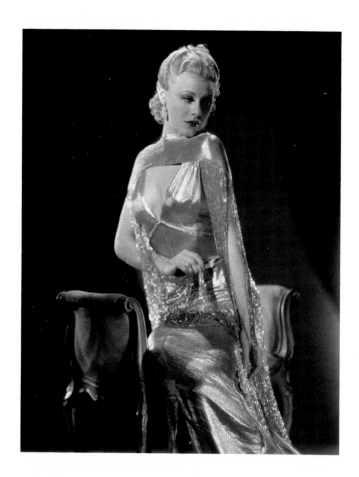

OPPOSITE Kay Francis, 1932

LEFT Ginger Rogers, 1935

BELOW Melvyn Douglas and Luise Rainer in *The Toy Wife*, 1938

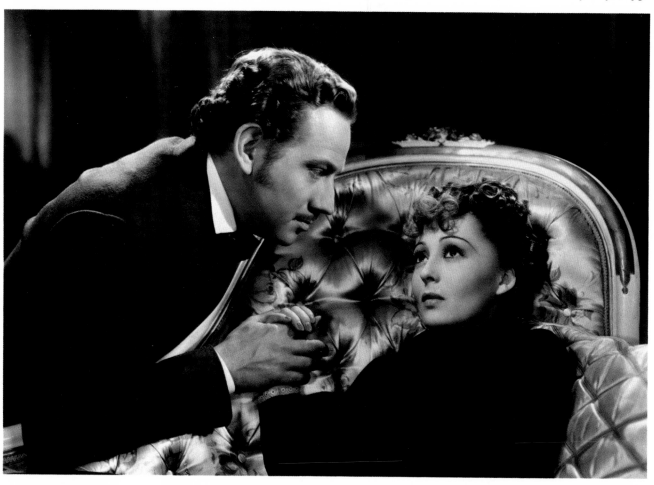

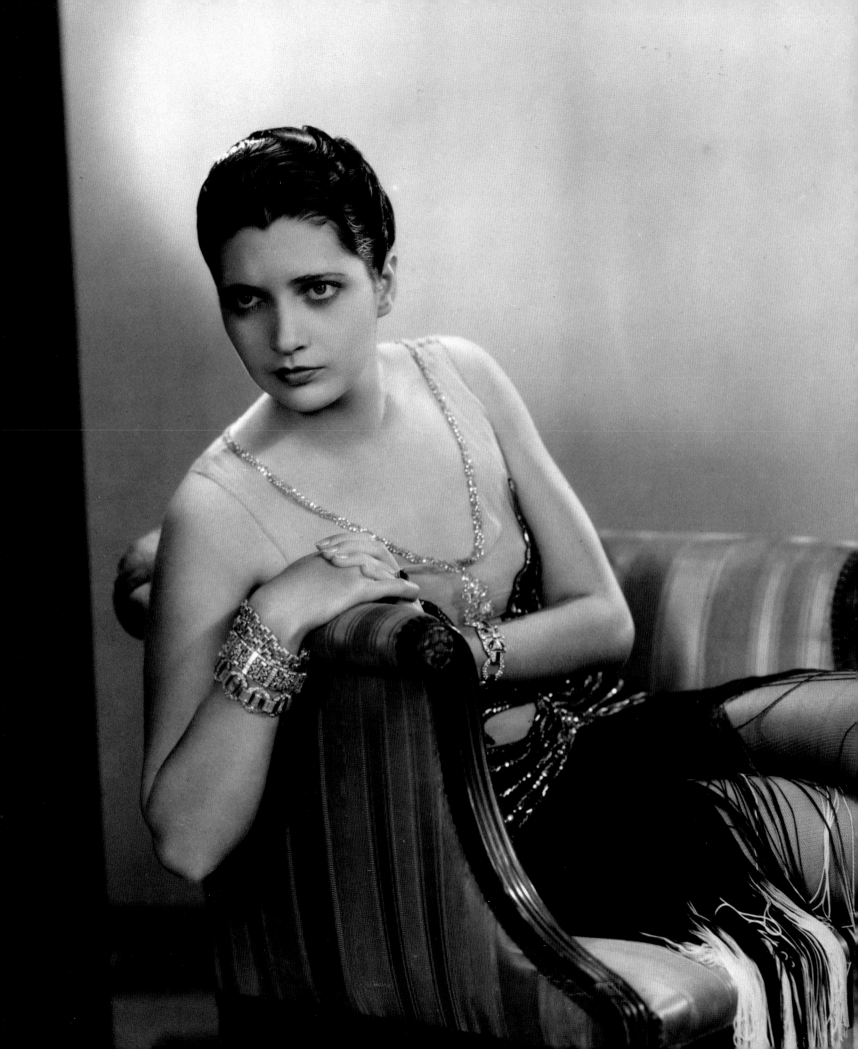

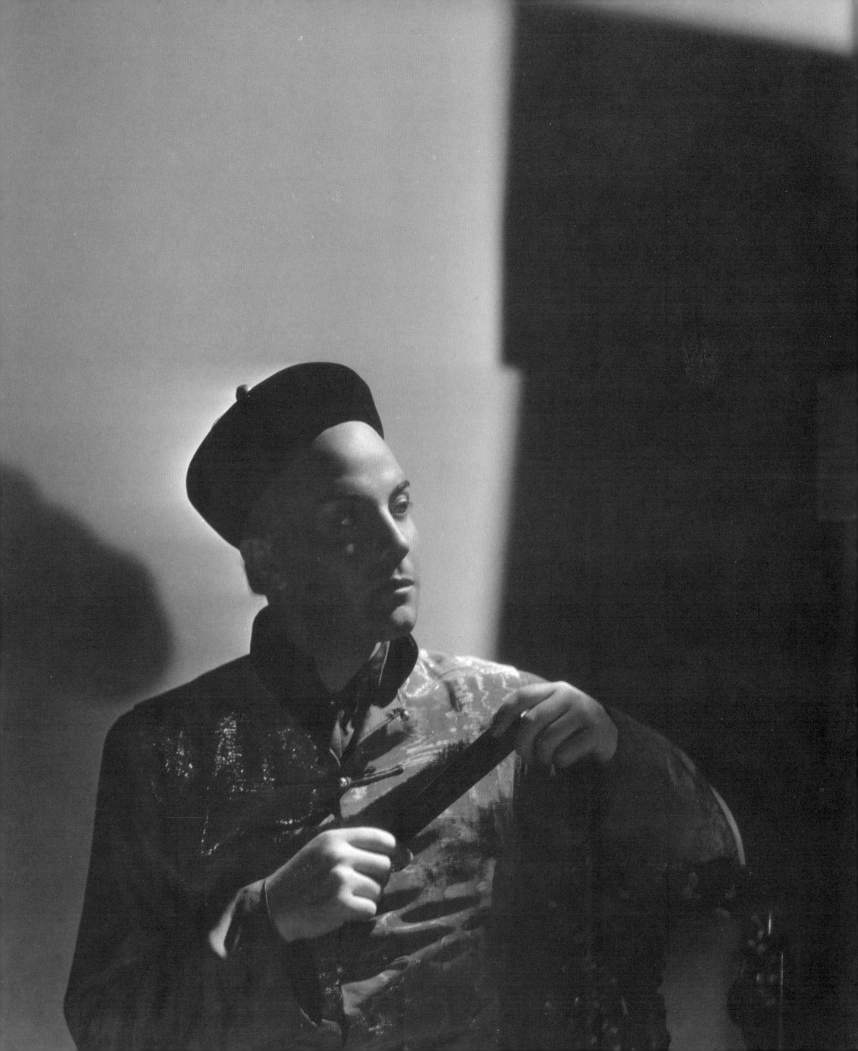

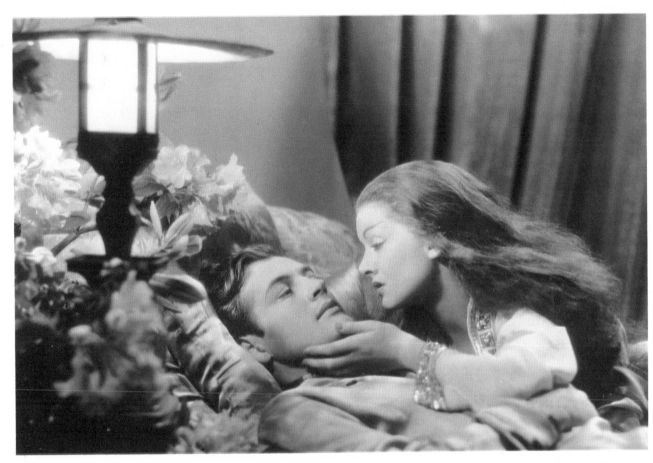

Charles Starrett and Myrna Loy in *The Mask of Fu Manchu*, 1932

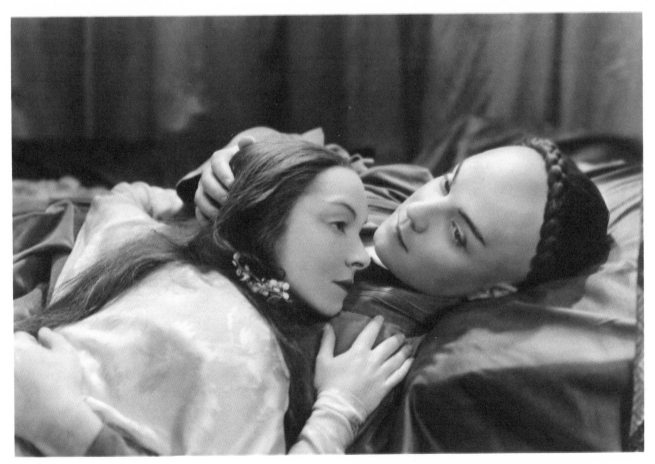

OPPOSITE
Ramon Novarro, 1932

Helen Hayes and Ramon Novarro in *The Son-Daughter*, 1932

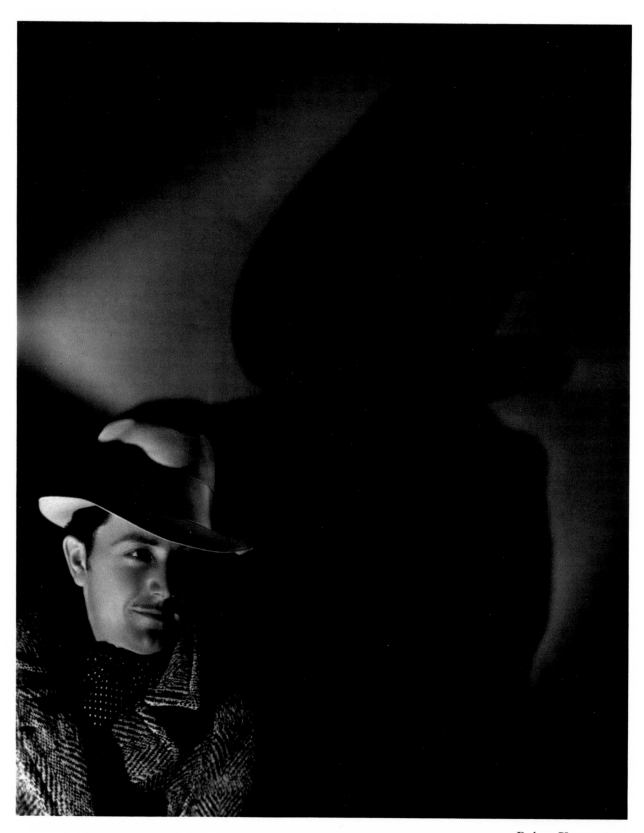

Robert Young, 1933

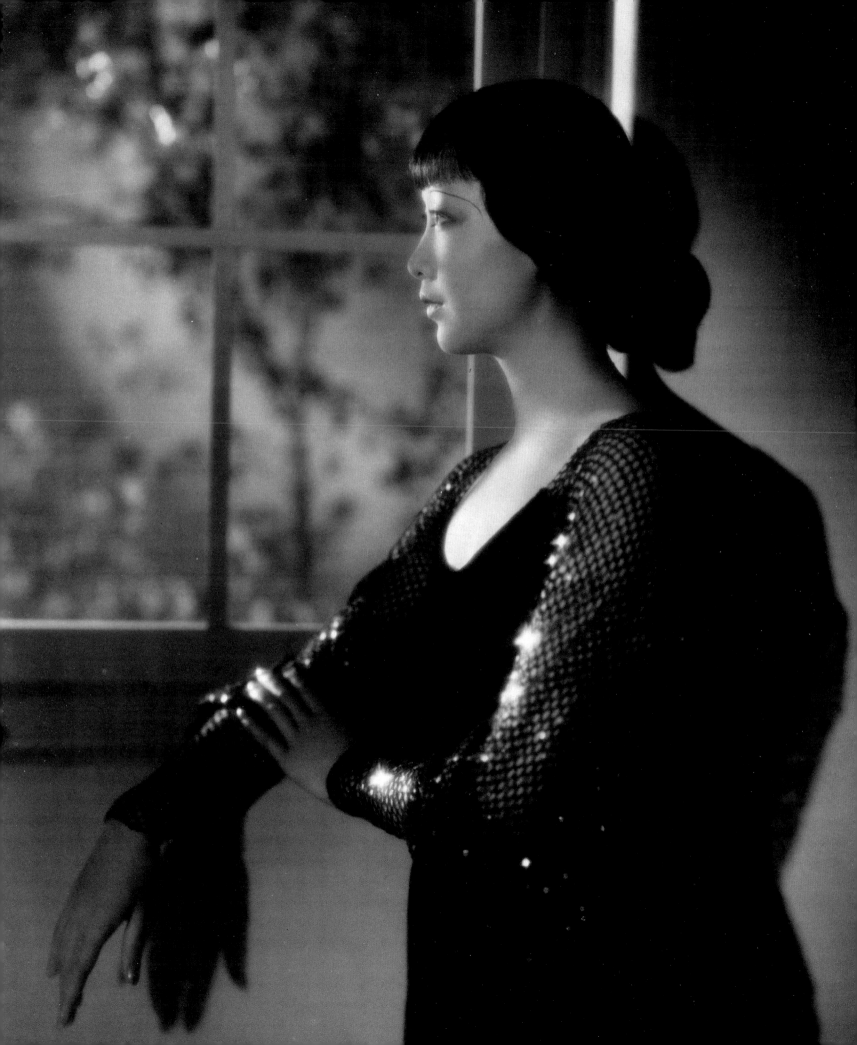

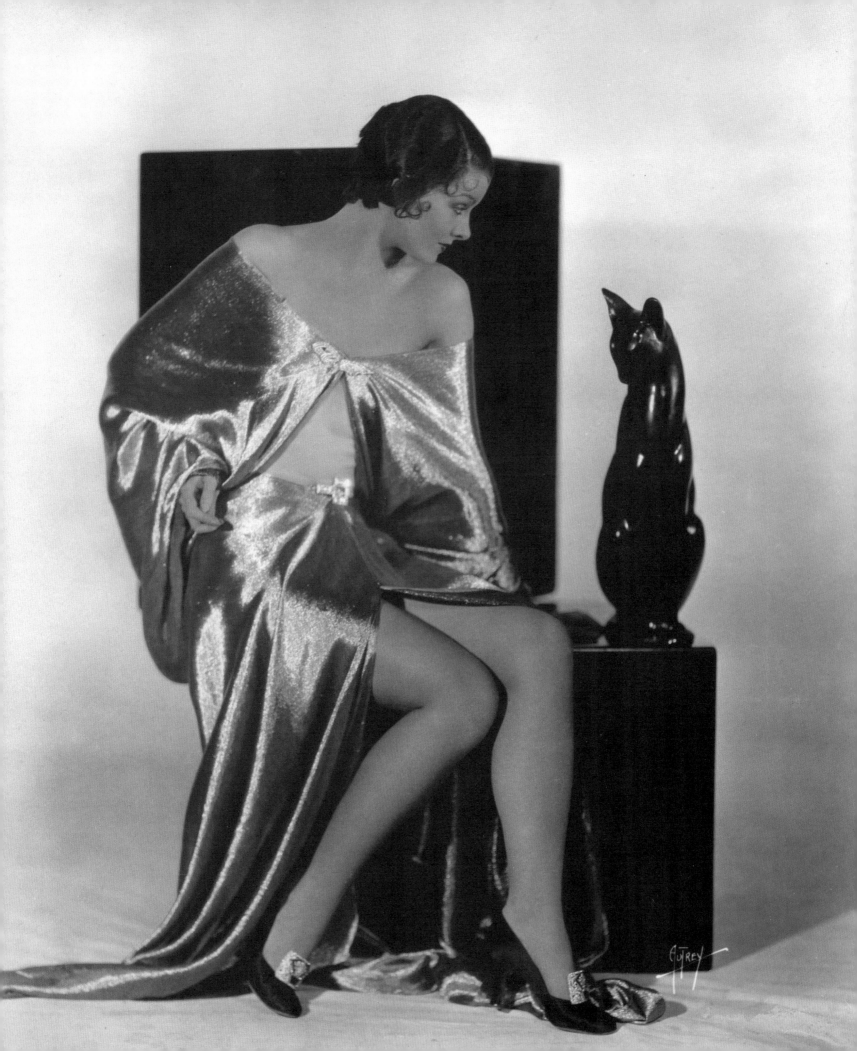

OPPOSITE Myrna Loy, 1930

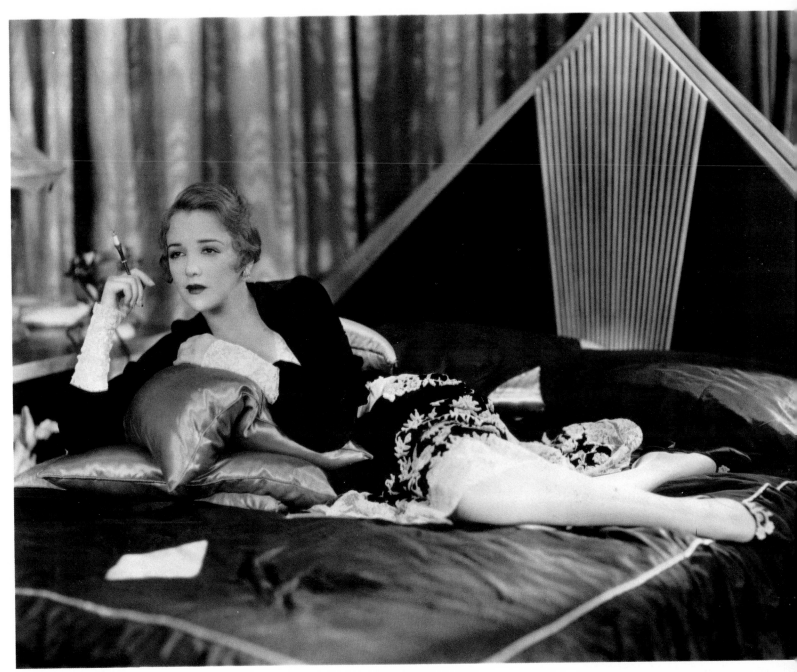

Bebe Daniels in *My Past*, 1931

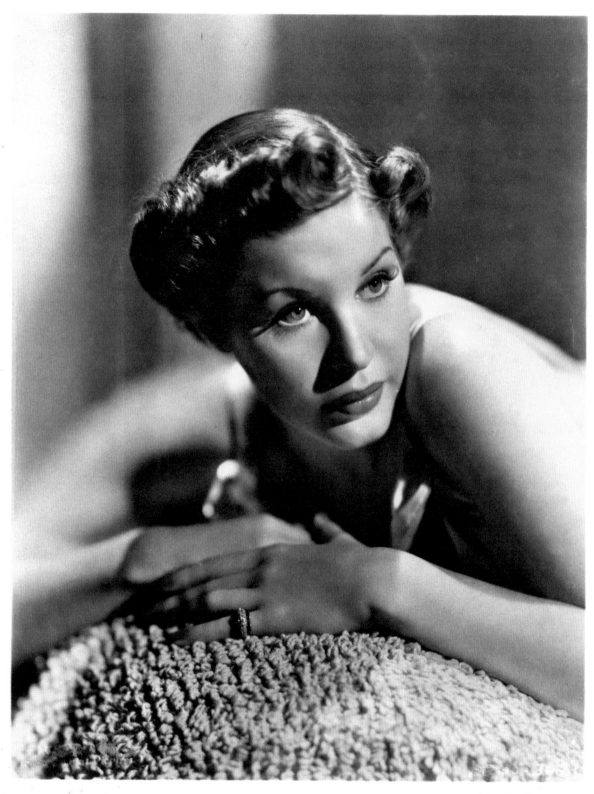

Martha Raye, 1939

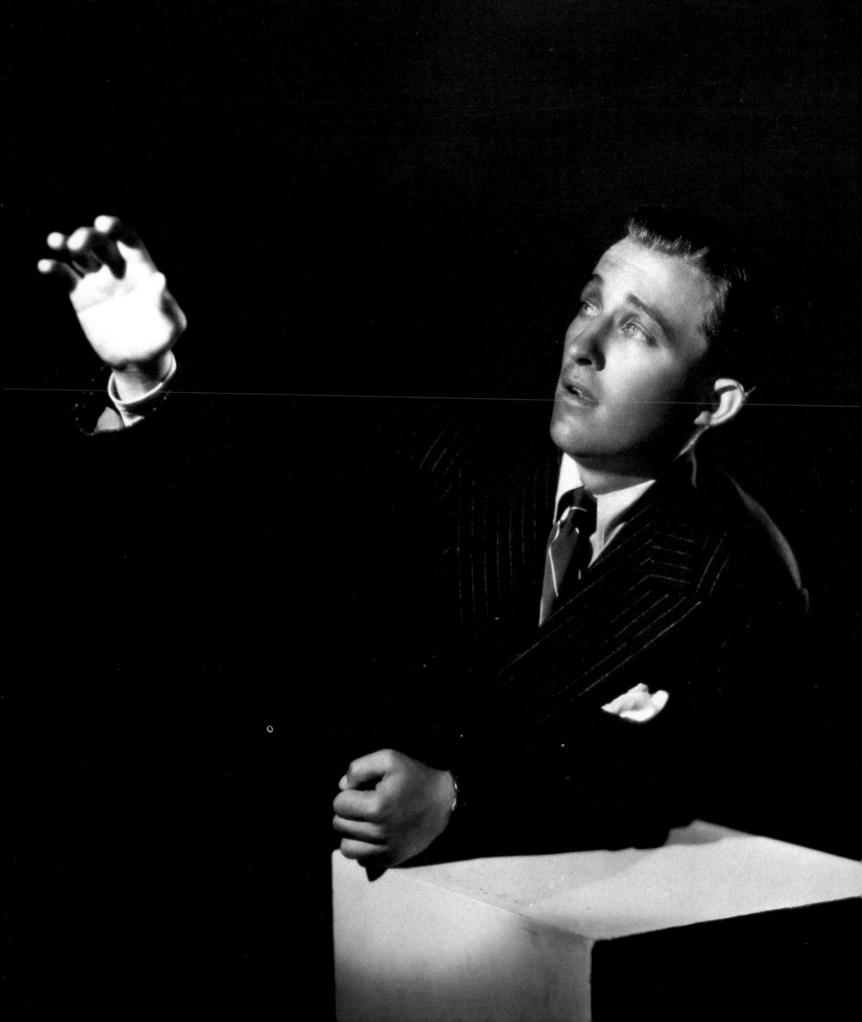

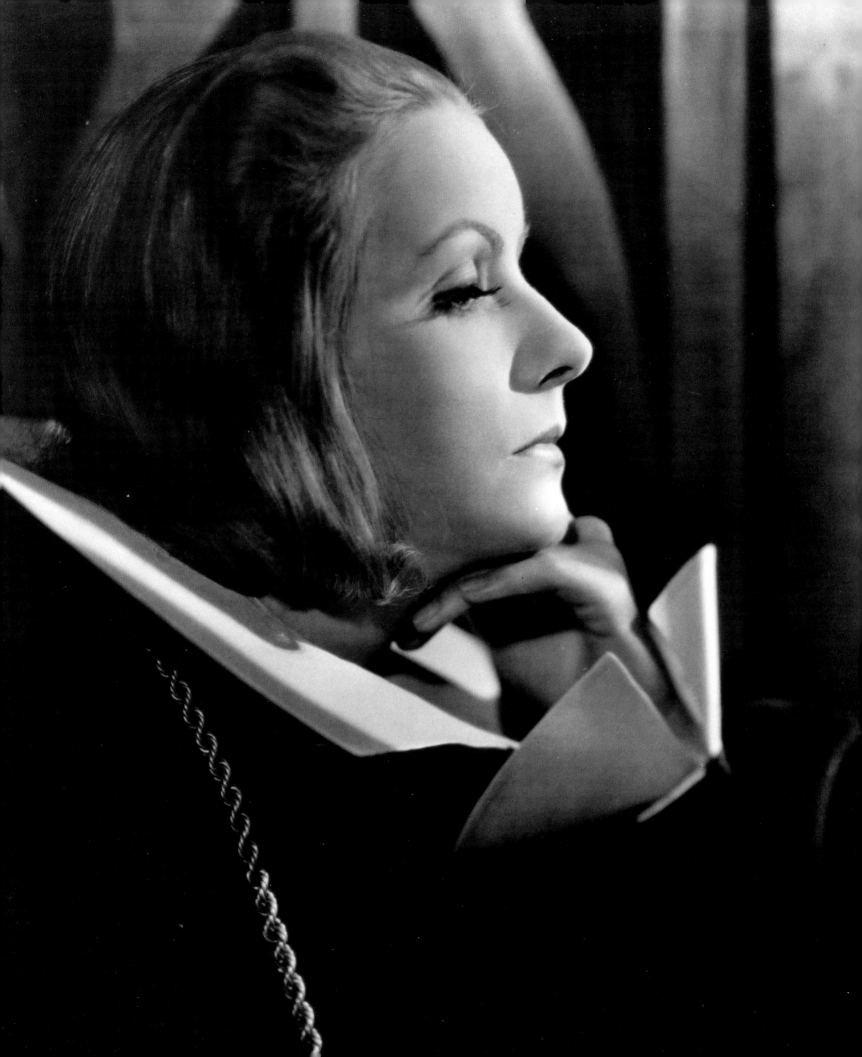

OPPOSITE Greta Garbo

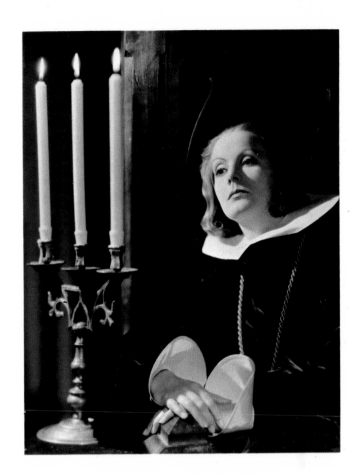

Queen Christina, 1933

RIGHT Greta Garbo

BELOW Greta Garbo and John Gilbert

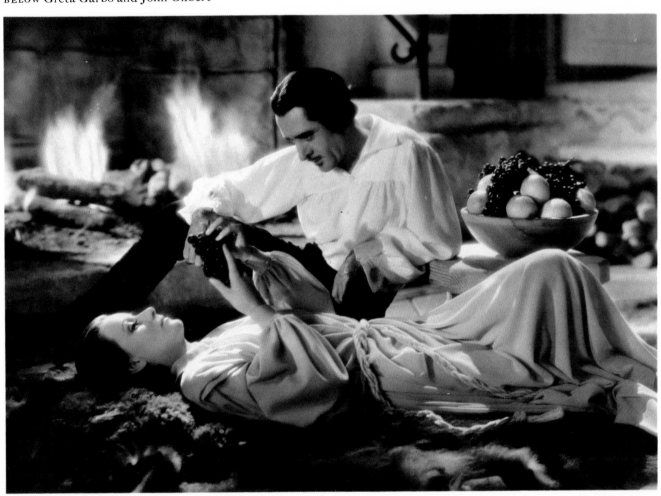

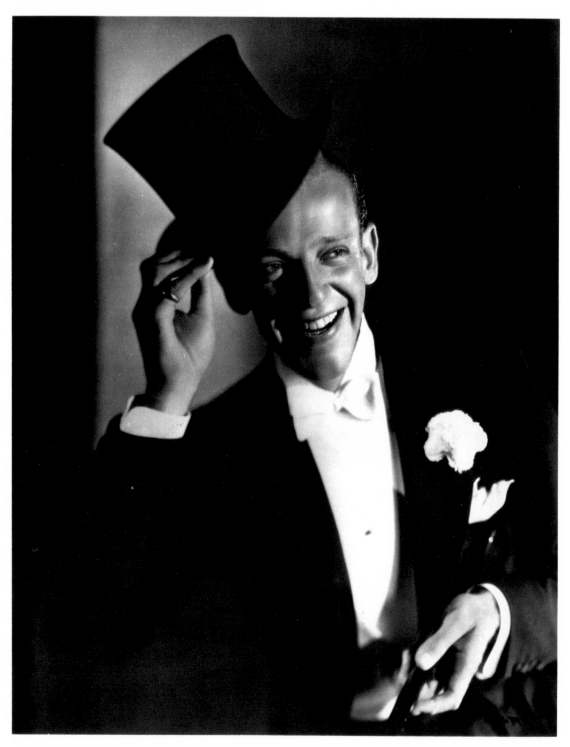

Fred Astaire in *The Gay Divorcee*, 1934

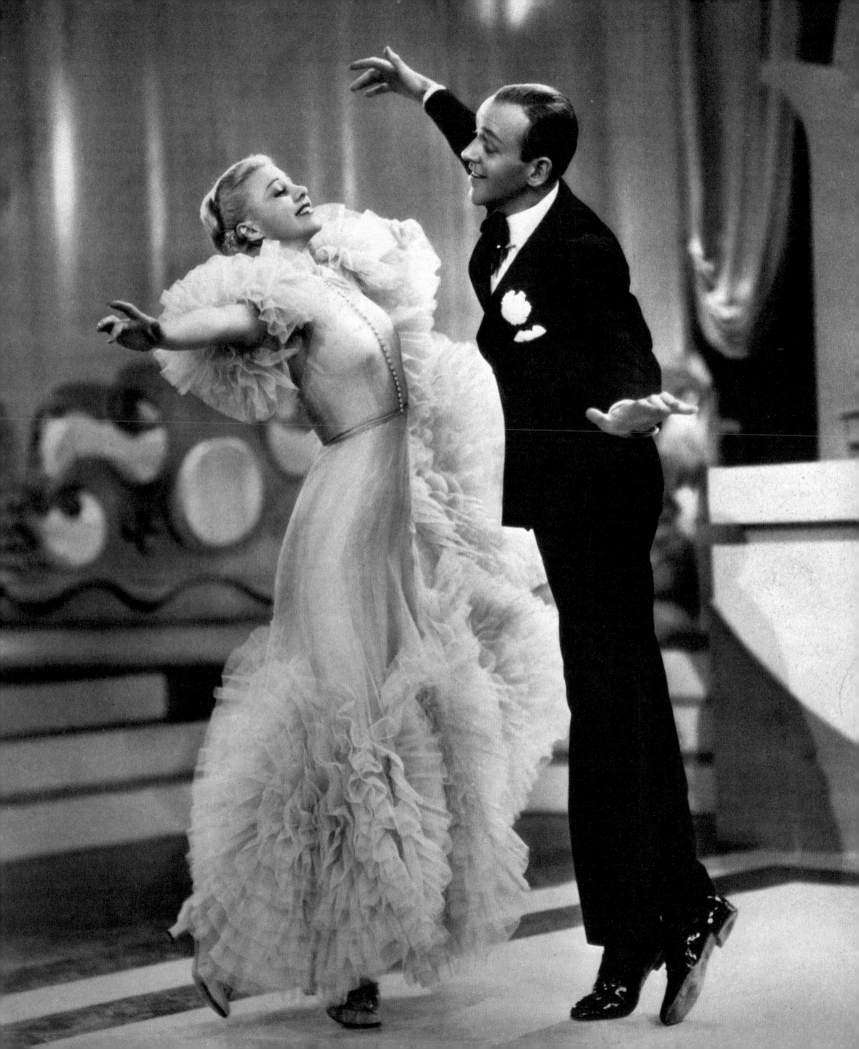

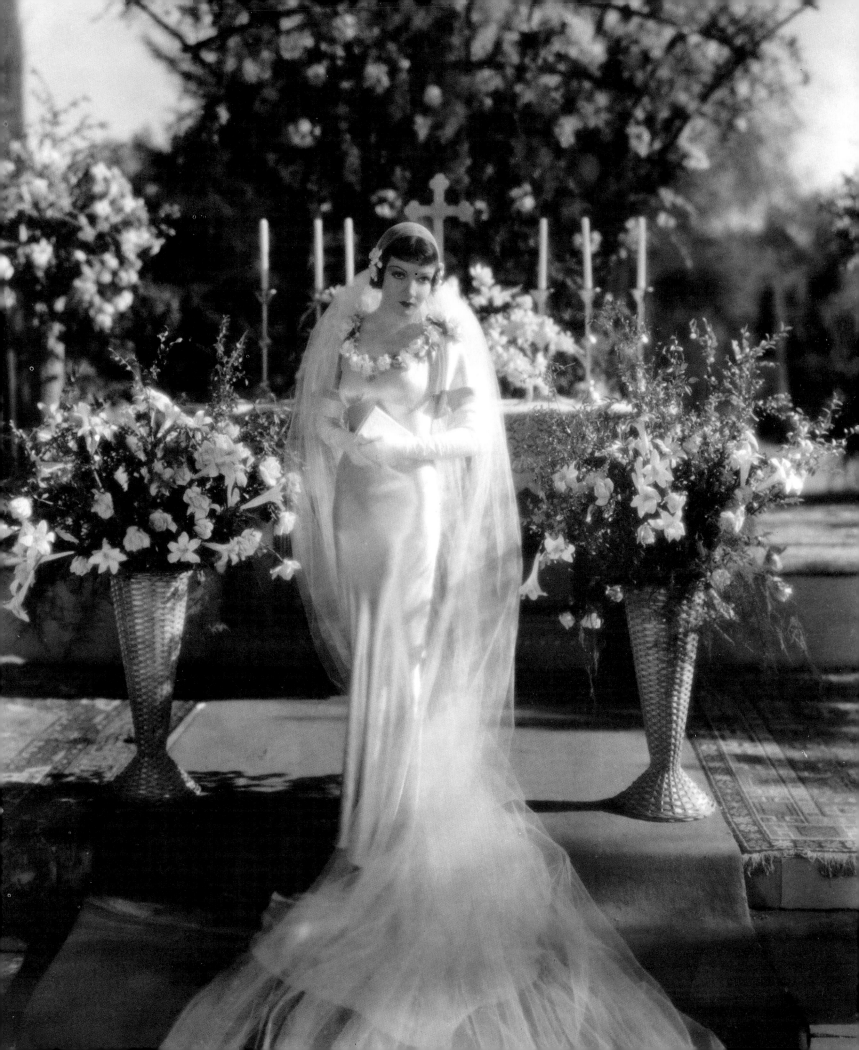

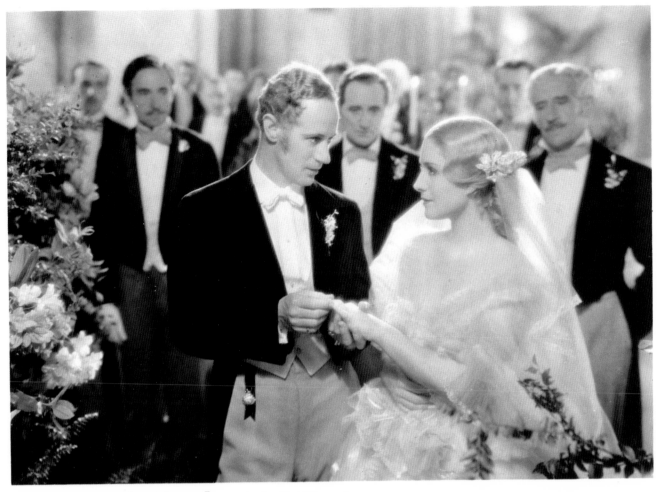

ABOVE Leslie Howard and Norma Shearer in *Smilin' Through*, 1932

RIGHT Robert Taylor in *Camille*, 1936

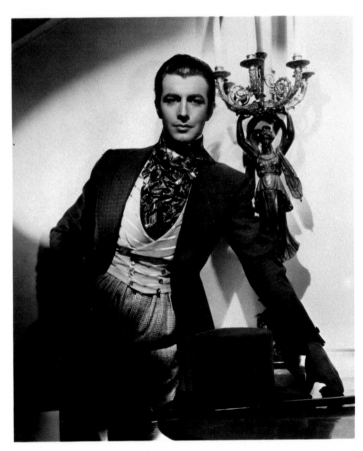

OPPOSITE Claudette Colbert in *It Happened One Night*, 1934

OPPOSITE Leslie Howard and Ingrid Bergman in *Intermezzo*, 1937

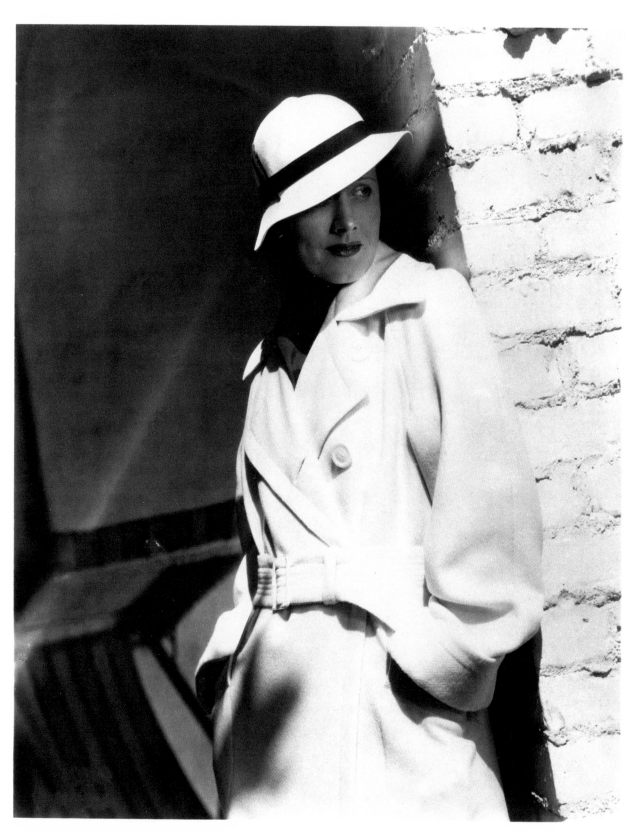

Irene Dunne, 1935

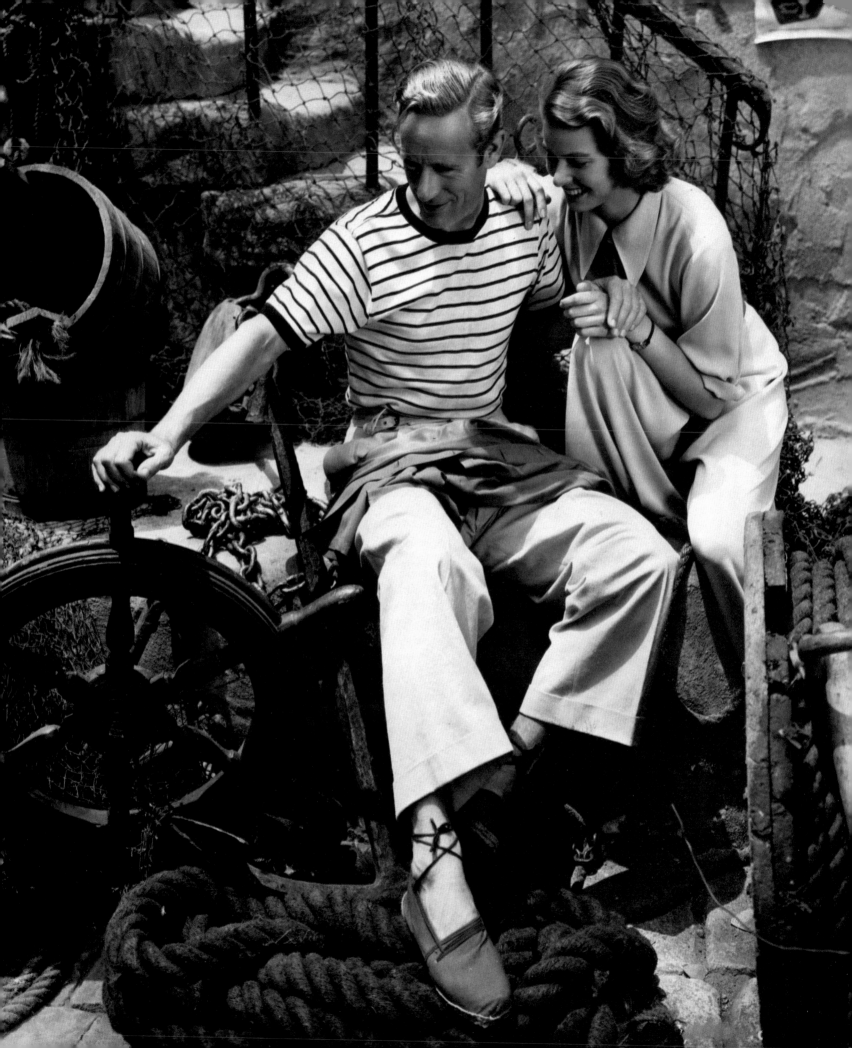

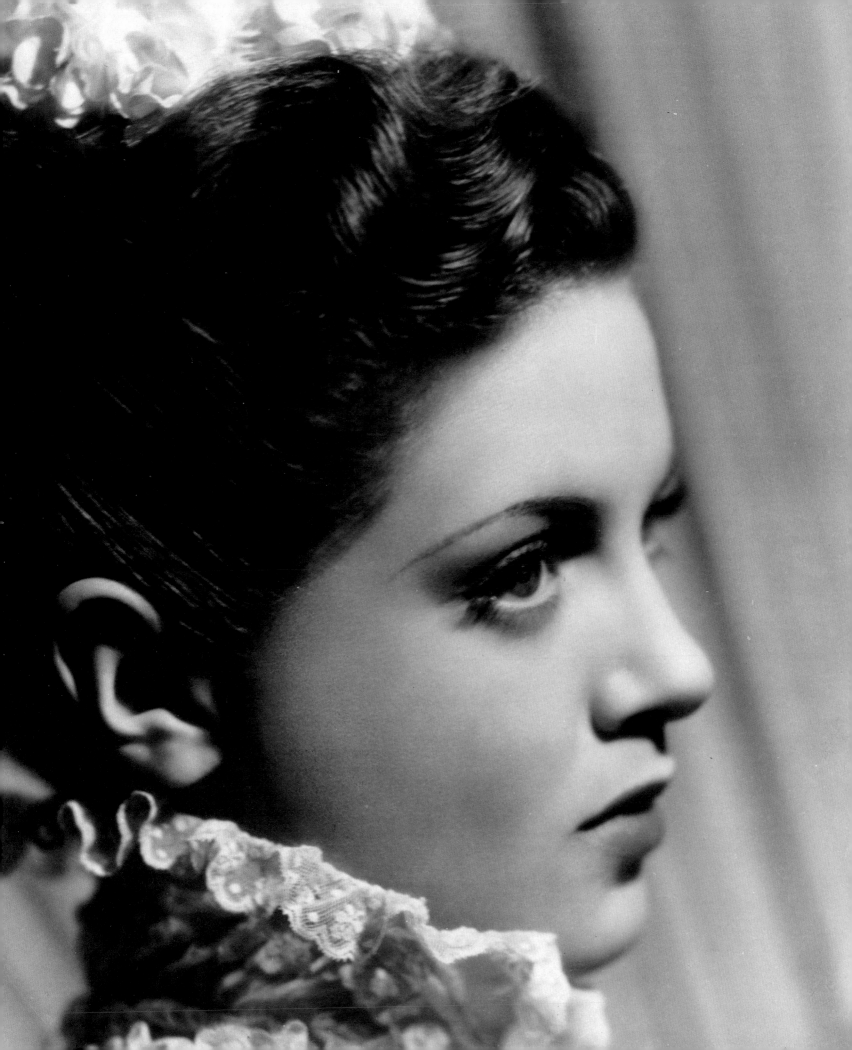

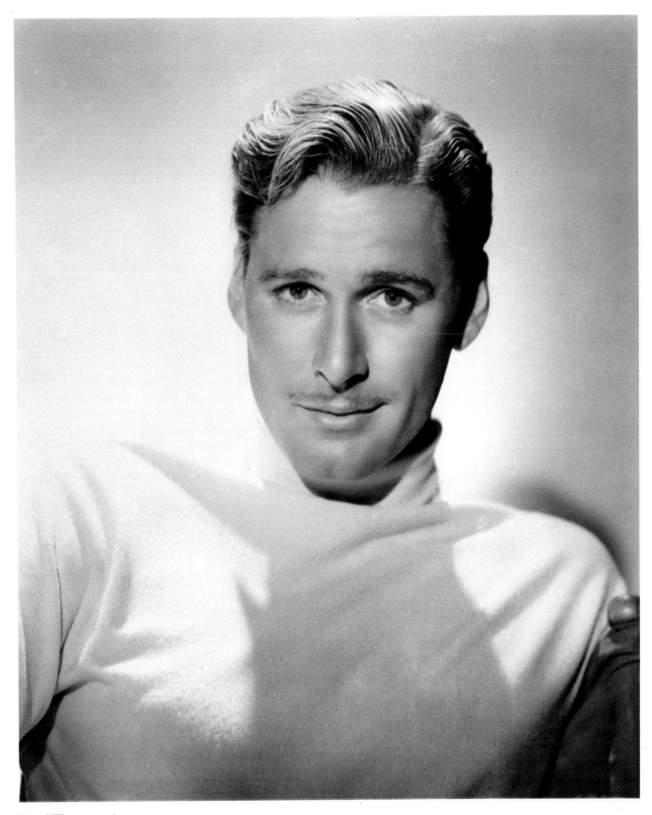

Errol Flynn, 1938

OPPOSITE Lana Turner, 1937

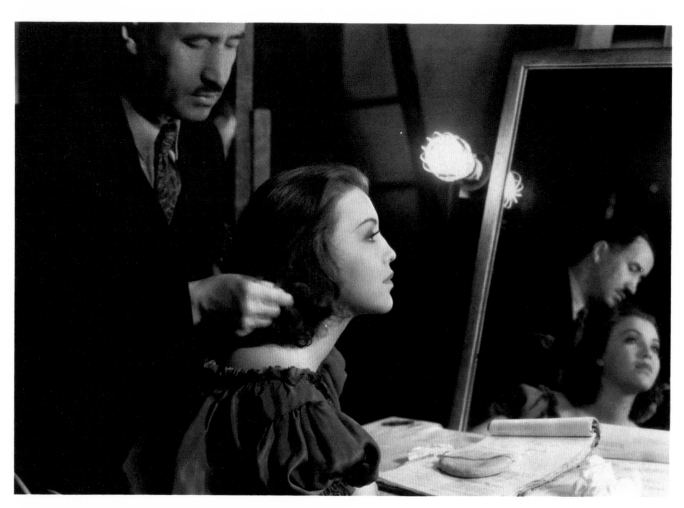

ABOVE Margo, 1936

LEFT Sari Maritza, 1933

OPPOSITE Carole Lombard on the set of *The Princess Comes Across*, 1936

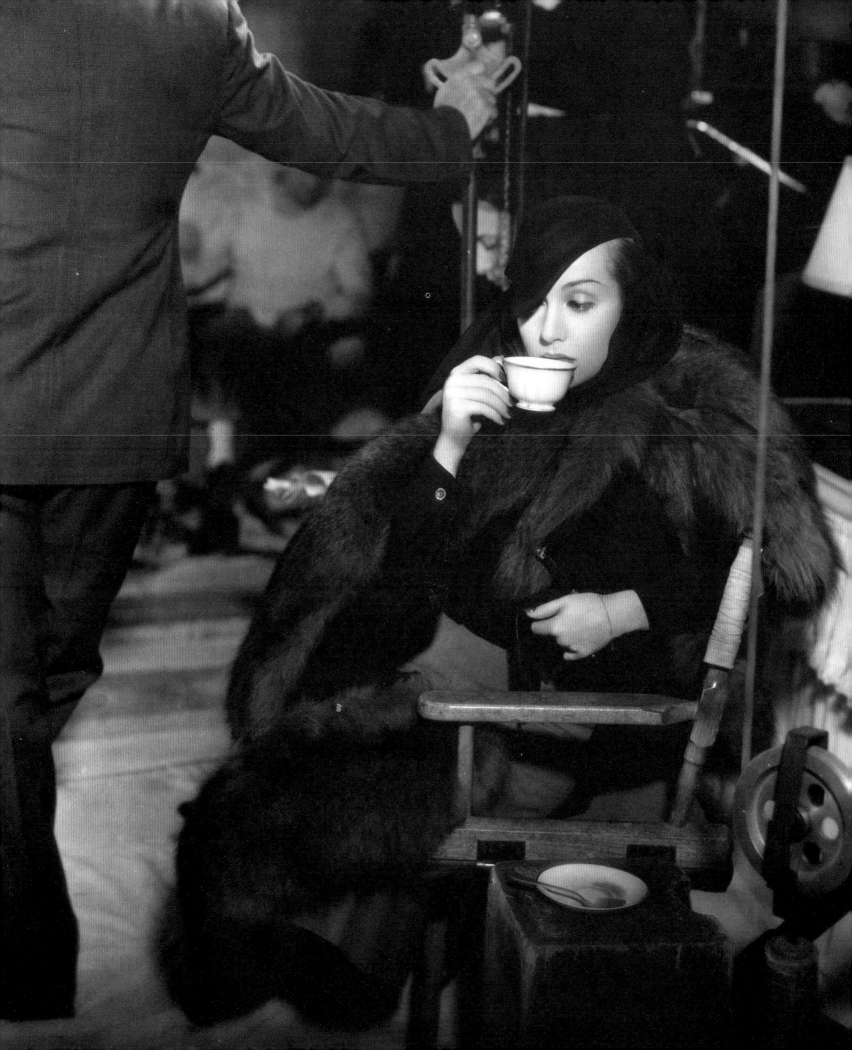

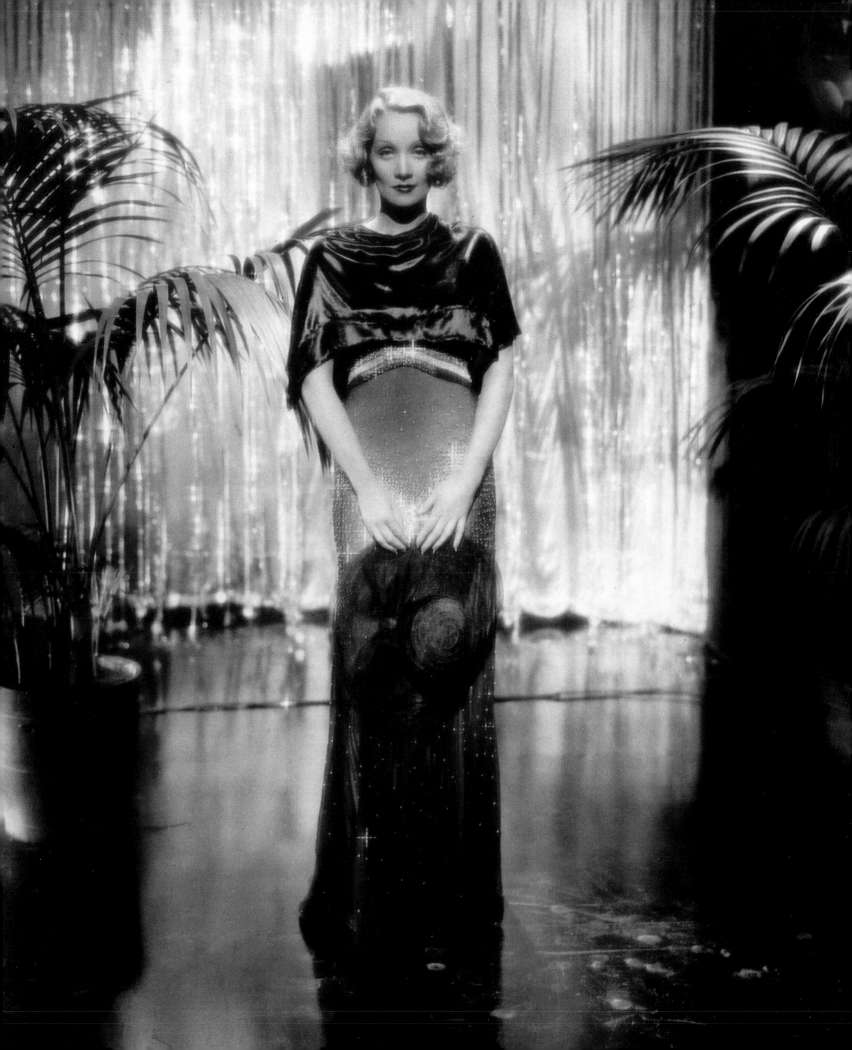

OPPOSITE Marlene Dietrich, 1932

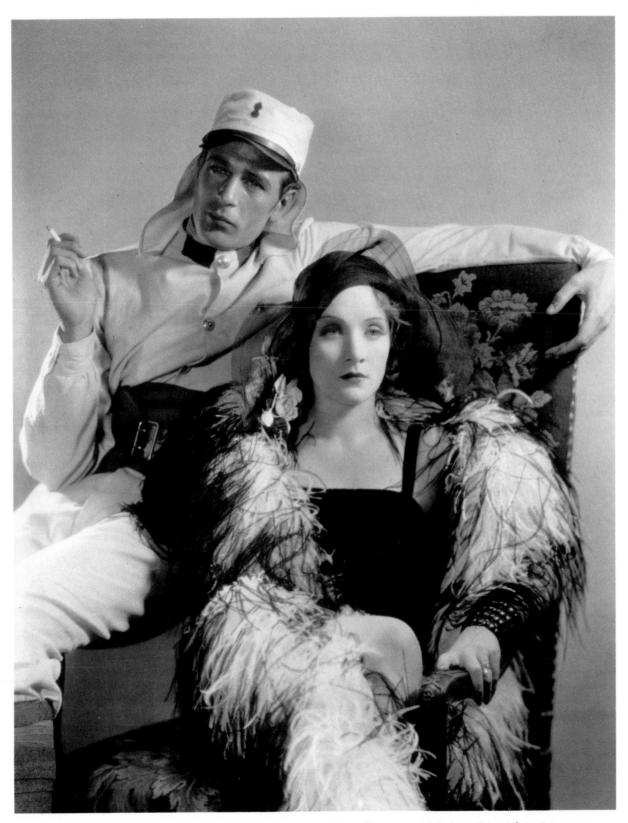

Gary Cooper and Marlene Dietrich in *Morocco*, 1930

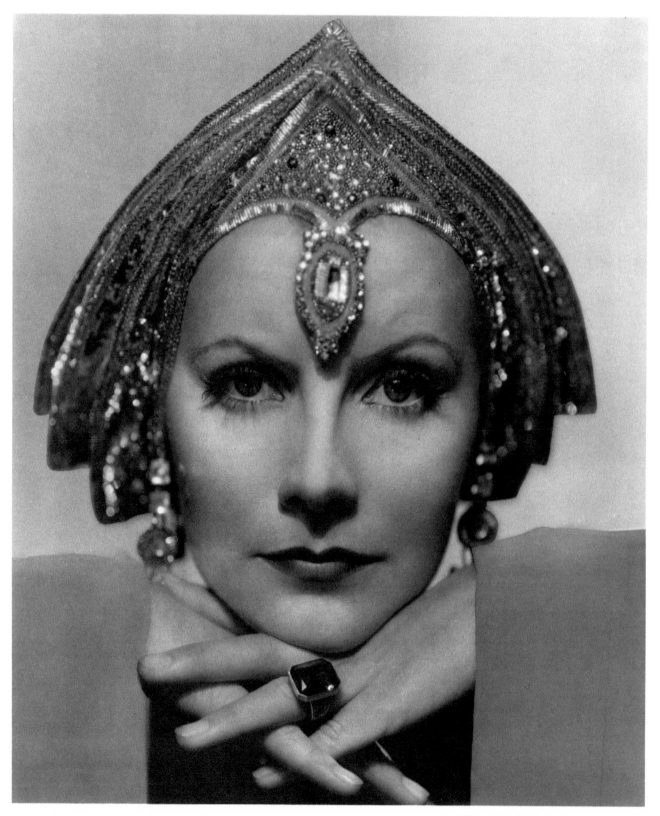

Greta Garbo in *Mata Hari*, 1931

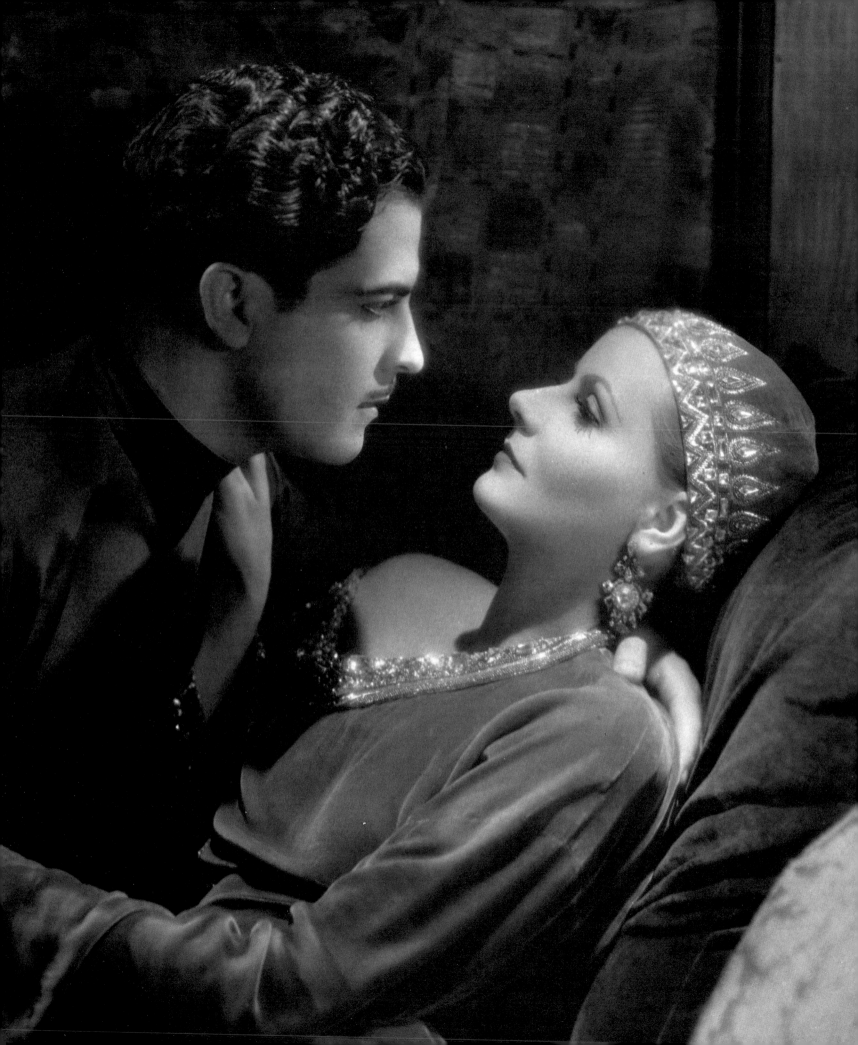

Boris Karloff in *The Black Room*, 1935

OPPOSITE George Arliss in *Voltaire*, 1933

OPPOSITE Dick Powell, 1933

RIGHT Ruby Keeler, 1933

BELOW Alice Faye, 1934

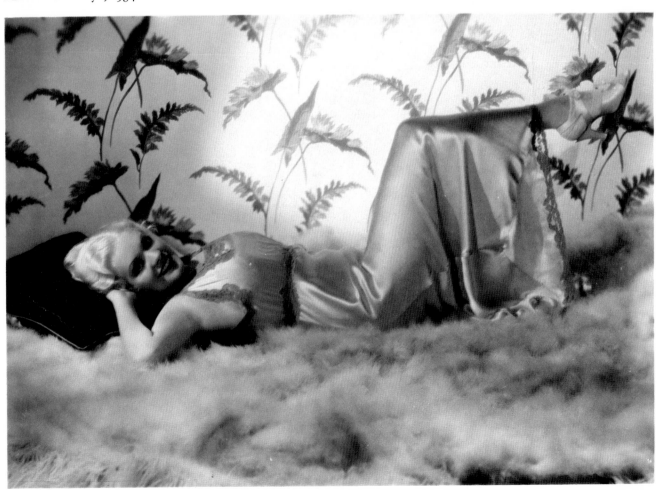

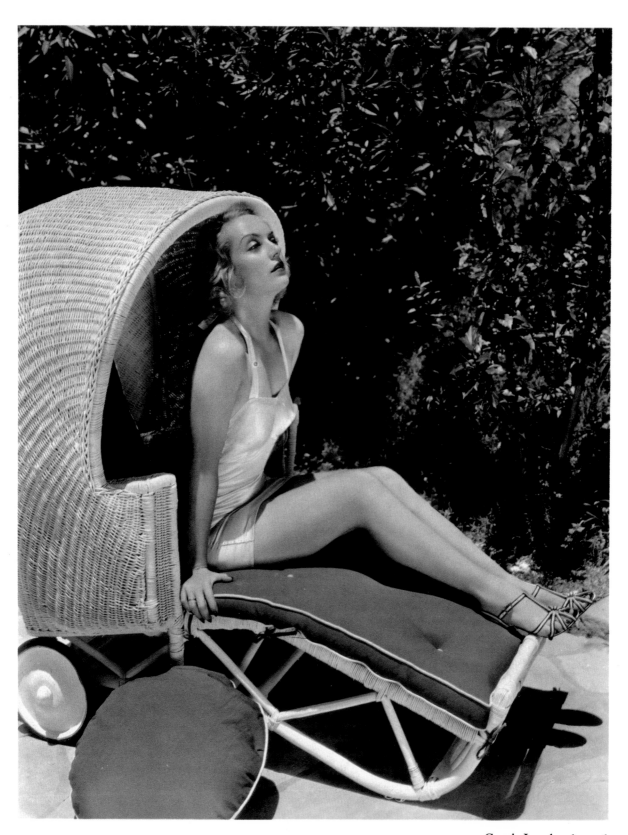

Carole Lombard, 1936

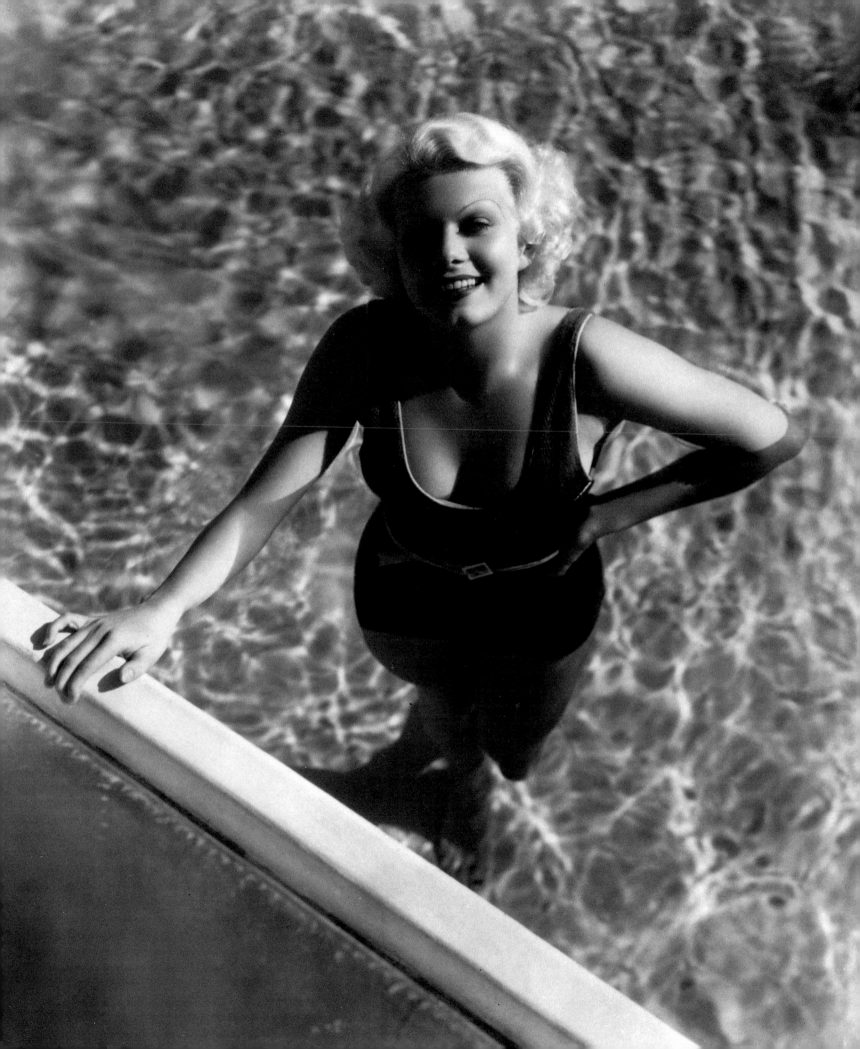

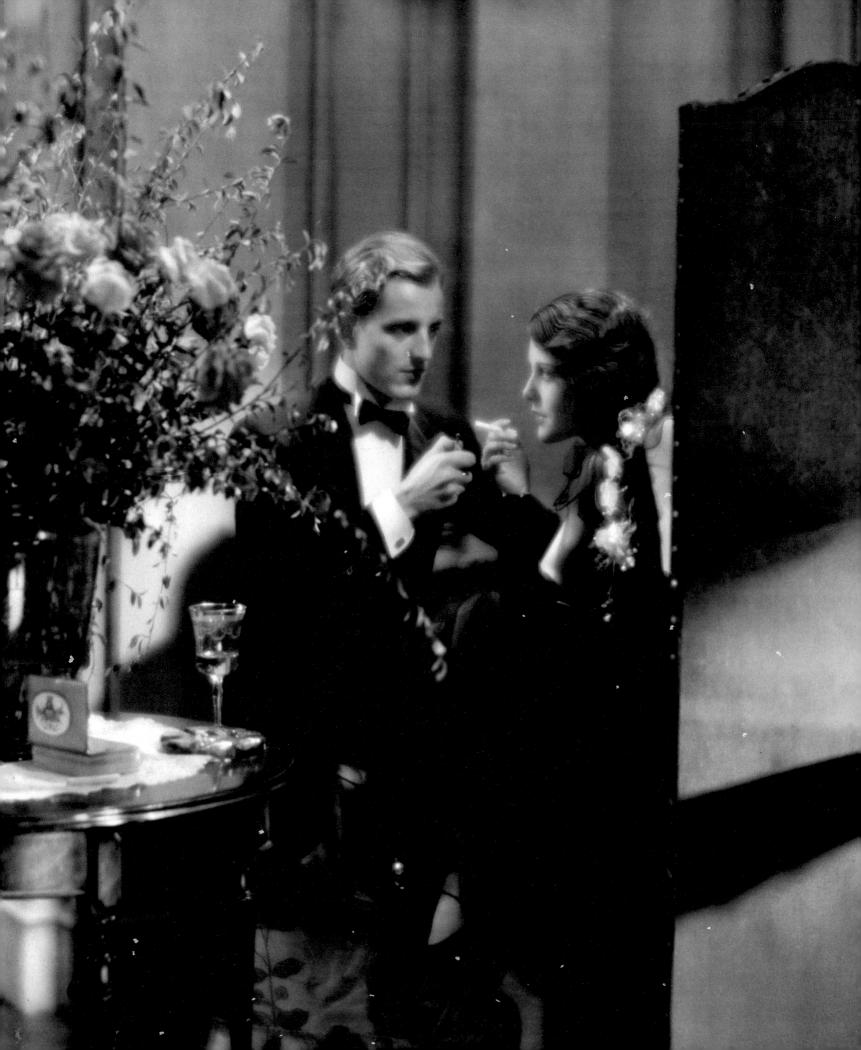

OPPOSITE Phillips Holmes and Frances Dee in *An American Tragedy*, 1931

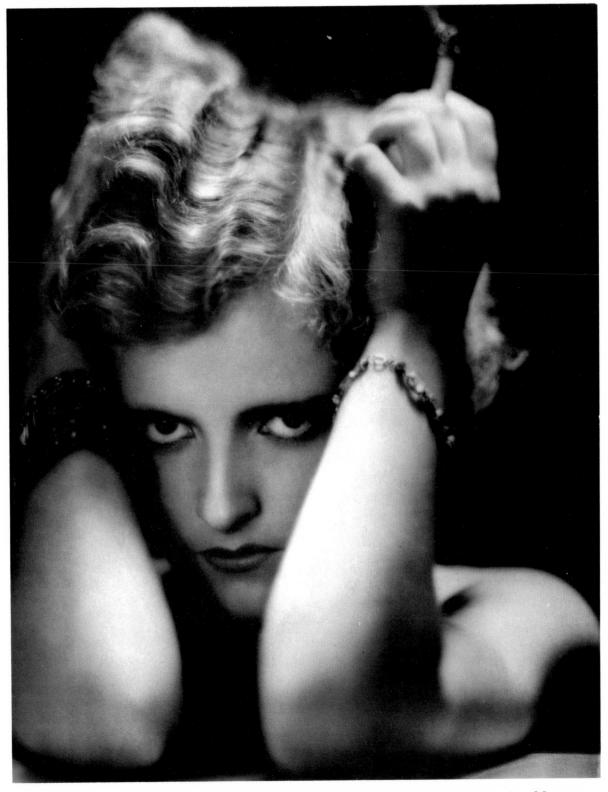

Lois Moran, 1931

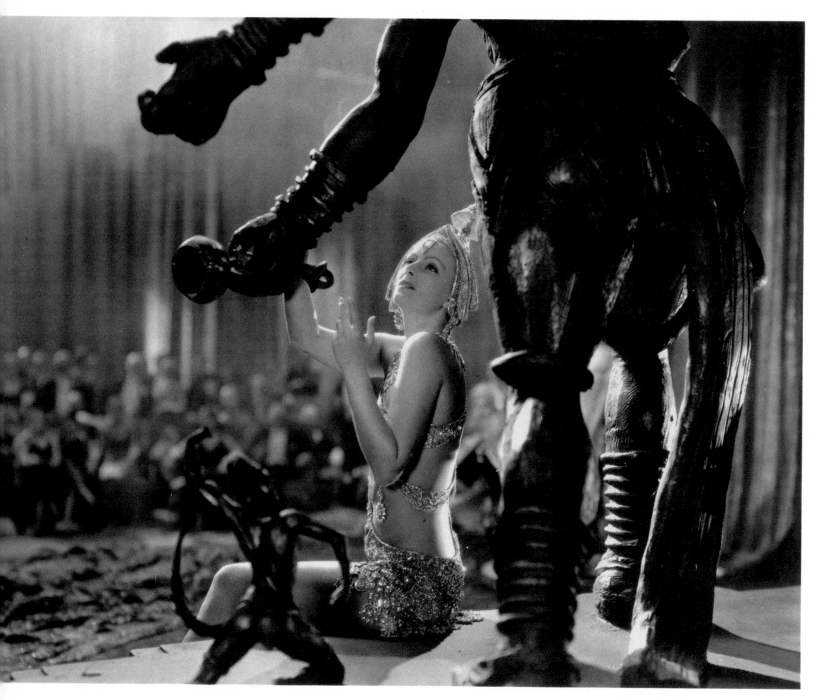

Greta Garbo, in *Mata Hari*, 1931

opposite Marlene Dietrich, 1939

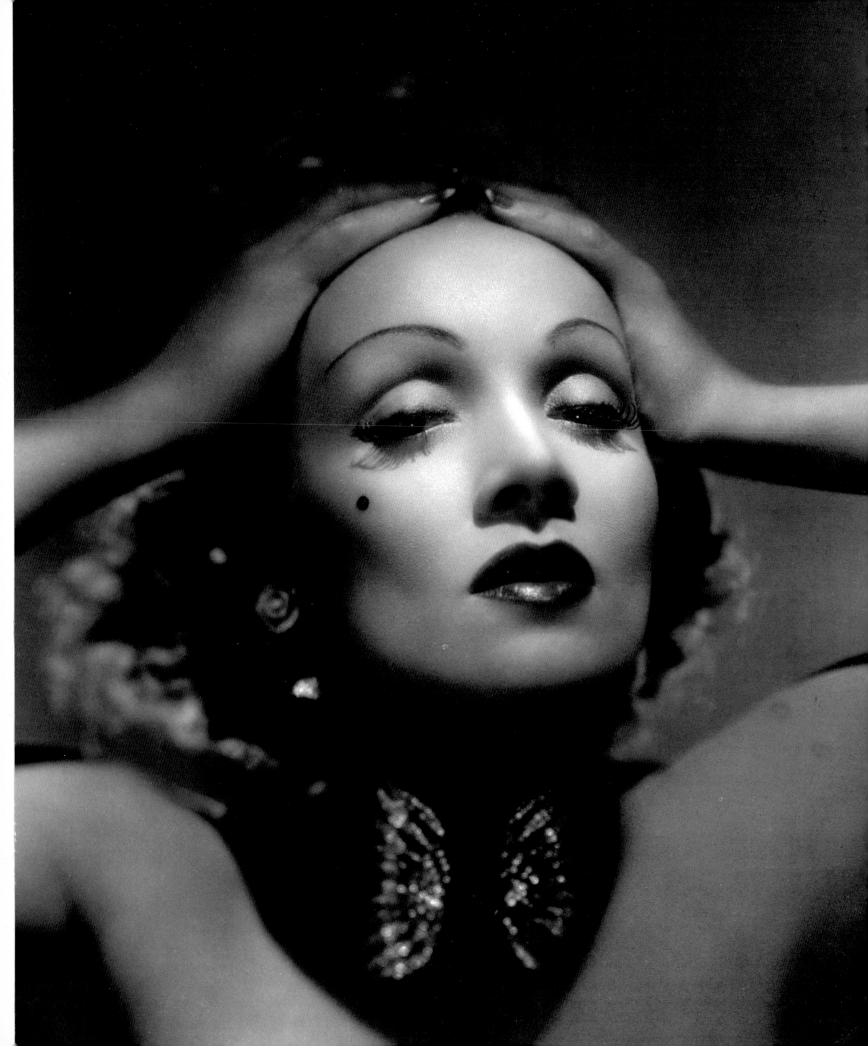

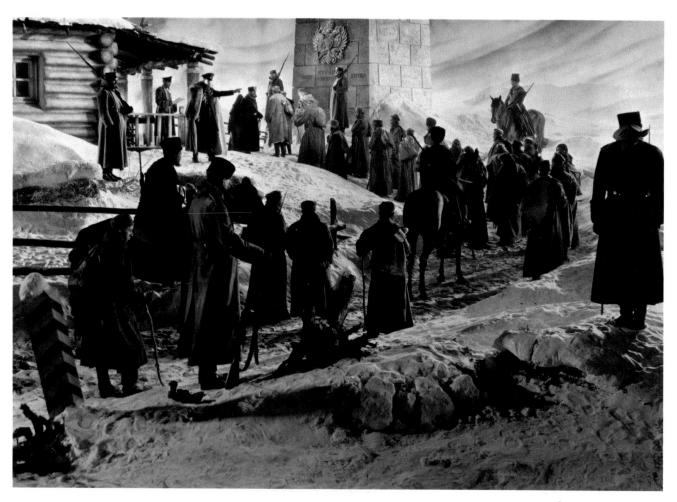

ABOVE *We Live Again*, 1934

LEFT Humphrey Bogart in *The Roaring Twenties*, 1939

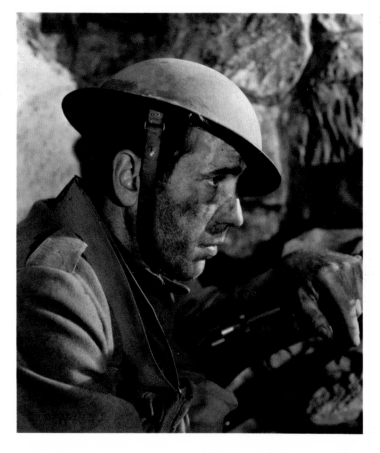

OPPOSITE Gary Cooper in *A Man From Wyoming*, 1930

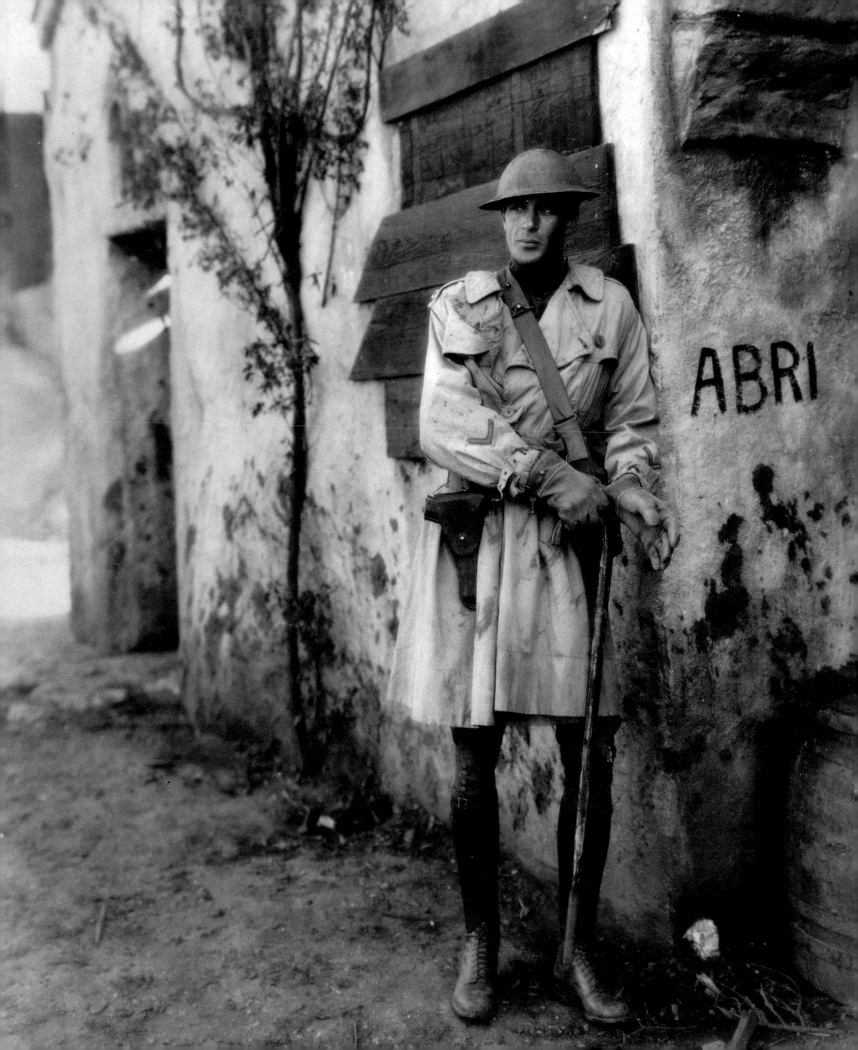

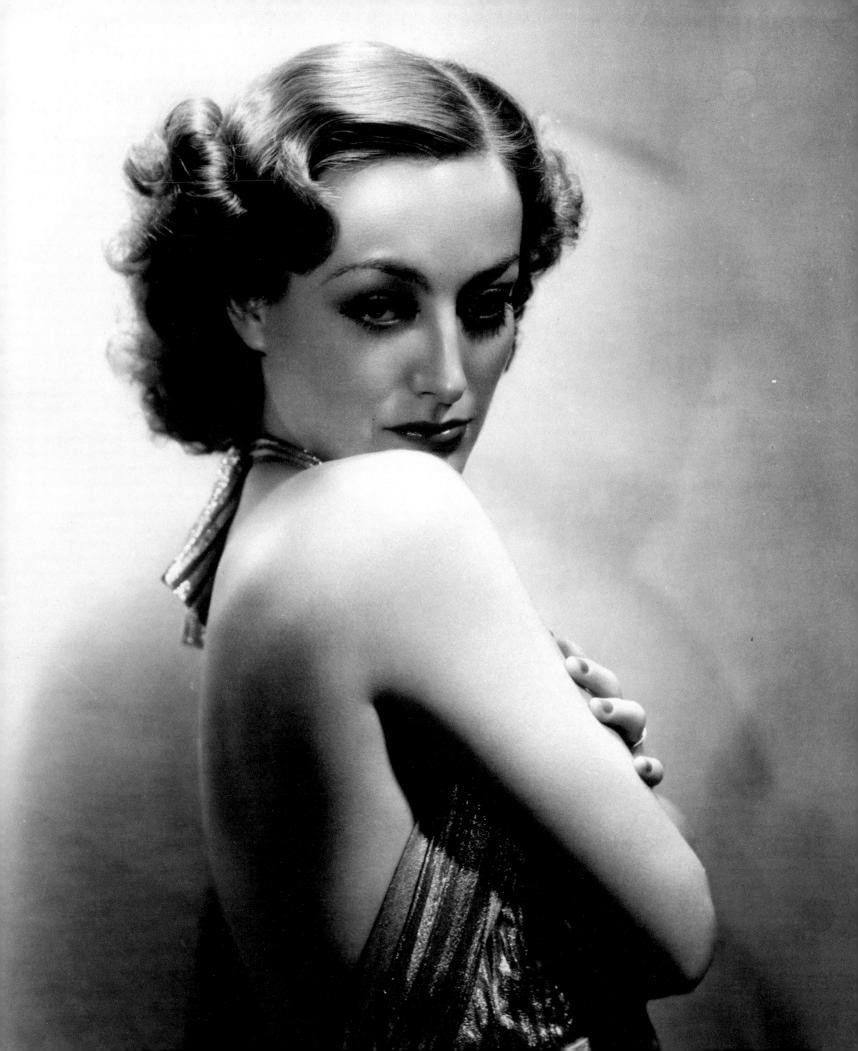

OPPOSITE Joan Crawford, 1935

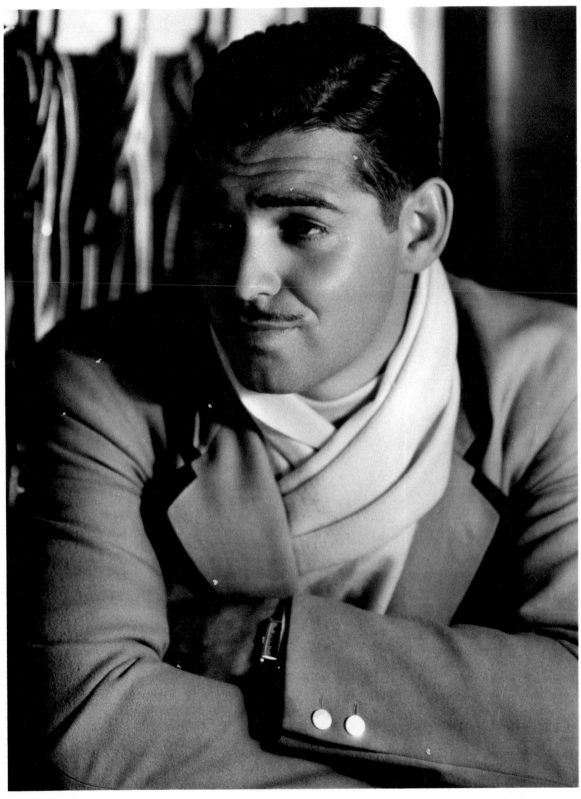

Clark Gable, 1933

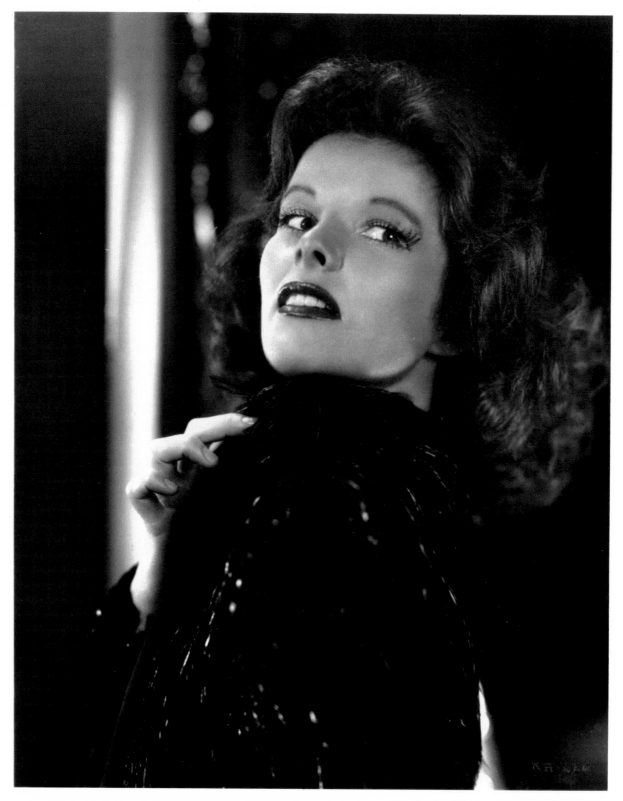

Katharine Hepburn in *Stage Door*, 1937

OPPOSITE Laurence Olivier and Gloria Swanson in *Perfect Understanding*, 1933

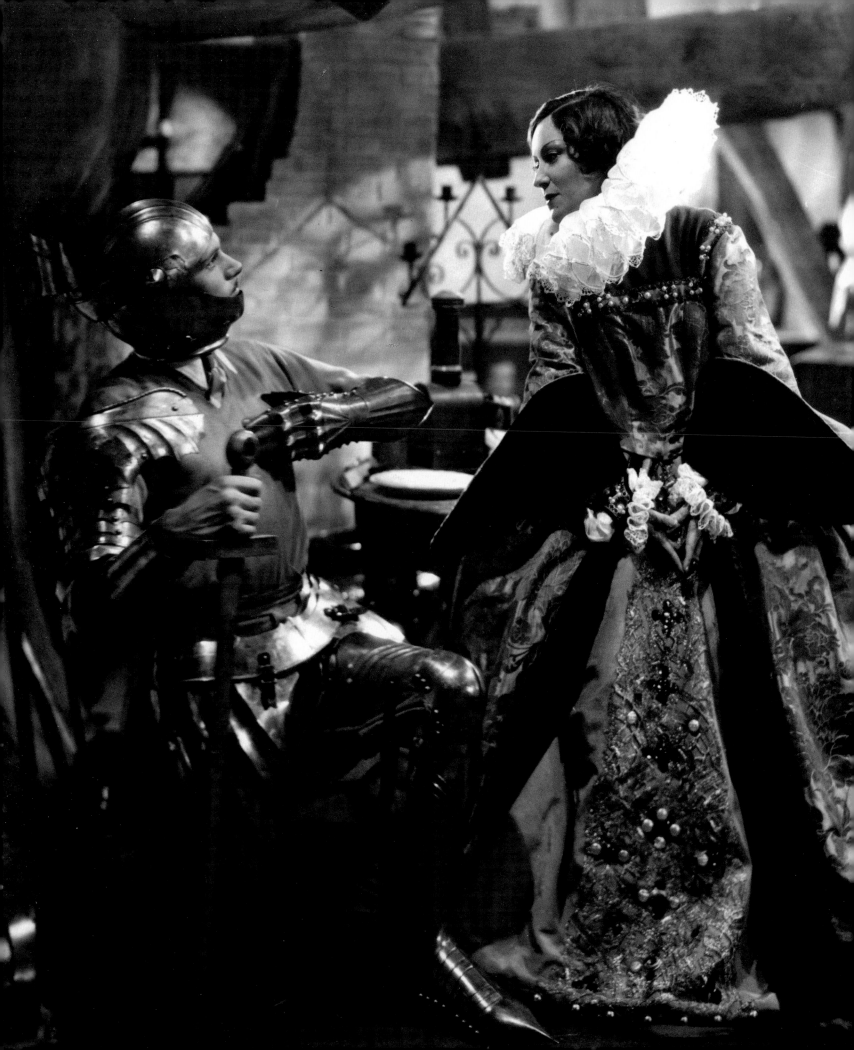

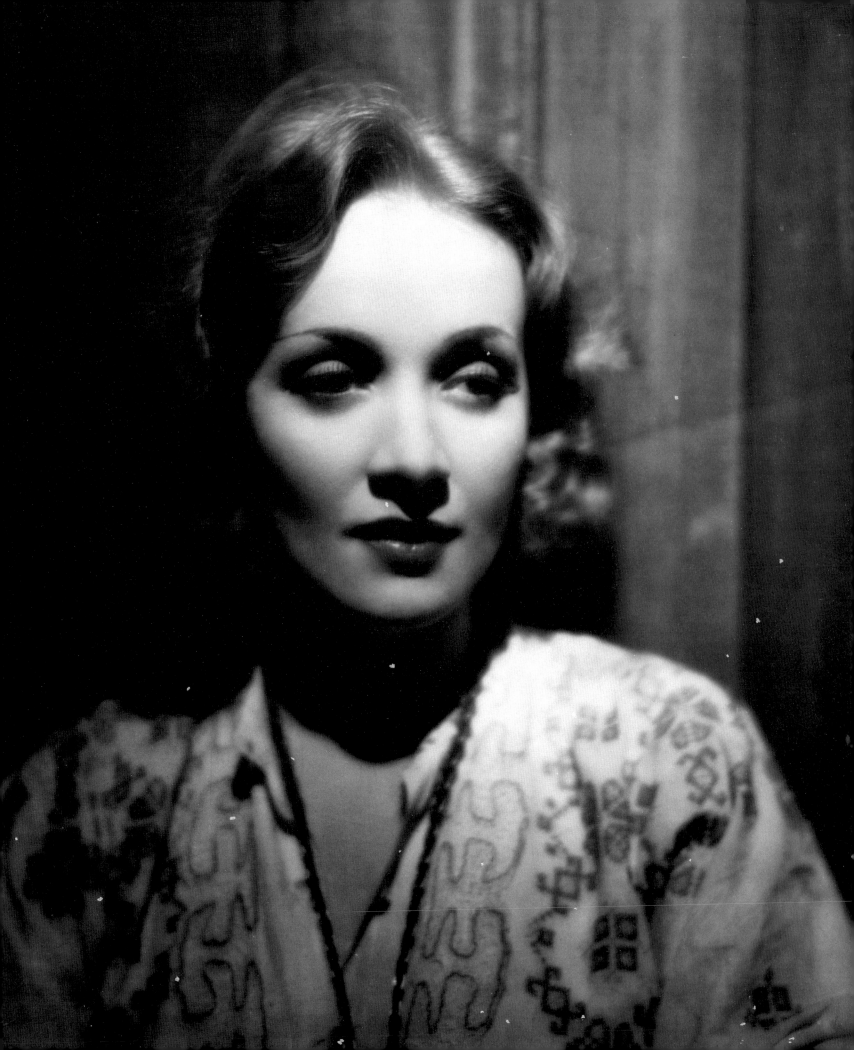

OPPOSITE Marlene Dietrich in *Dishonored*, 1931

Gary Cooper in *Morocco*, 1930

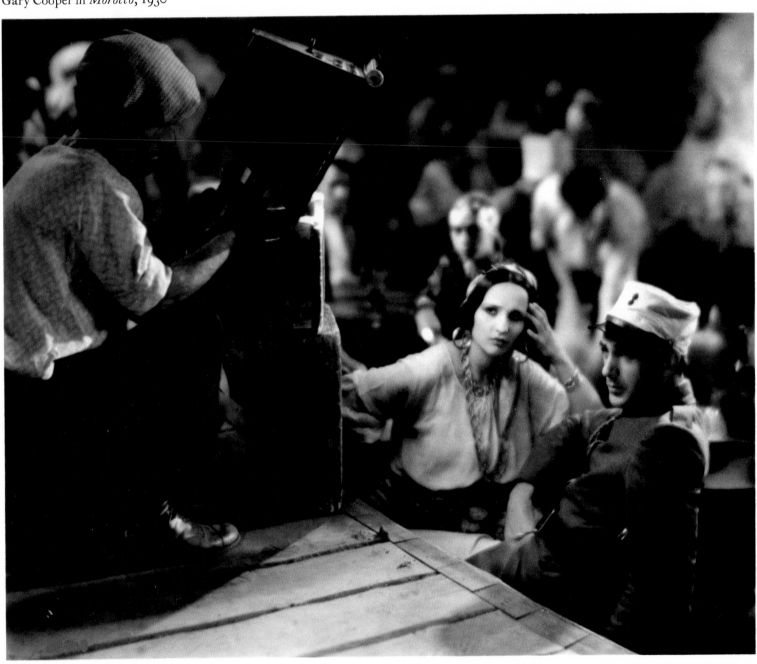

OPPOSITE Mae West with Boris Petroff (left), Mae's dramatic advisor, and John Hammell (right), Paramount's censorship expert, 1934

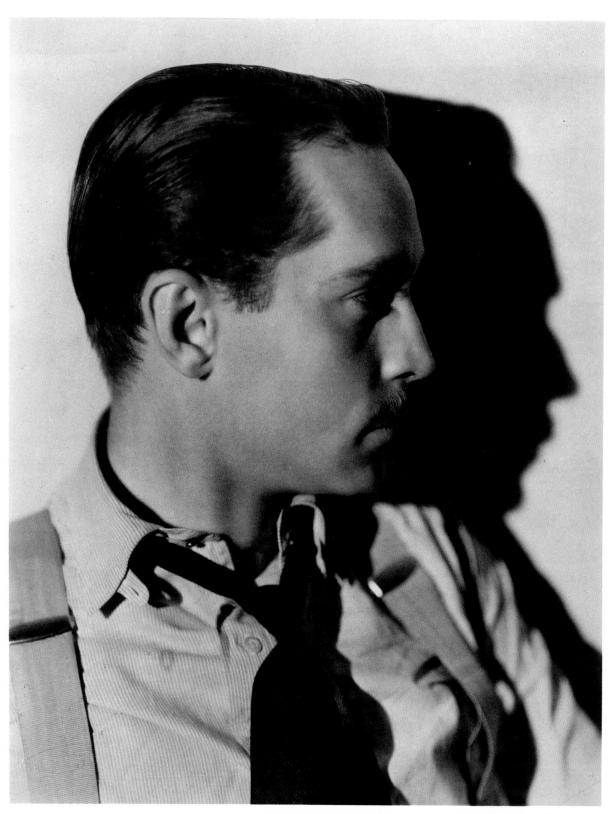

Franchot Tone, 1933

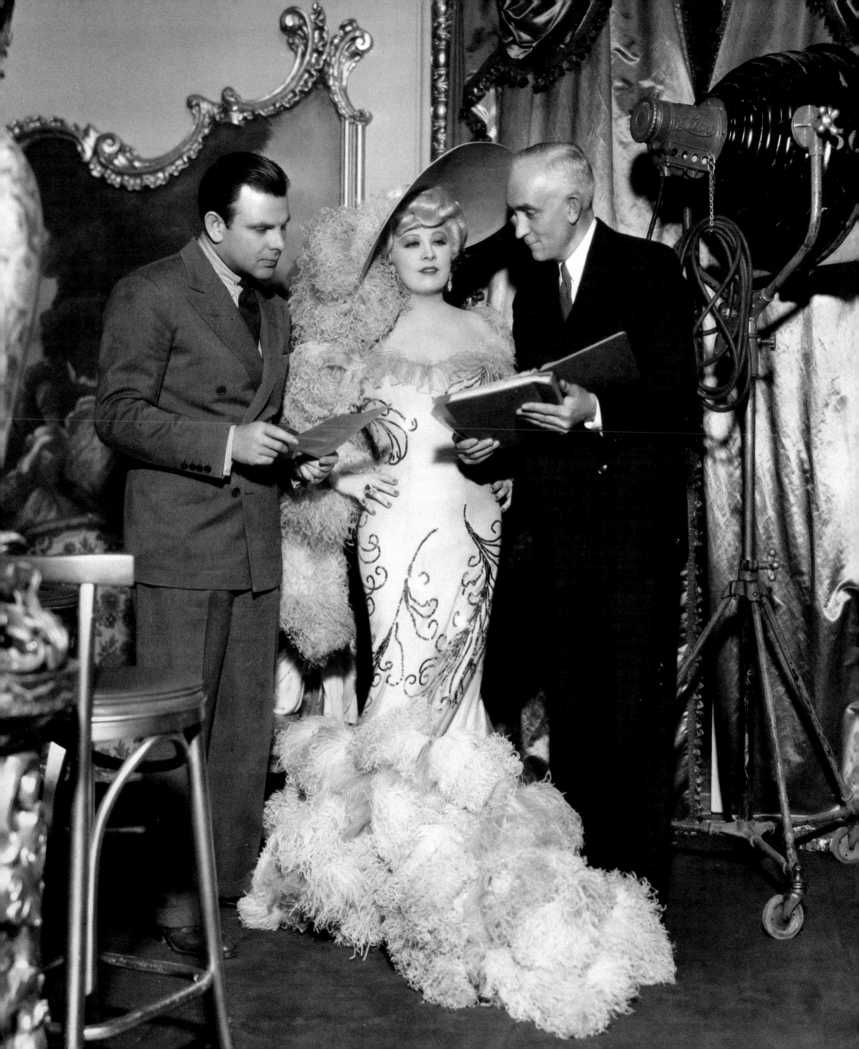

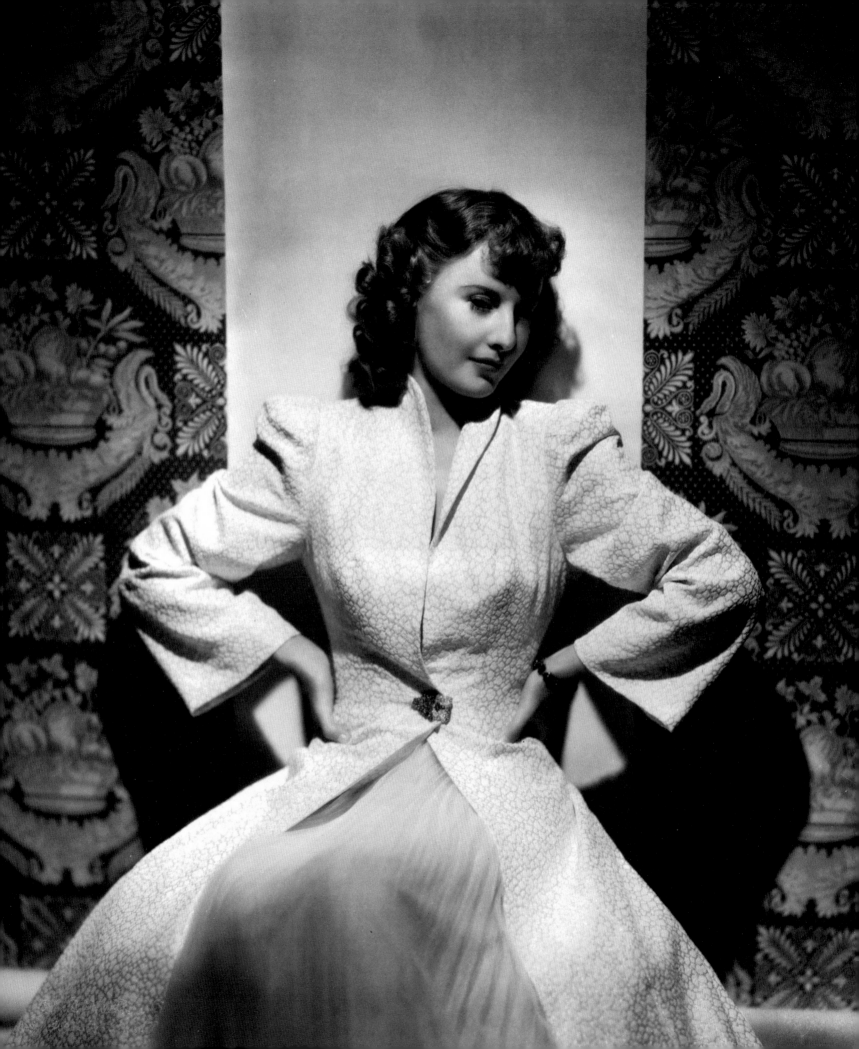

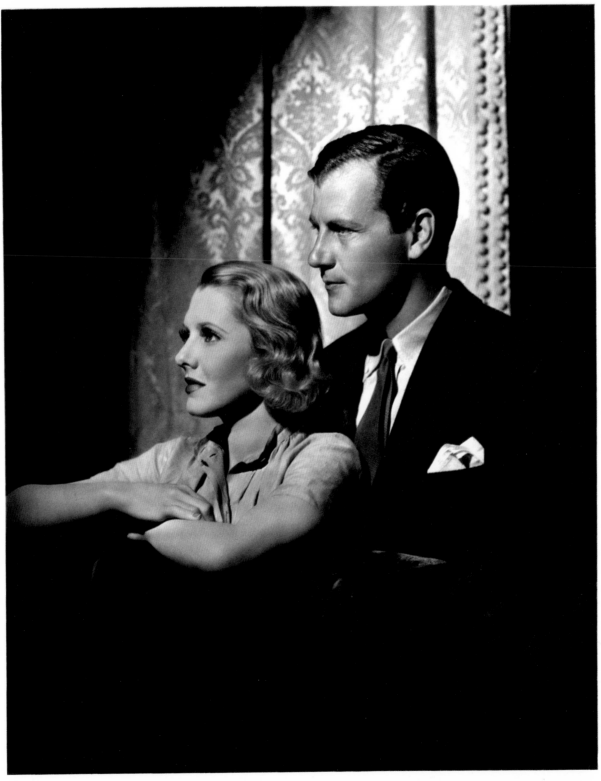

Jean Arthur and Joel McCrea, 1936

OPPOSITE Katharine Hepburn in *Sylvia Scarlet*, 1935

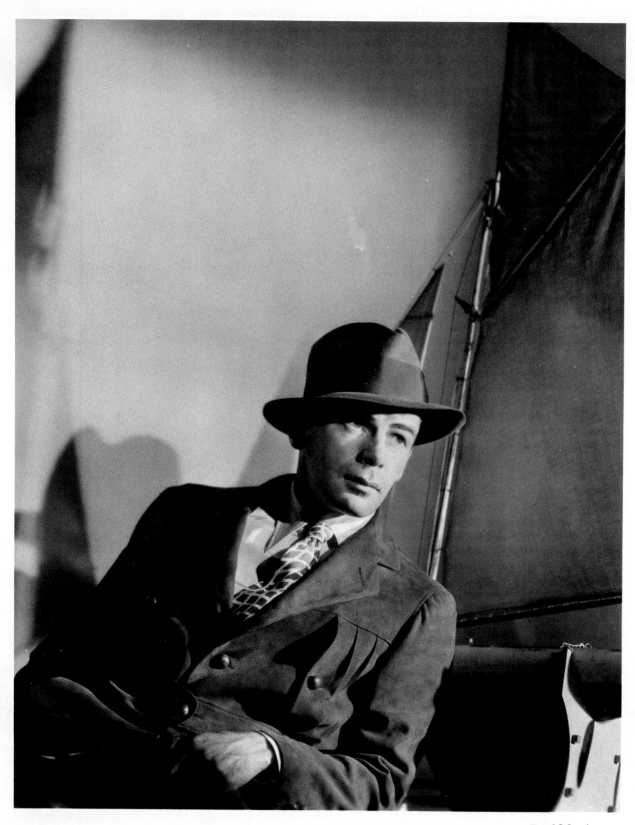

Paul Muni, 1934

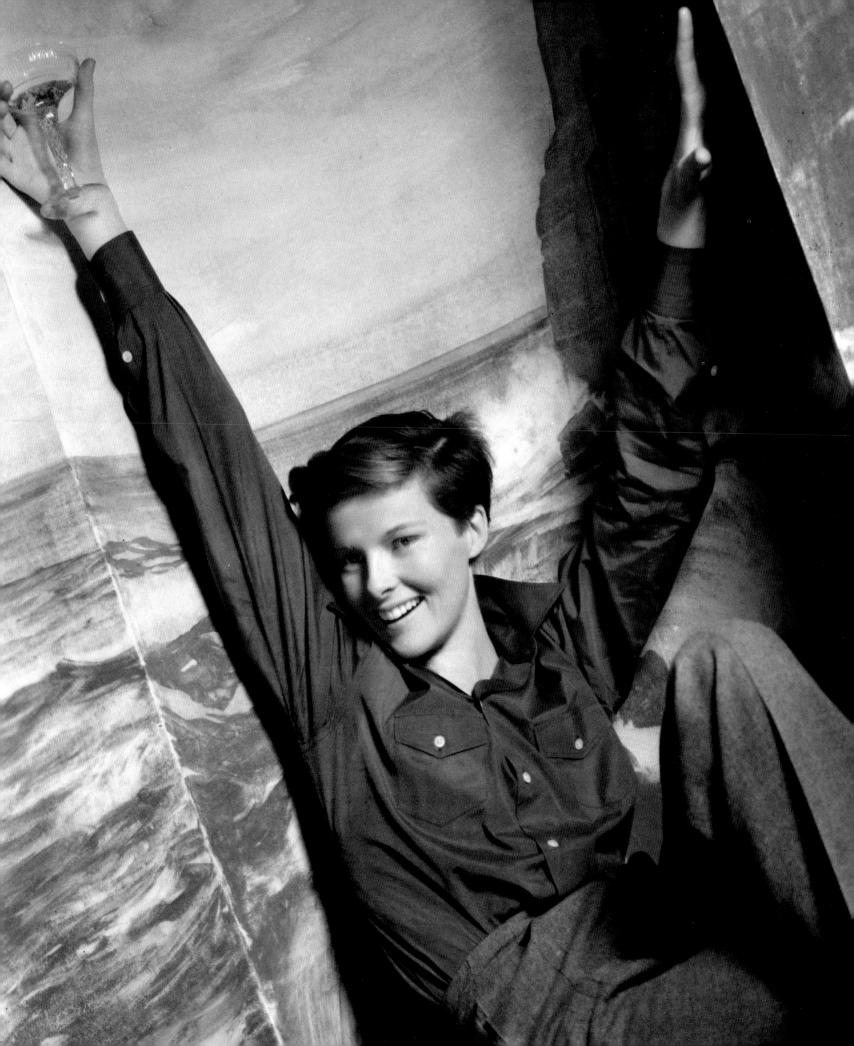

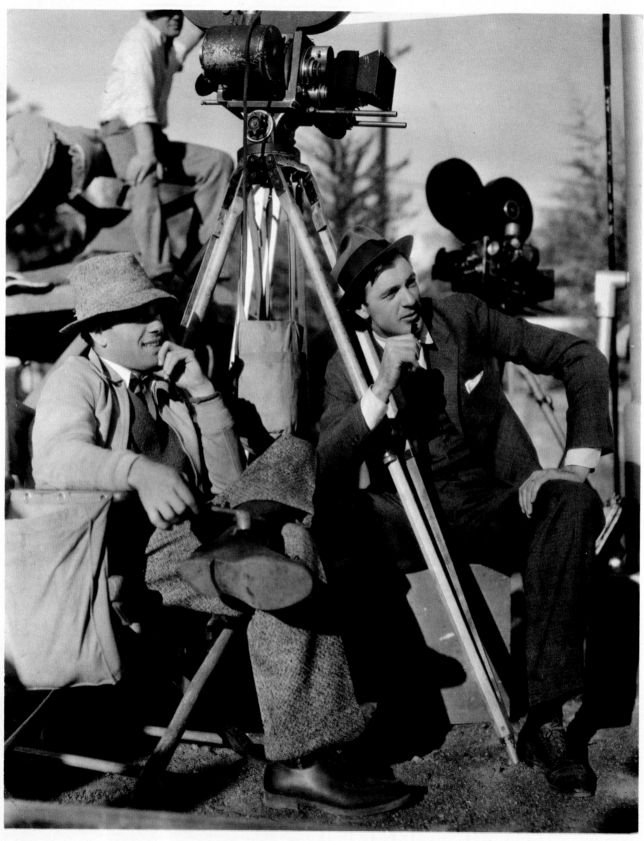

Director, Frank Capra and Gary Cooper on the set of *Mr. Deeds Goes to Town*, 1936

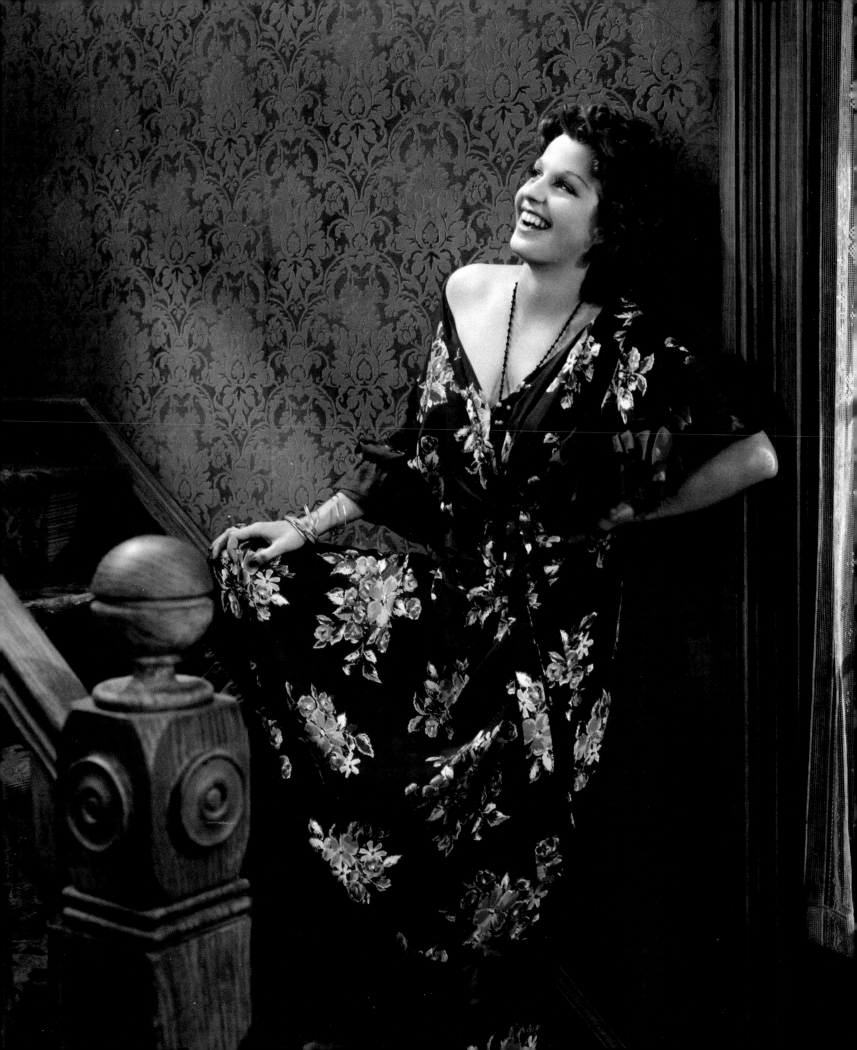

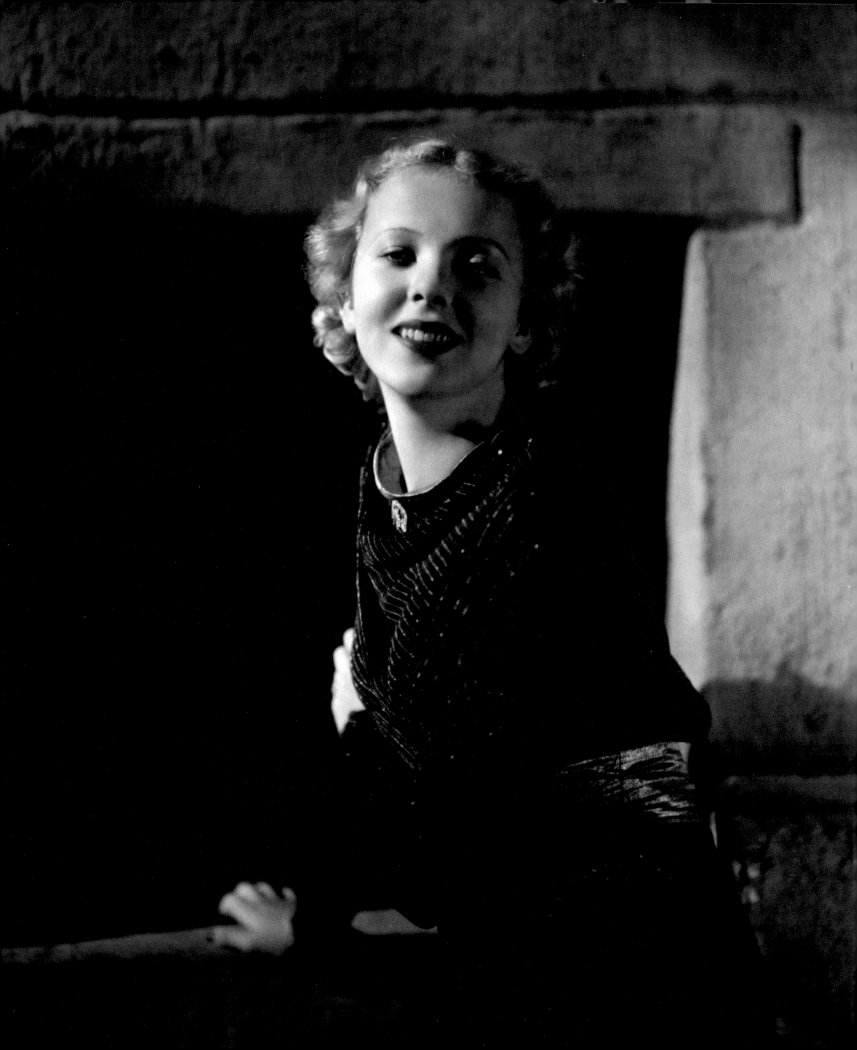

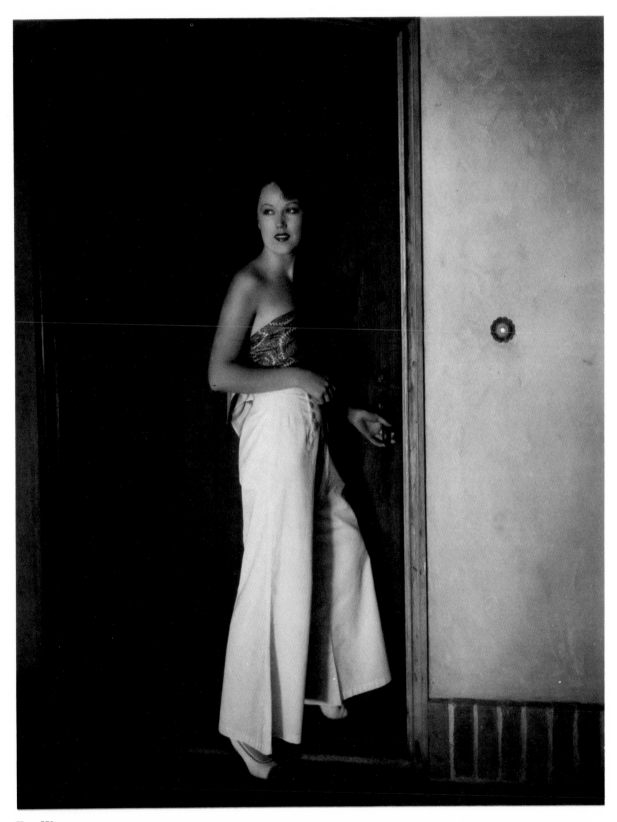

Fay Wray, 1933

OPPOSITE Ida Lupino, 1935

OPPOSITE Marlene Dietrich with Director, Rouben Mamoulian, on the set of *Song of Songs*, 1933

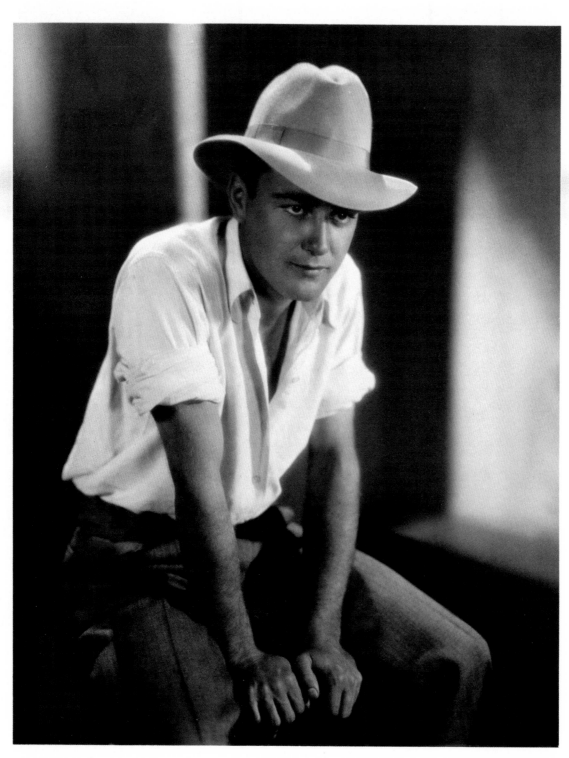

Lew Ayres, 1931

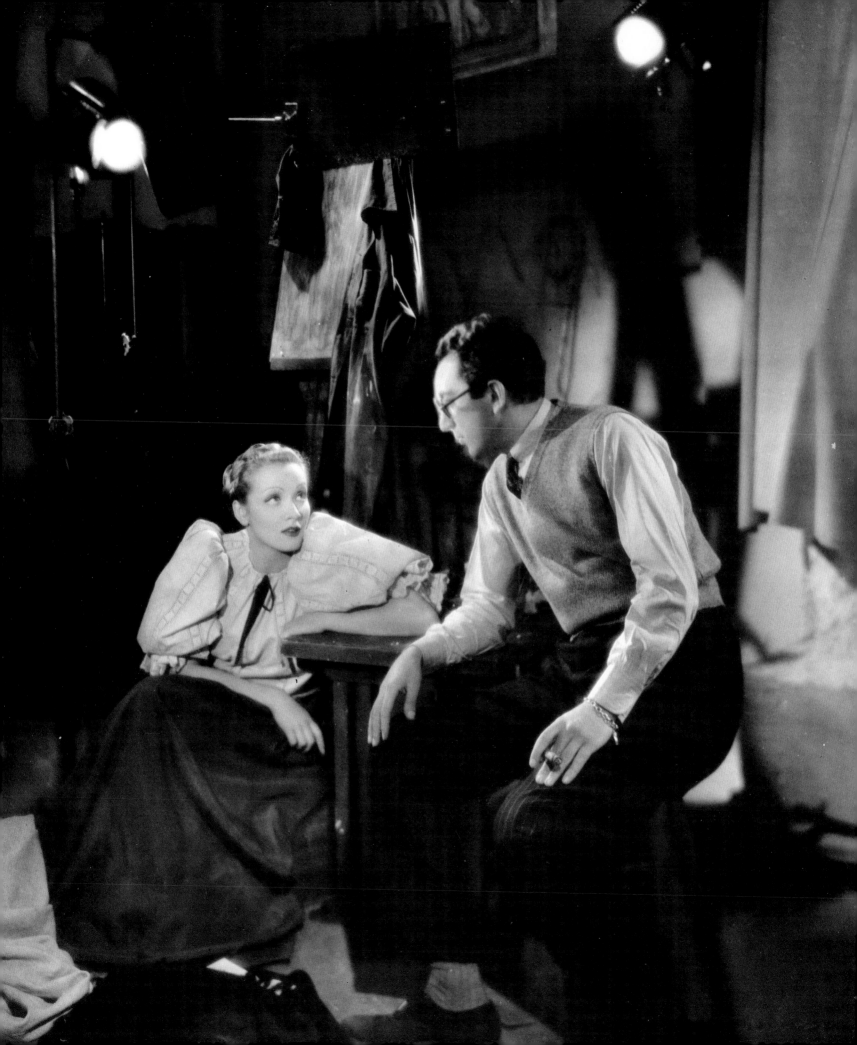

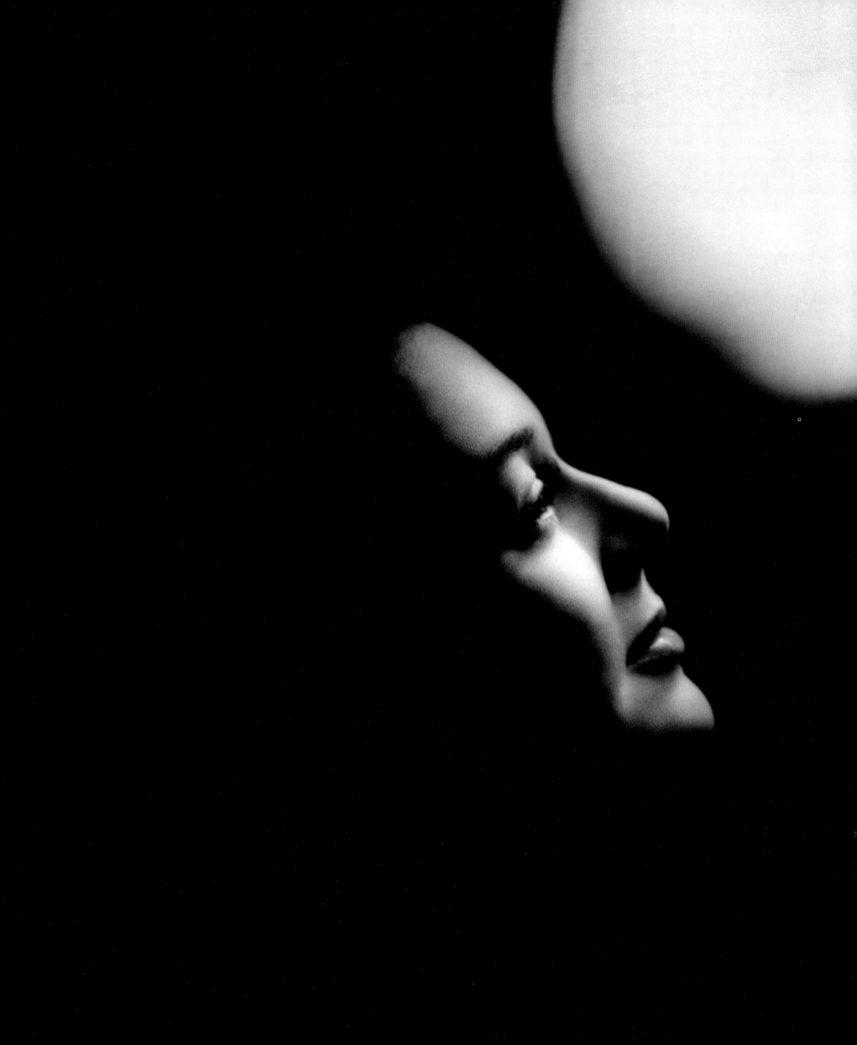

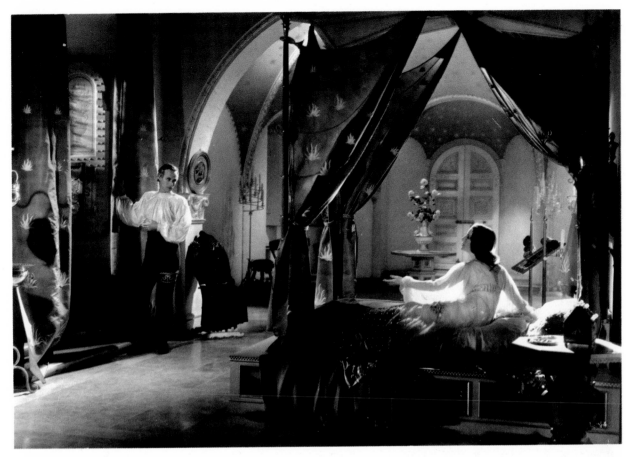

Leslie Howard and Norma Shearer in *Romeo and Juliet*, 1936

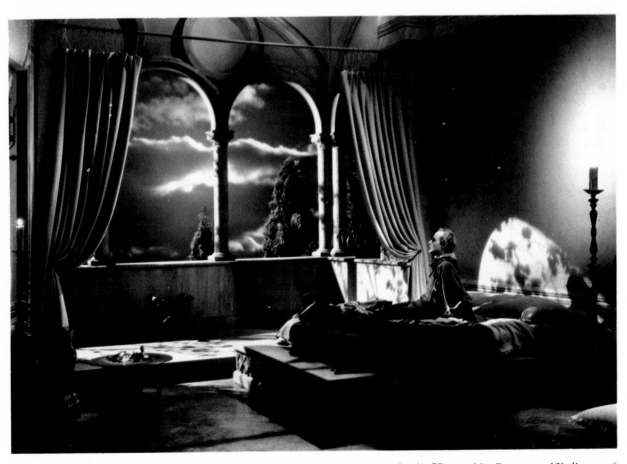

Leslie Howard in *Romeo and Juliet*, 1936

OPPOSITE Robert Montgomery and Constance Bennett in *The Easiest Way*, 1931

Joan Bennett, 1935

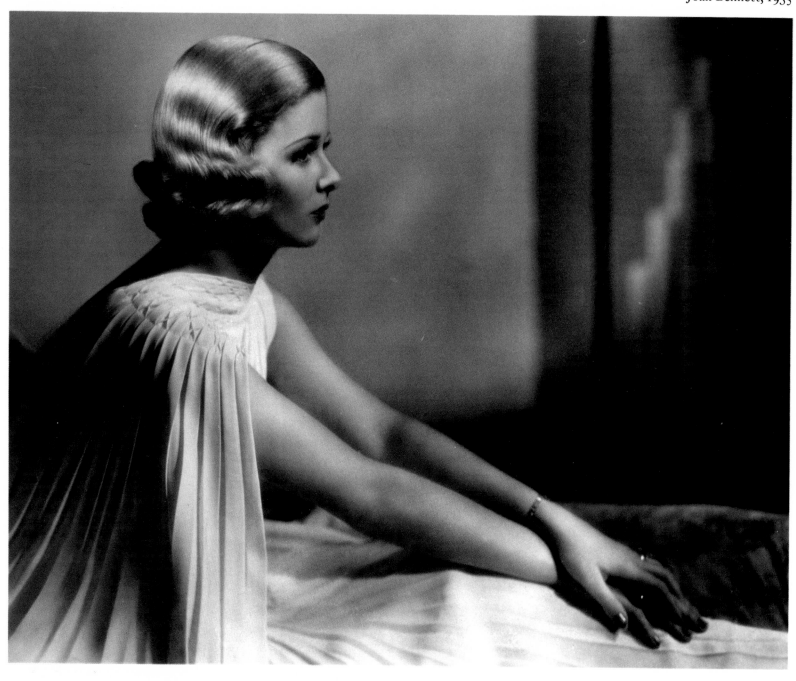

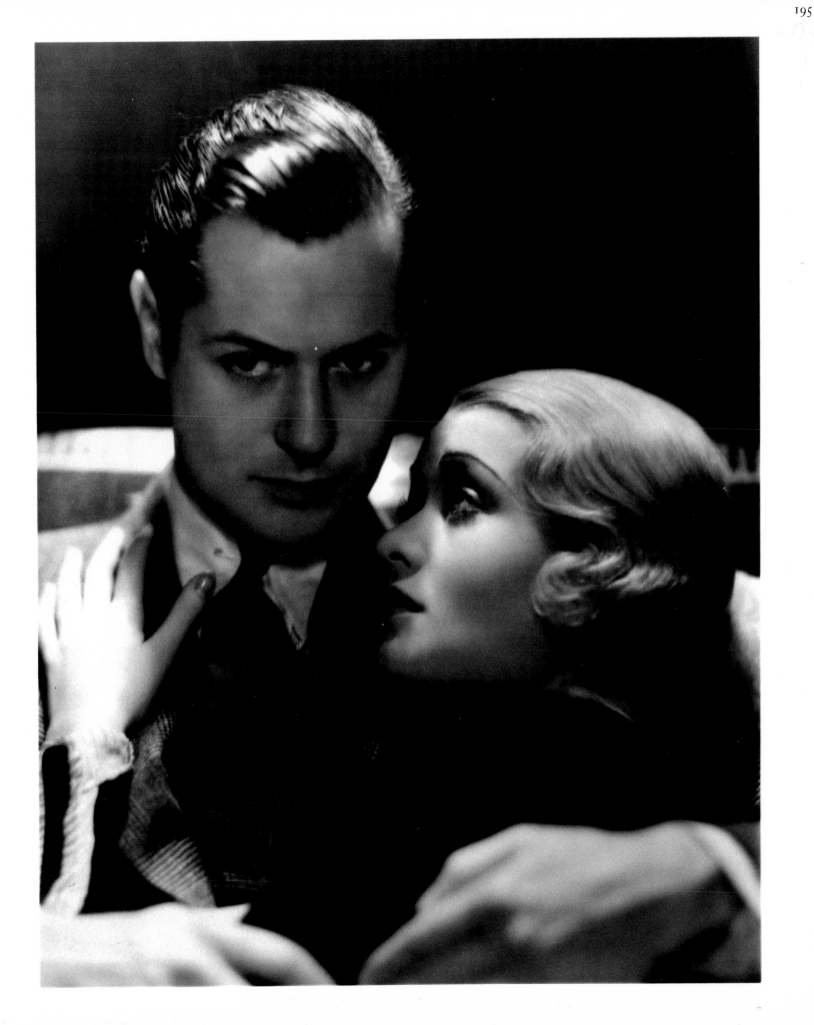

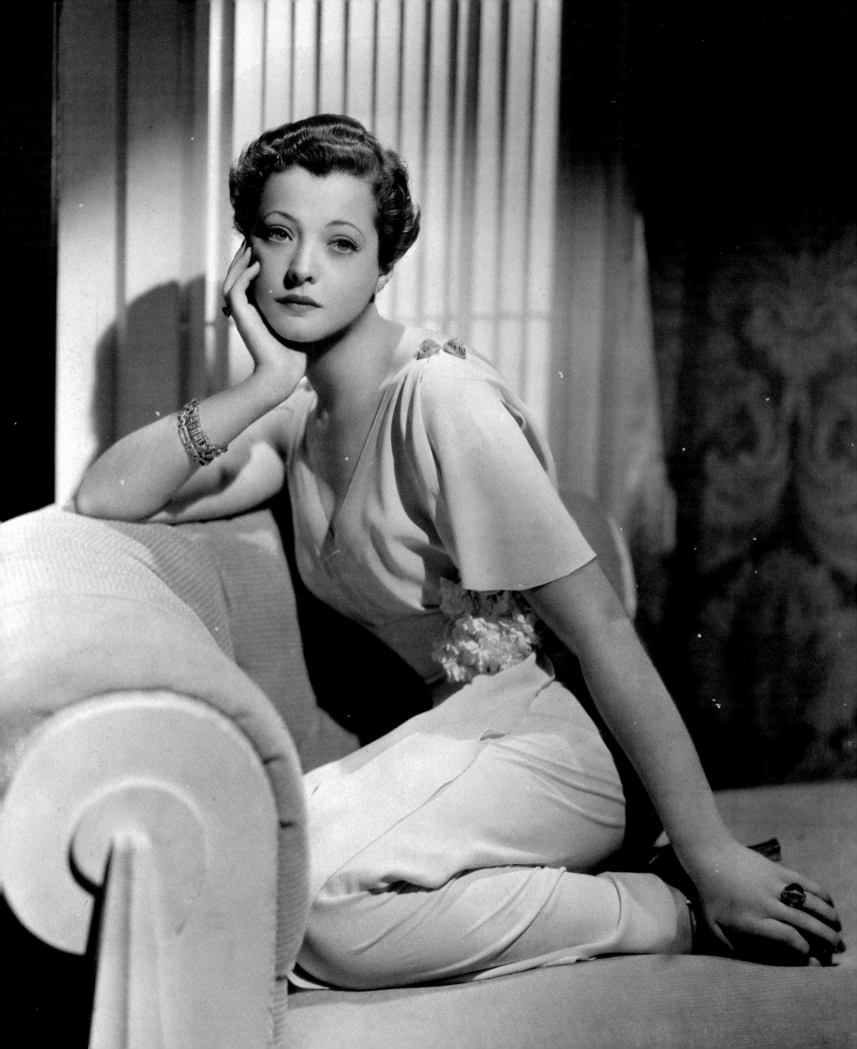

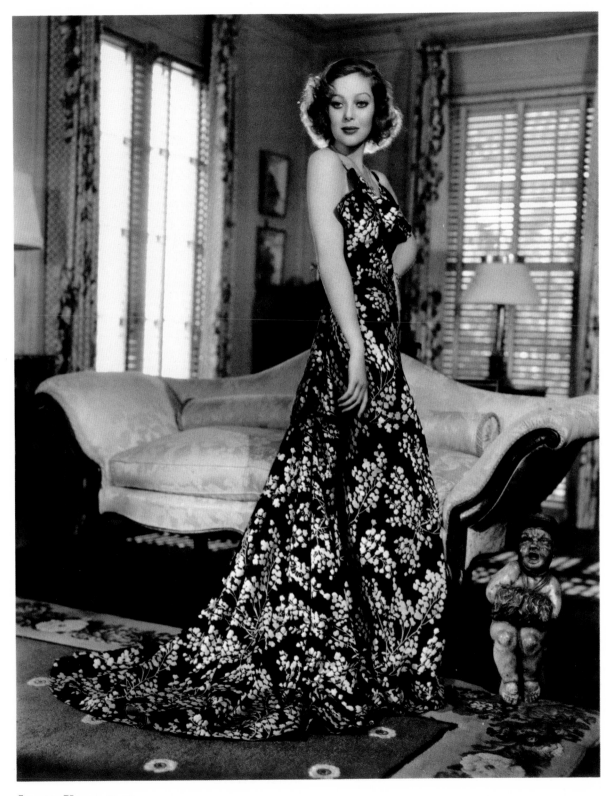

Loretta Young, 1935

OPPOSITE Sylvia Sidney, 1937

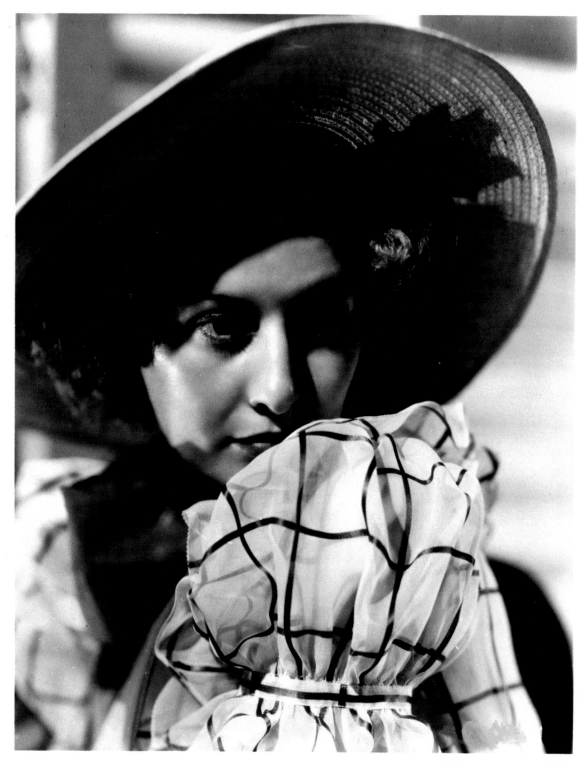

Barbara Stanwyck, 1937

OPPOSITE Henry Fonda, 1935

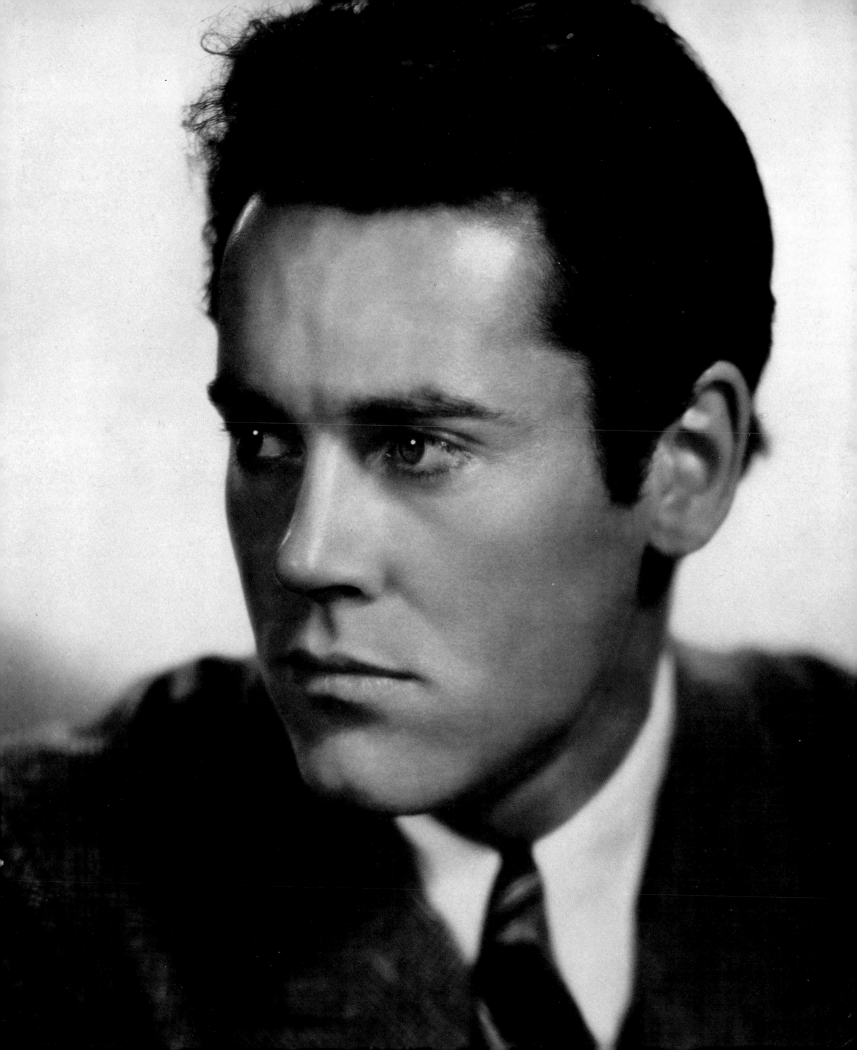

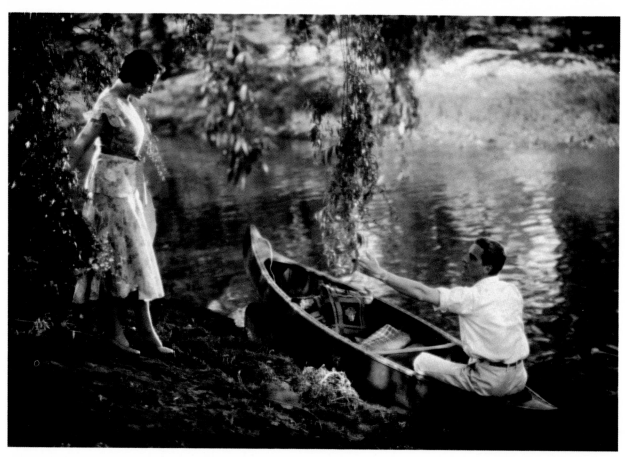

Sylvia Sidney and Phillips Holmes in *An American Tragedy*, 1931

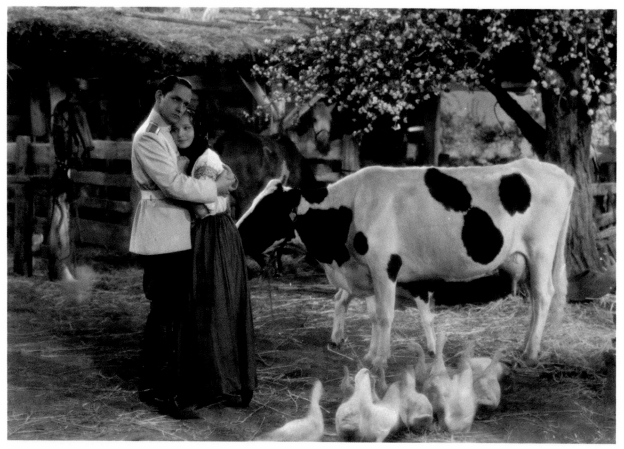

Frederic March and Anna Sten in *We Live Again*, 1934

OPPOSITE
Madeleine Carroll, 1938

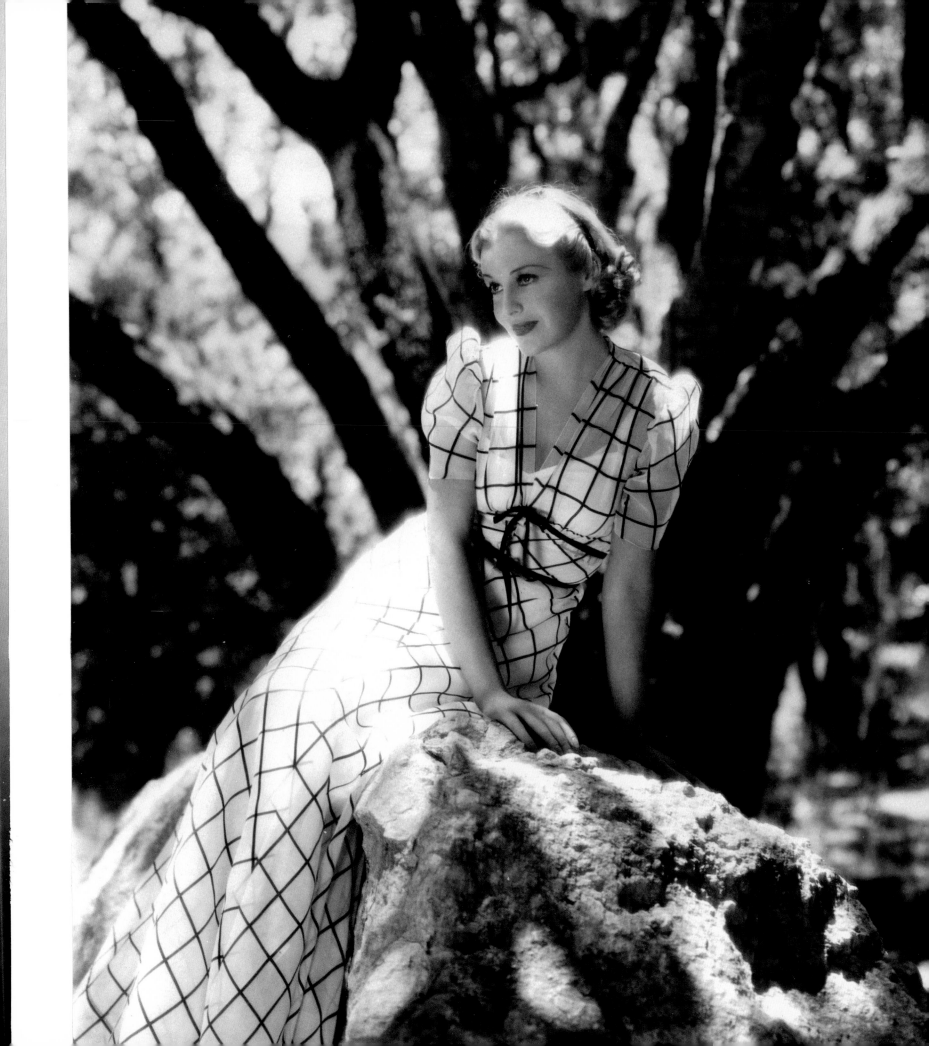

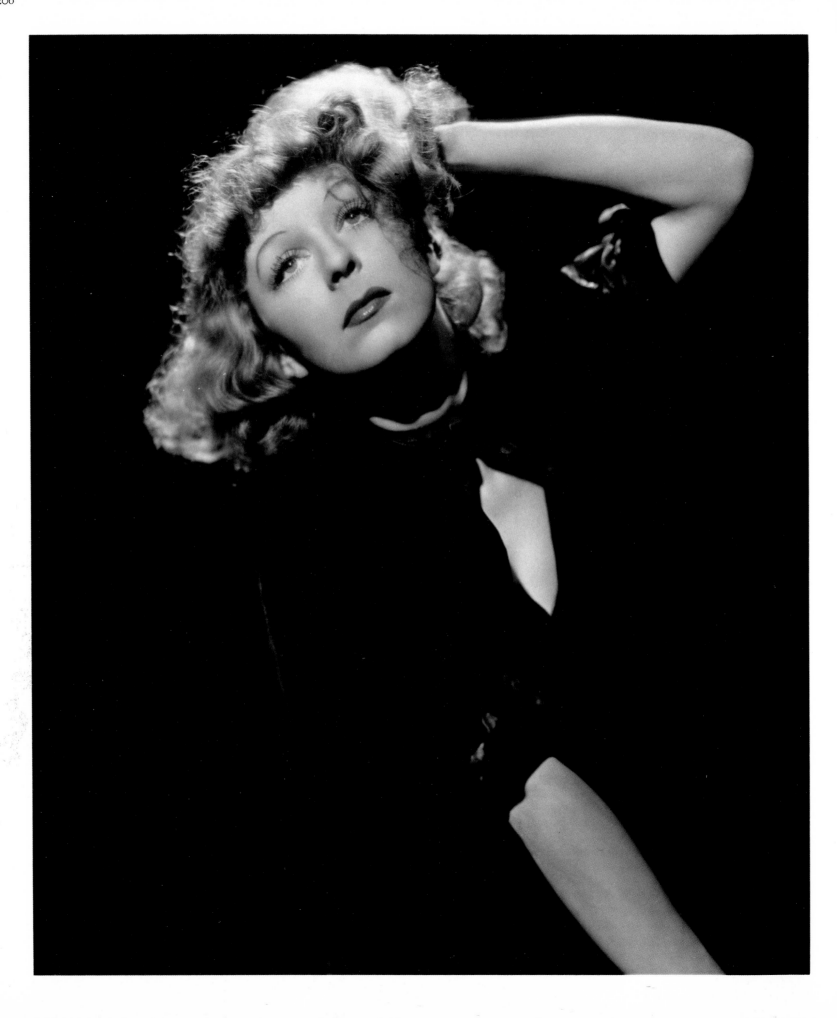

Part III

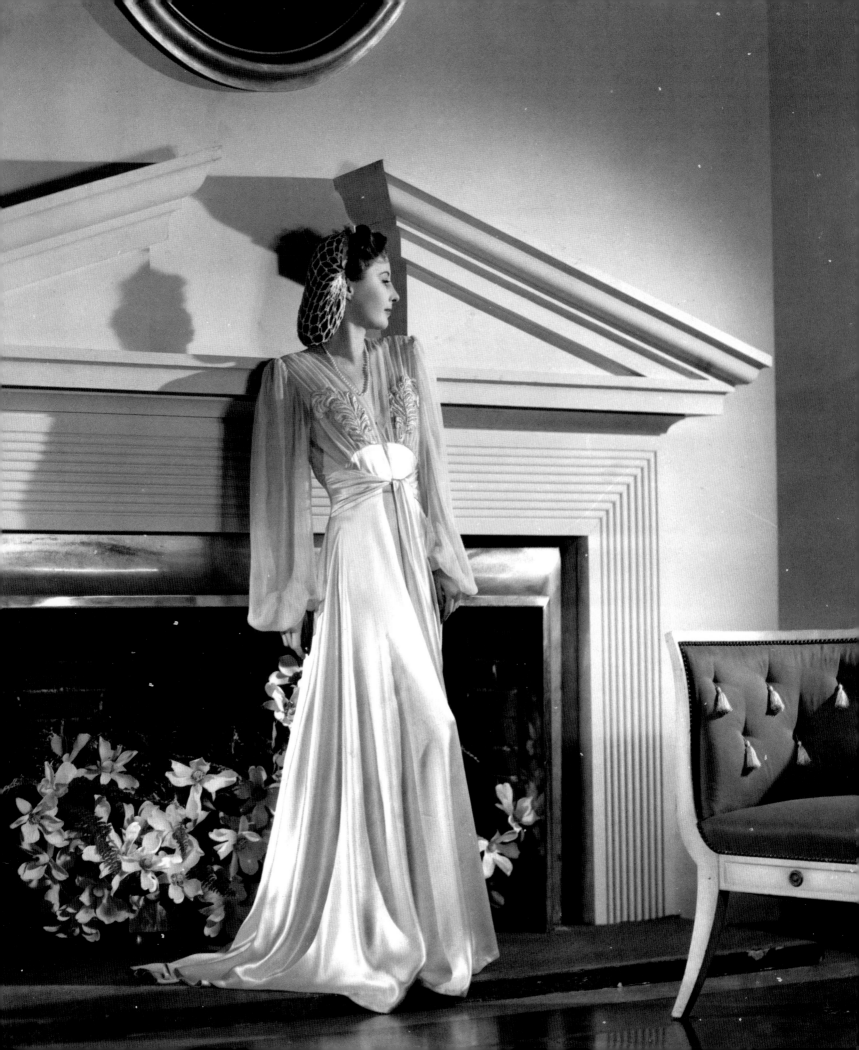

The Forties

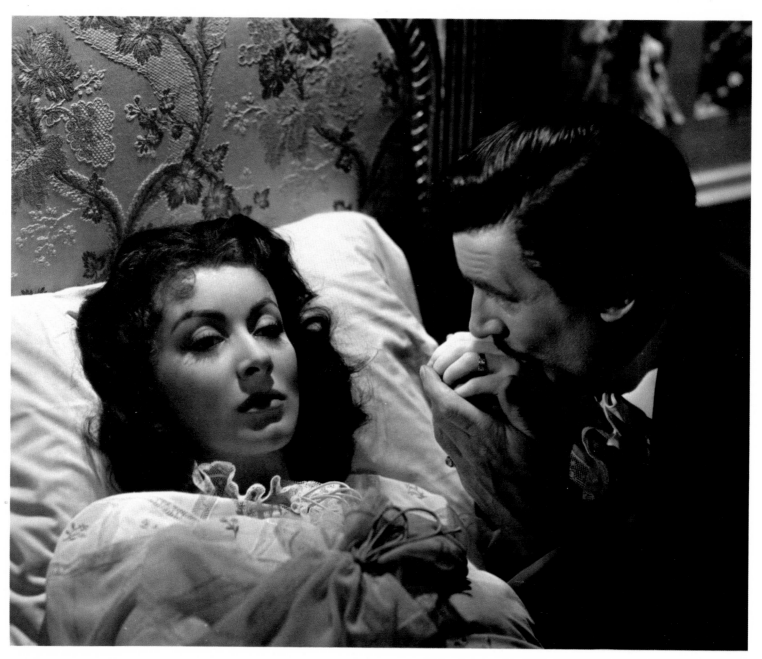

Greer Garson and Walter Pidgeon in *Mrs. Parkington*, 1944

OPPOSITE Vivien Leigh in *That Hamilton Woman*, 1941

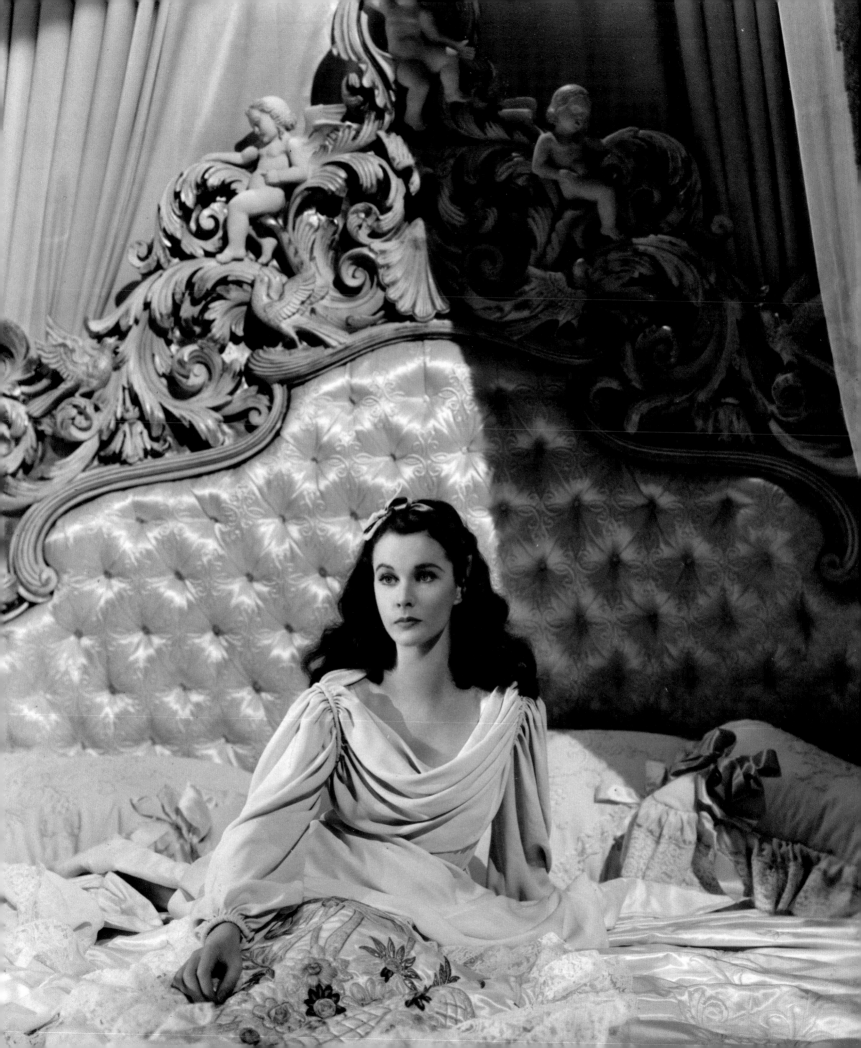

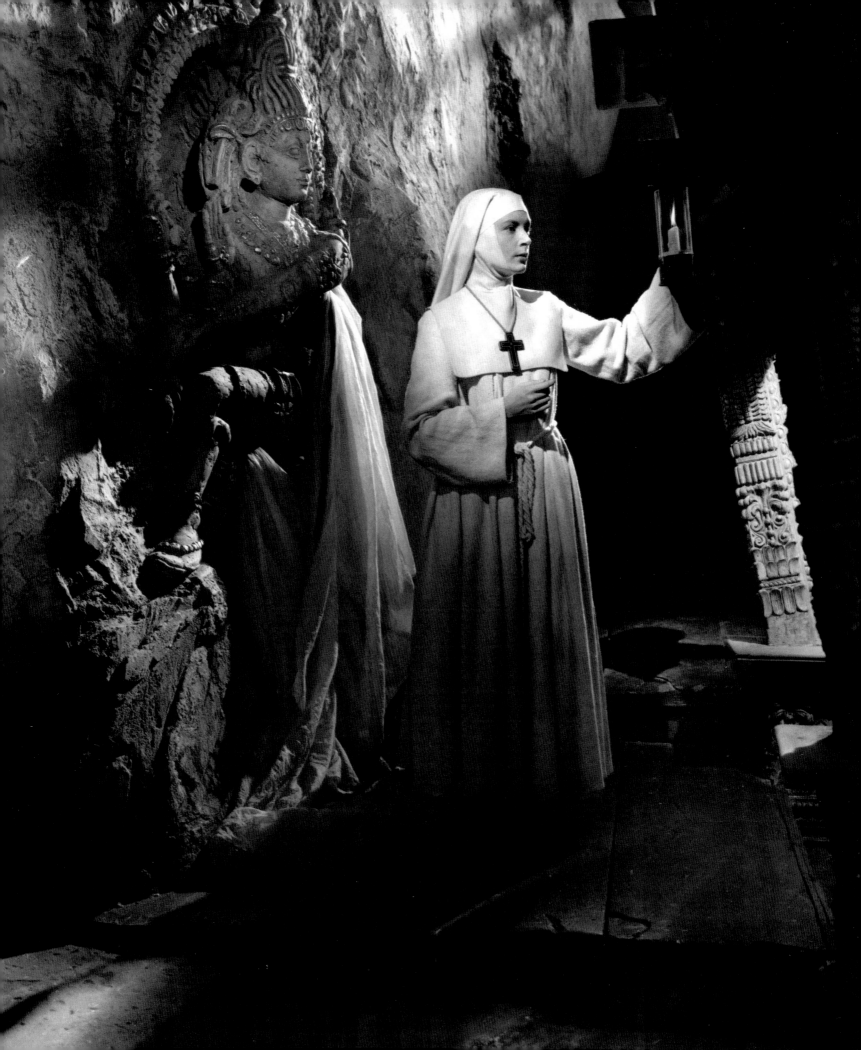

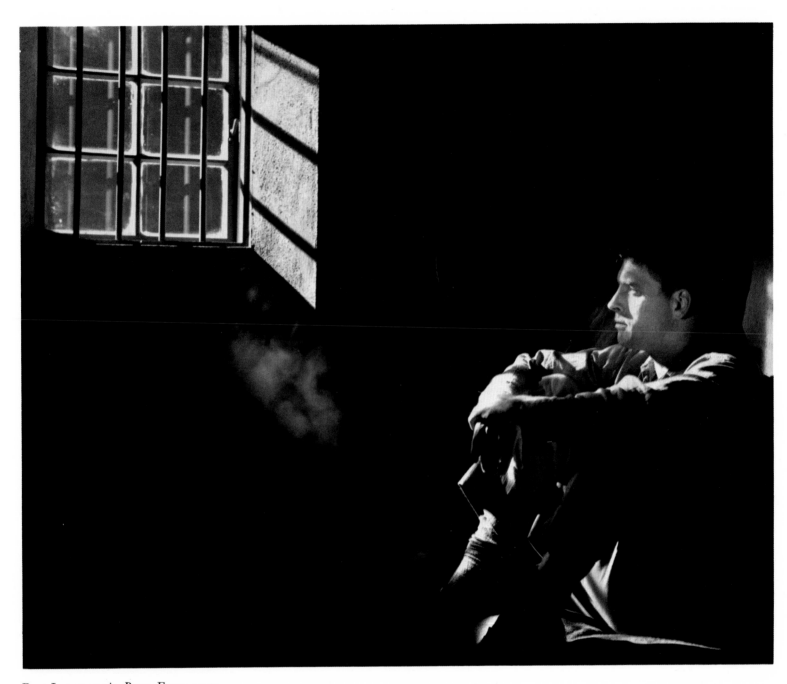

Burt Lancaster in *Brute Force*, 1947

OPPOSITE Deborah Kerr in *Black Narcissus*, 1946

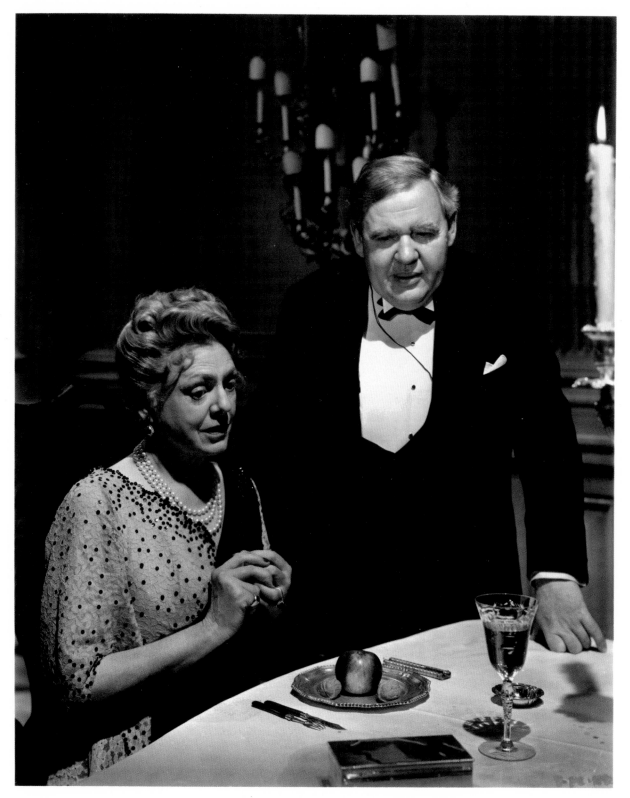

Ethel Barrymore and Charles Laughton in *The Paradine Case*, 1947

OPPOSITE Bette Davis in *Mr. Skeffington*, 1944

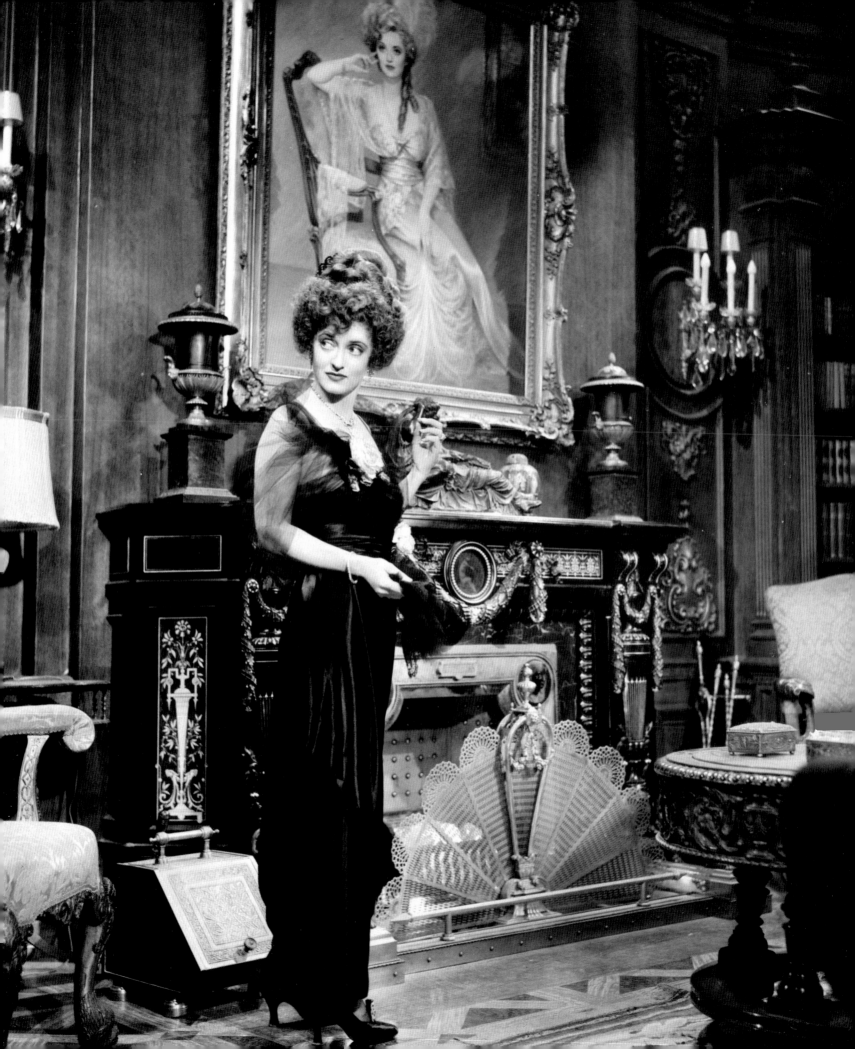

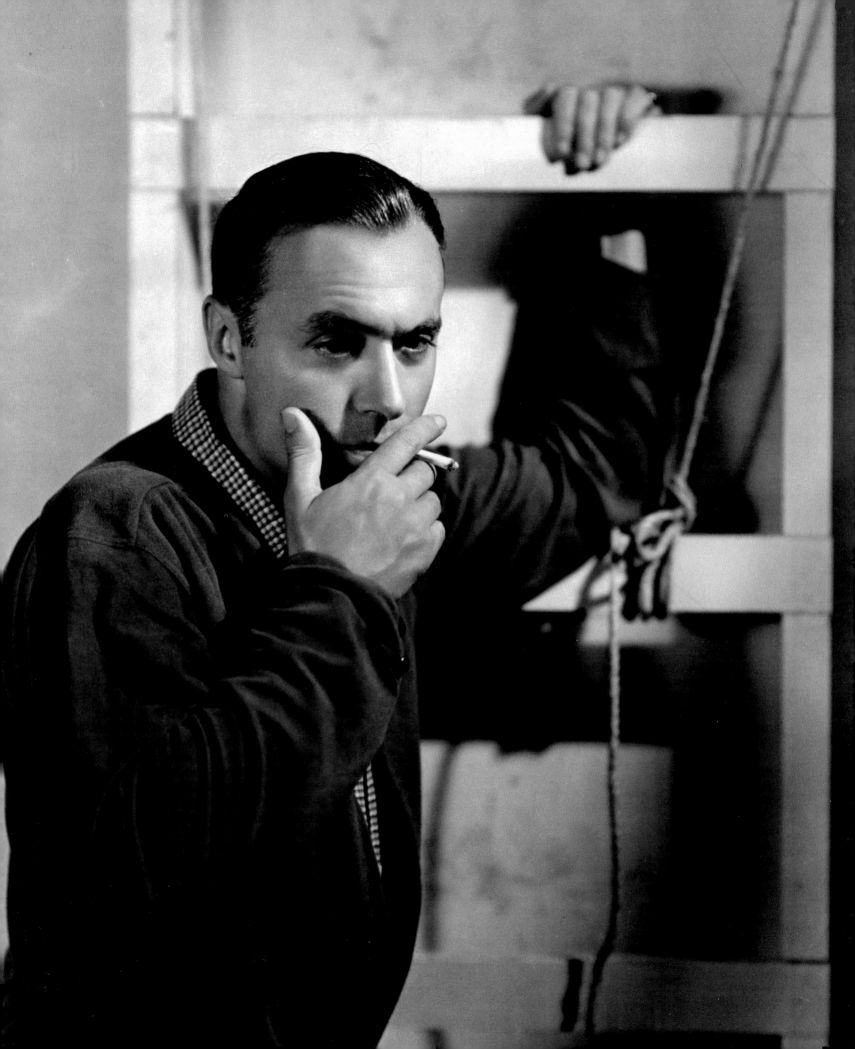

OPPOSITE Charles Boyer, 1941

Linda Darnell in *Star Dust*, 1940

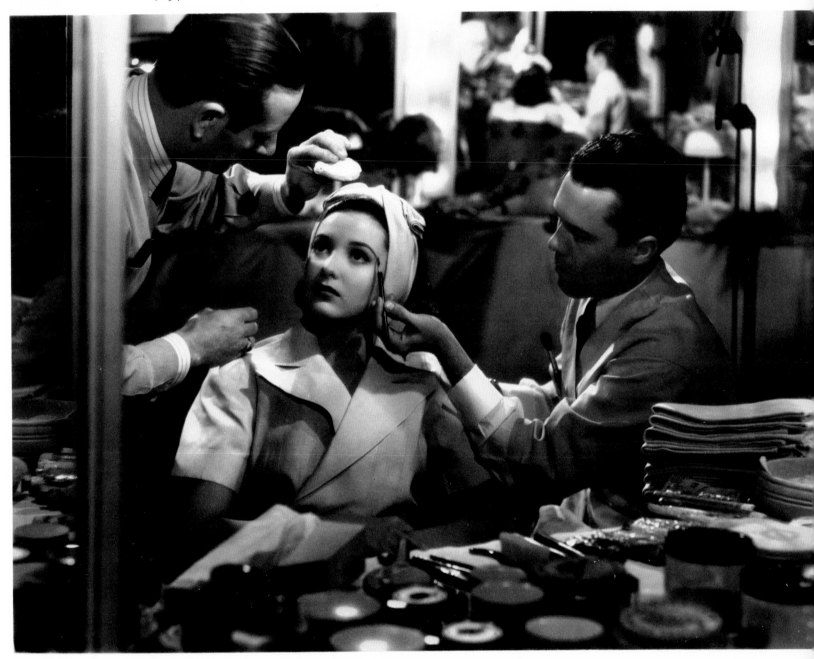

OPPOSITE Veronica Lake, 1941

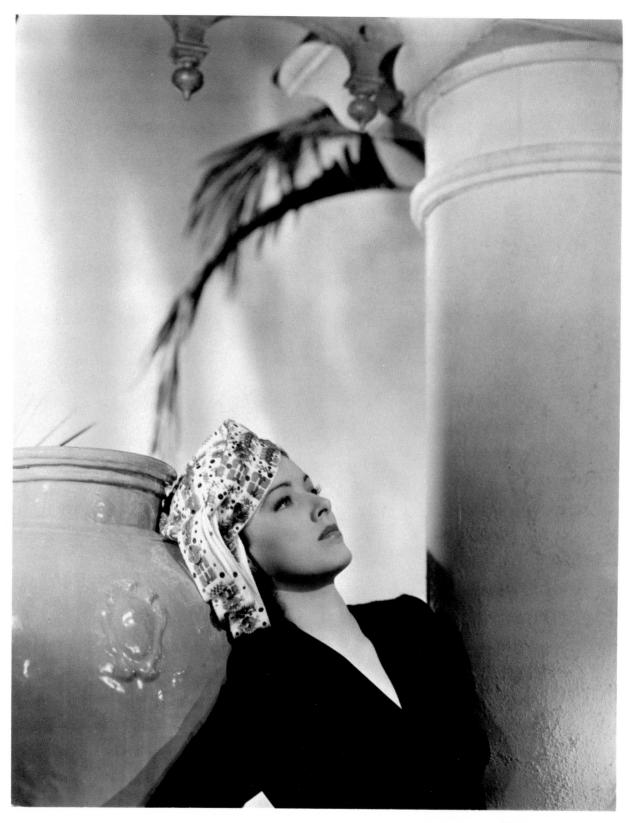

Eleanor Parker, 1943

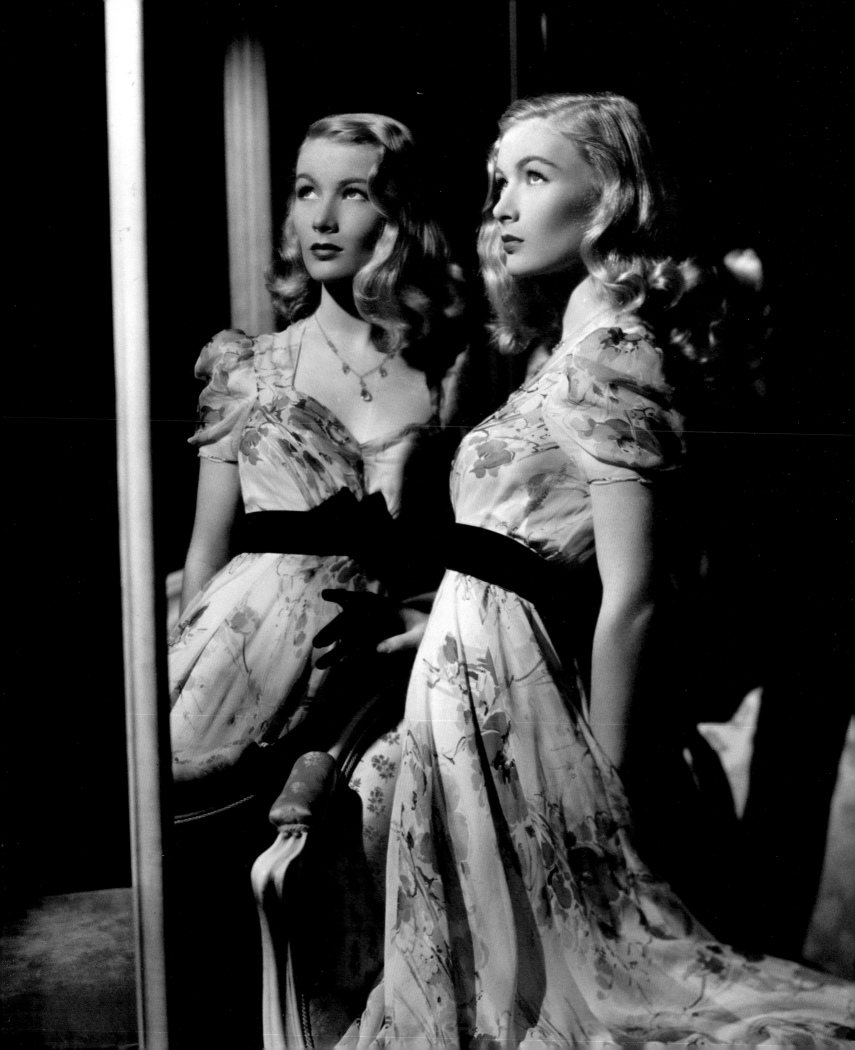

OPPOSITE Gary Cooper and Barbara Stanwyck, 1941

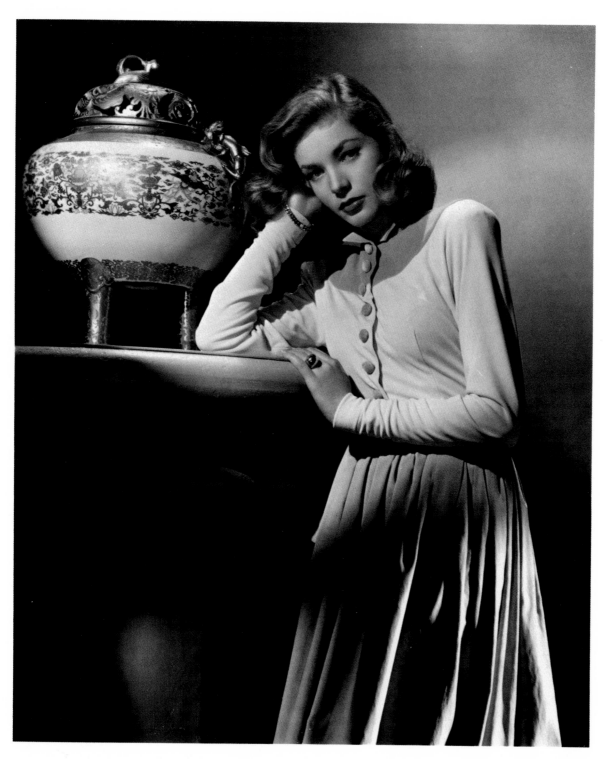

Lauren Bacall, 1945

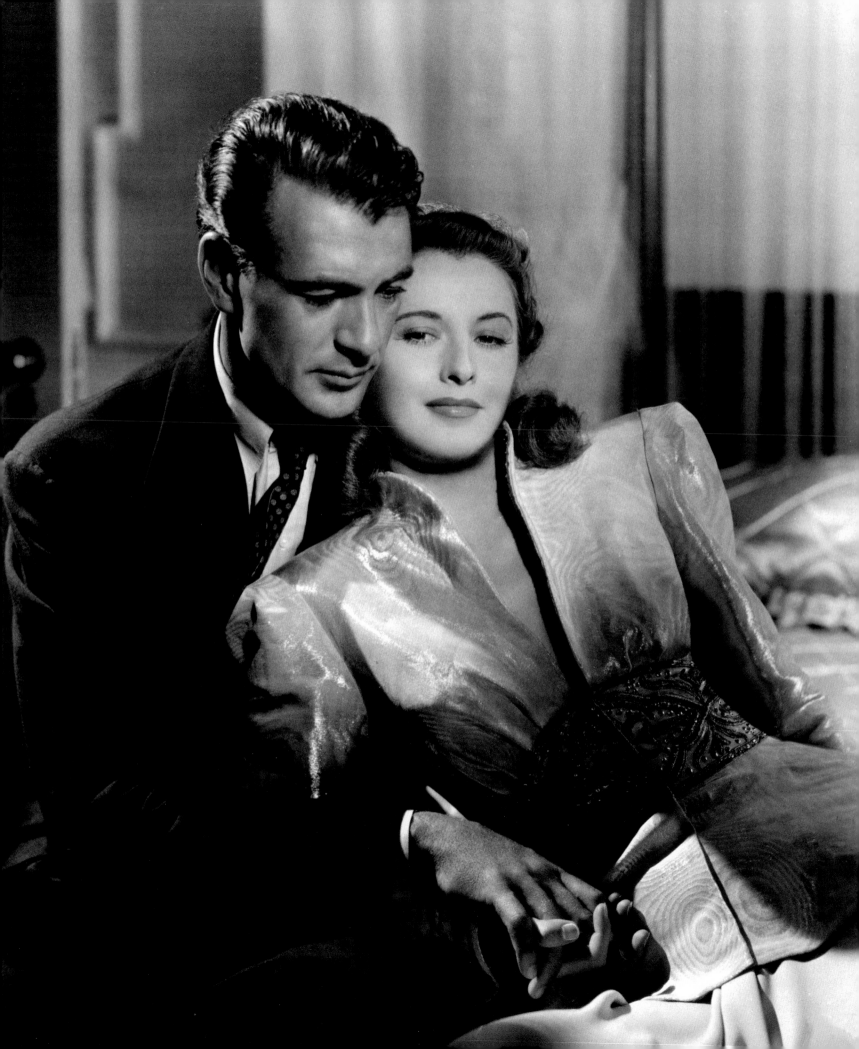

OPPOSITE Susan Hayward, 1942

Spencer Tracy in *The Seventh Cross*, 1944

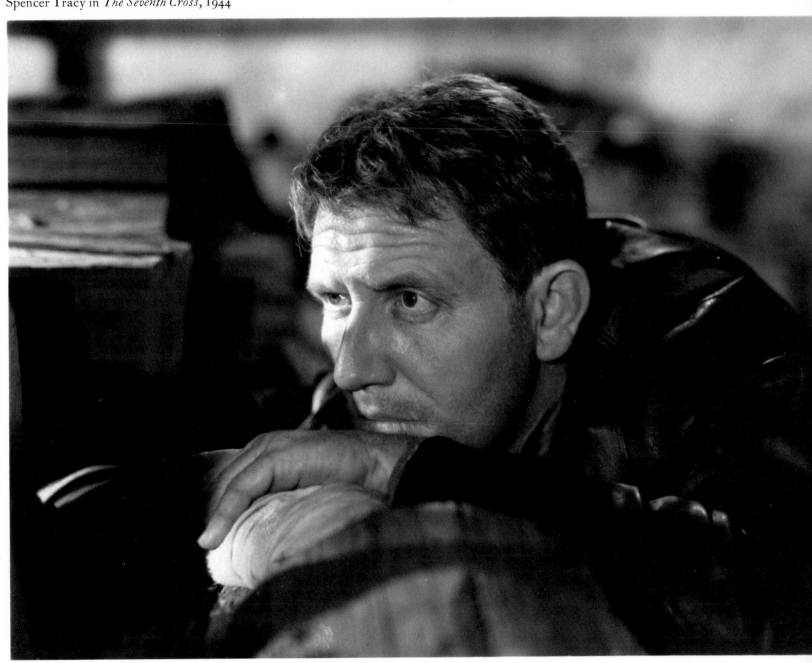

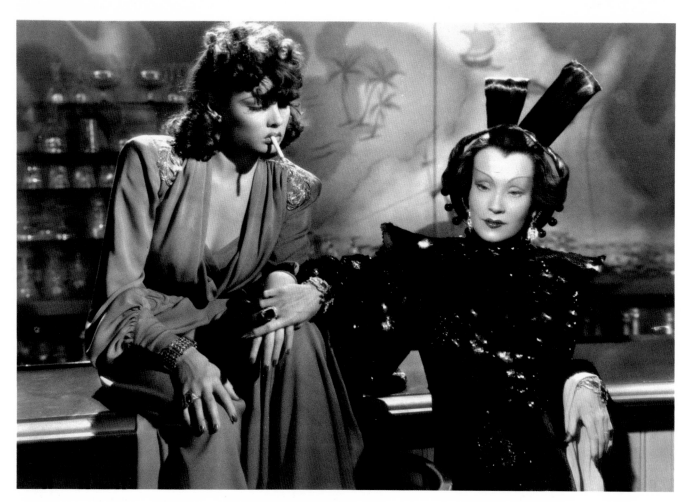

ABOVE Gene Tierney and Ona Munson in *The Shanghai Gesture*, 1941

LEFT Turhan Bey, 1945

OPPOSITE Joan Blondell, 1941

OPPOSITE Lana Turner, 1941

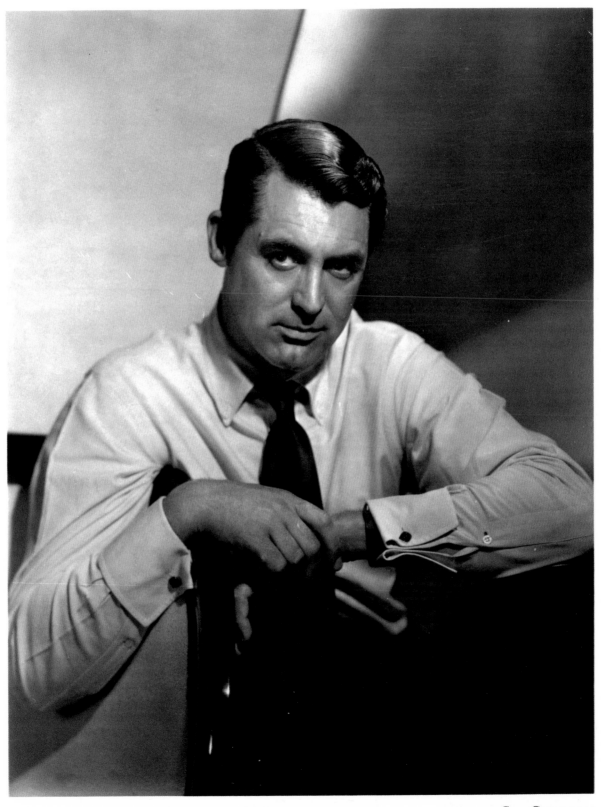

Cary Grant, 1943

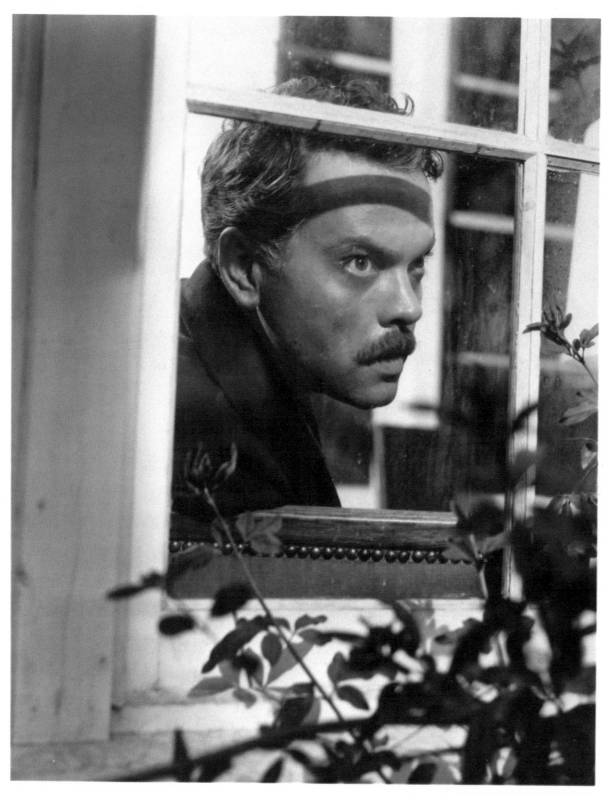

Orson Welles in *The Stranger*, 1946

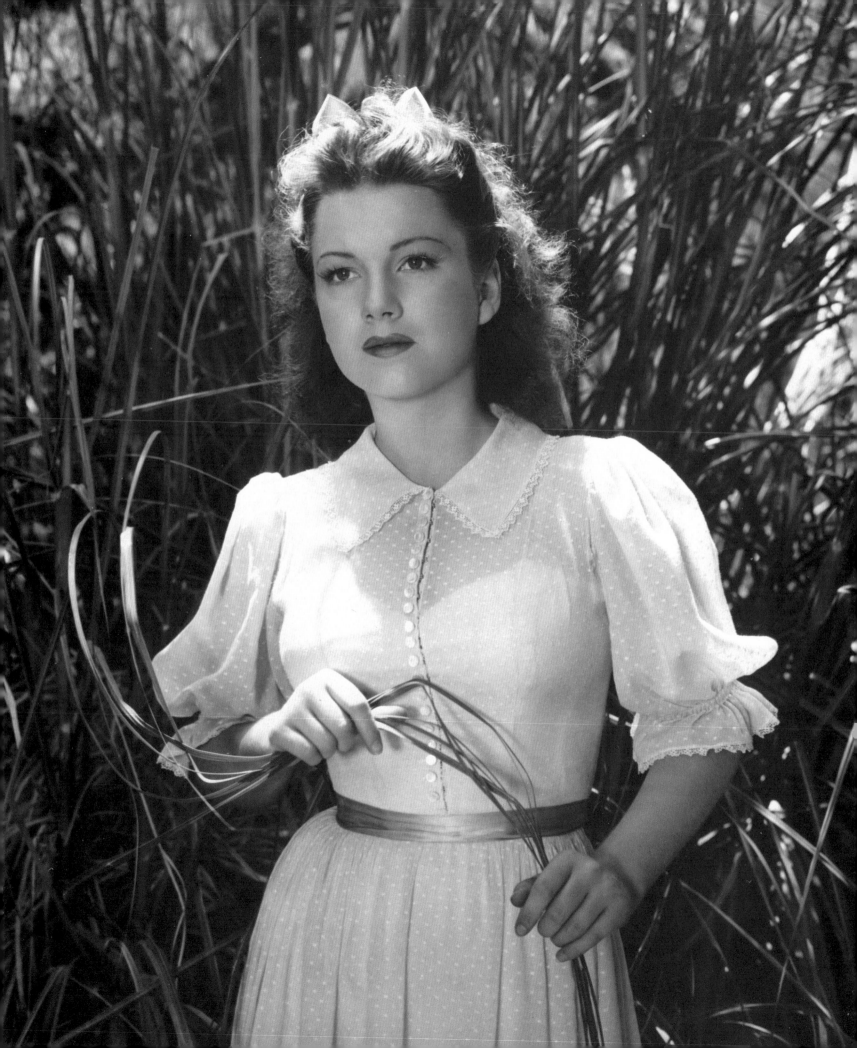

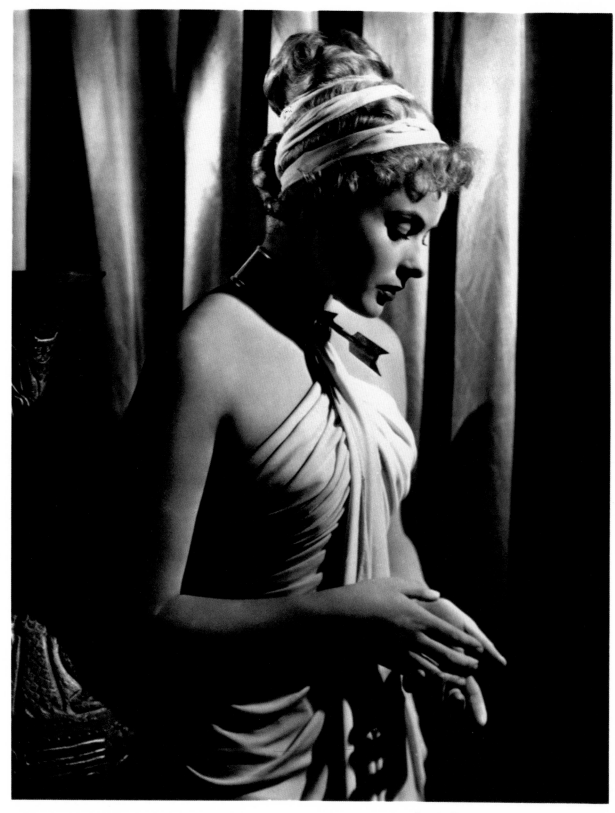

Ingrid Bergman in *Spellbound*, 1945

OPPOSITE Rita Hayworth, 1941

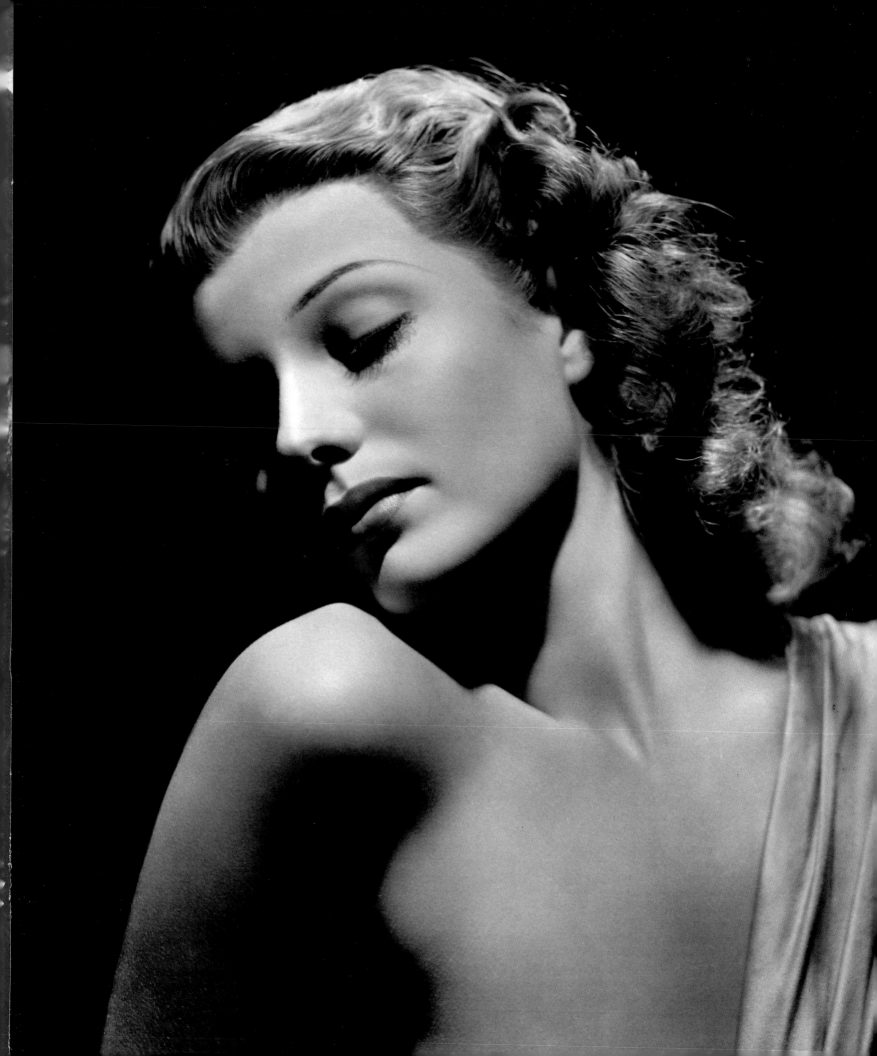

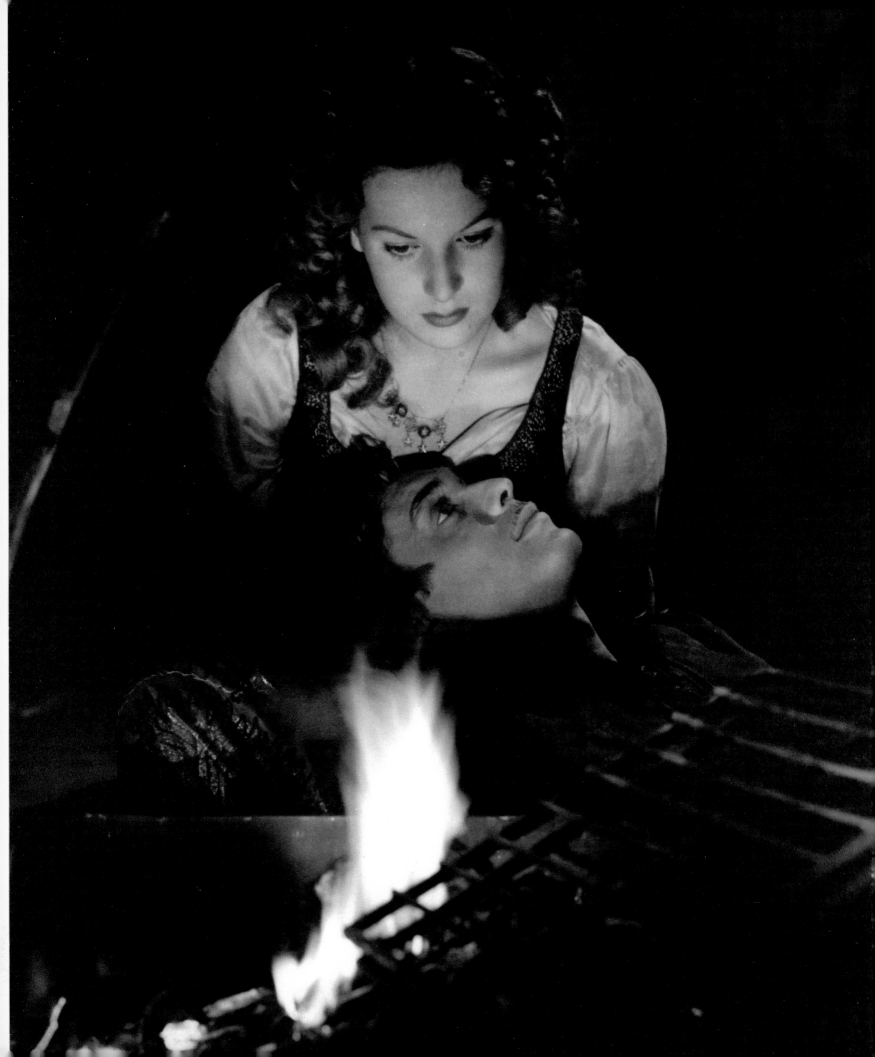

OPPOSITE Maureen O'Hara and Edmond O'Brien in *The Hunchback of Notre Dame*, 1940

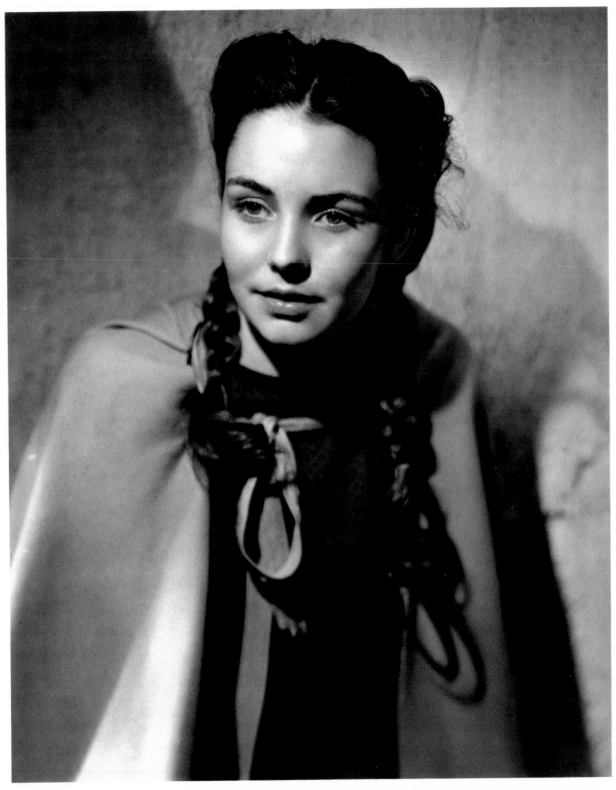

Jennifer Jones in *The Song of Bernadette*, 1944

OPPOSITE Bette Davis in *The Little Foxes*, 1941

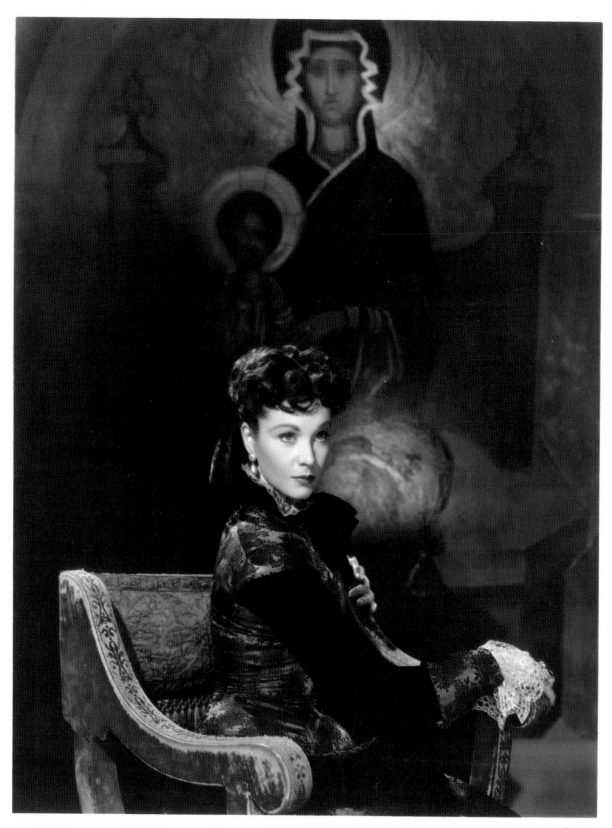

Vivien Leigh in *Anna Karenina*, 1948

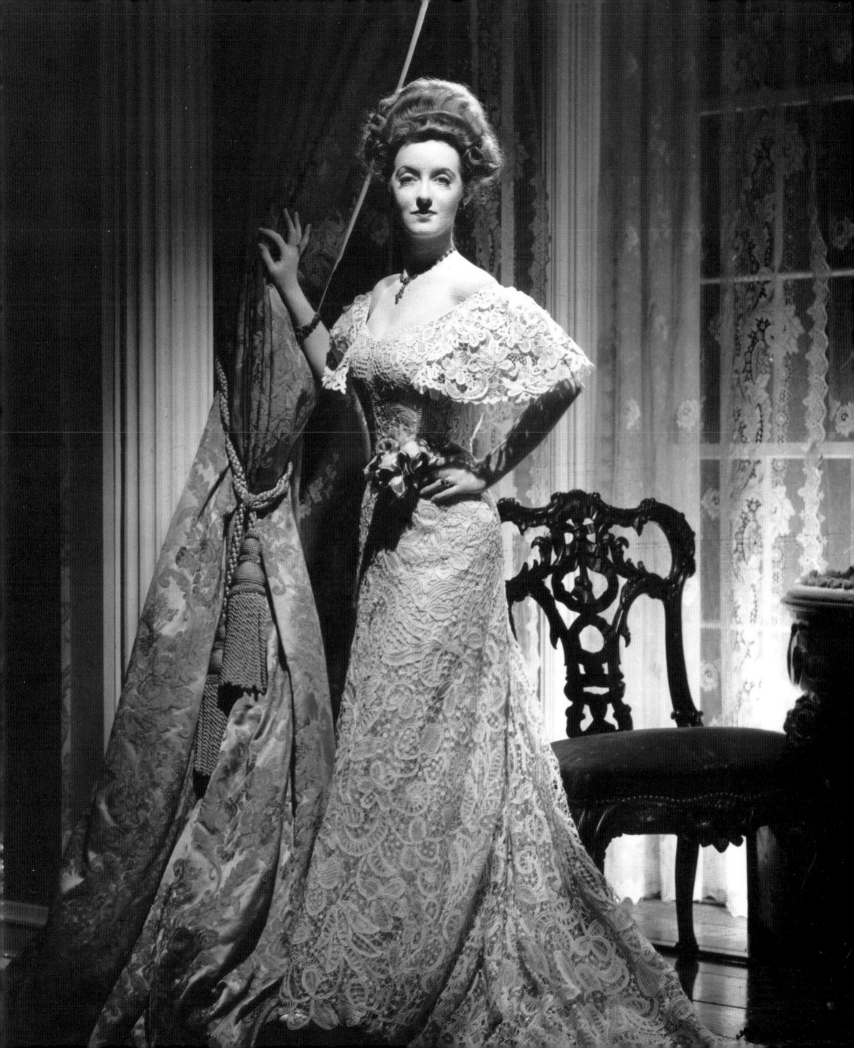

OPPOSITE Paulette Goddard in *An Ideal Husband*, 1948

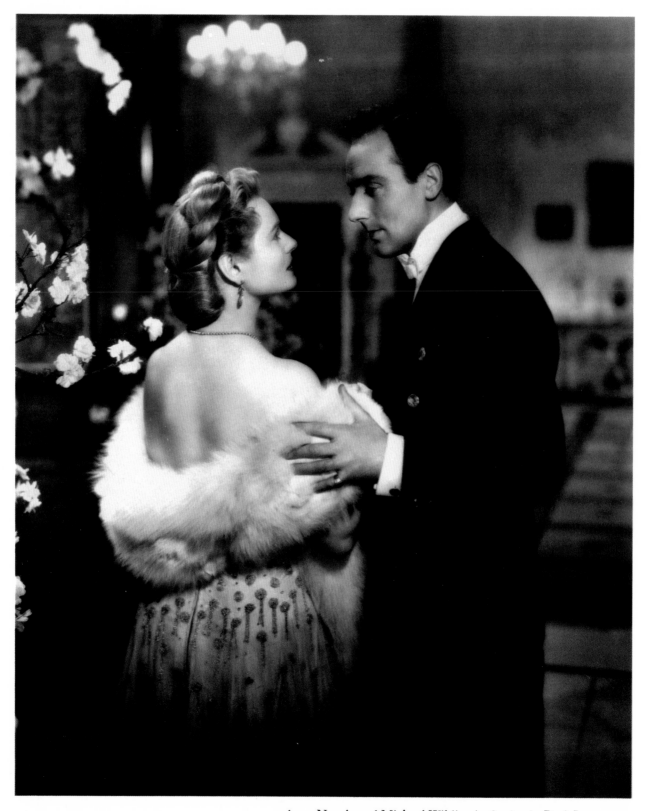

Anna Neagle and Michael Wilding in *Spring in Park Lane*, 1949

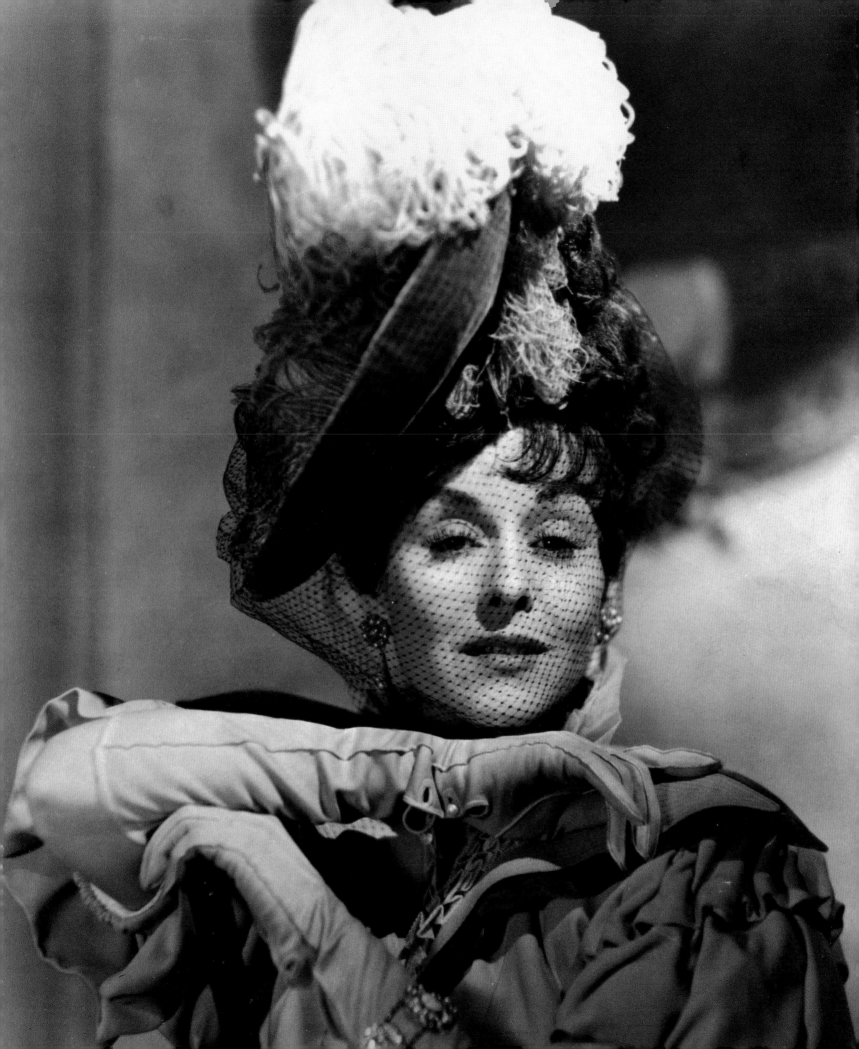

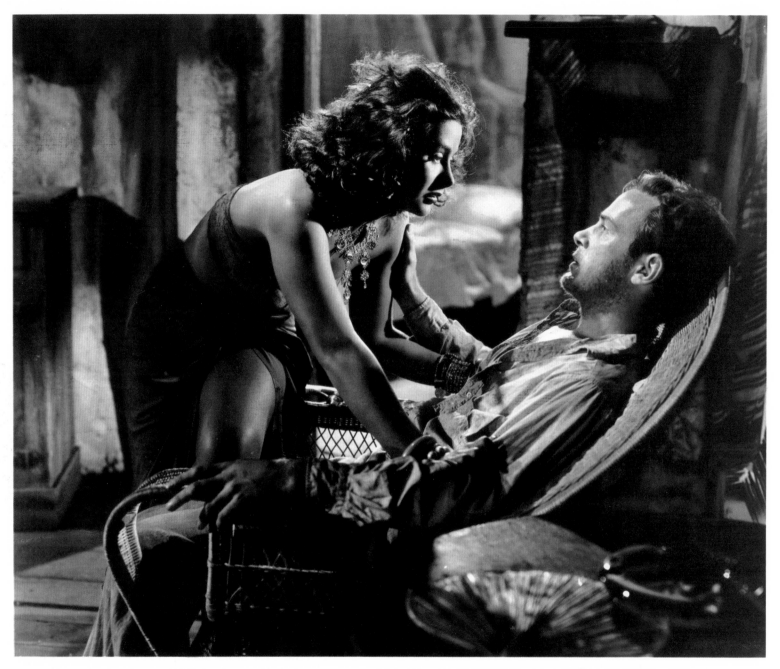

Hedy Lamarr and Richard Carlson in *White Cargo*, 1942

OPPOSITE Hedy Lamarr, 1944

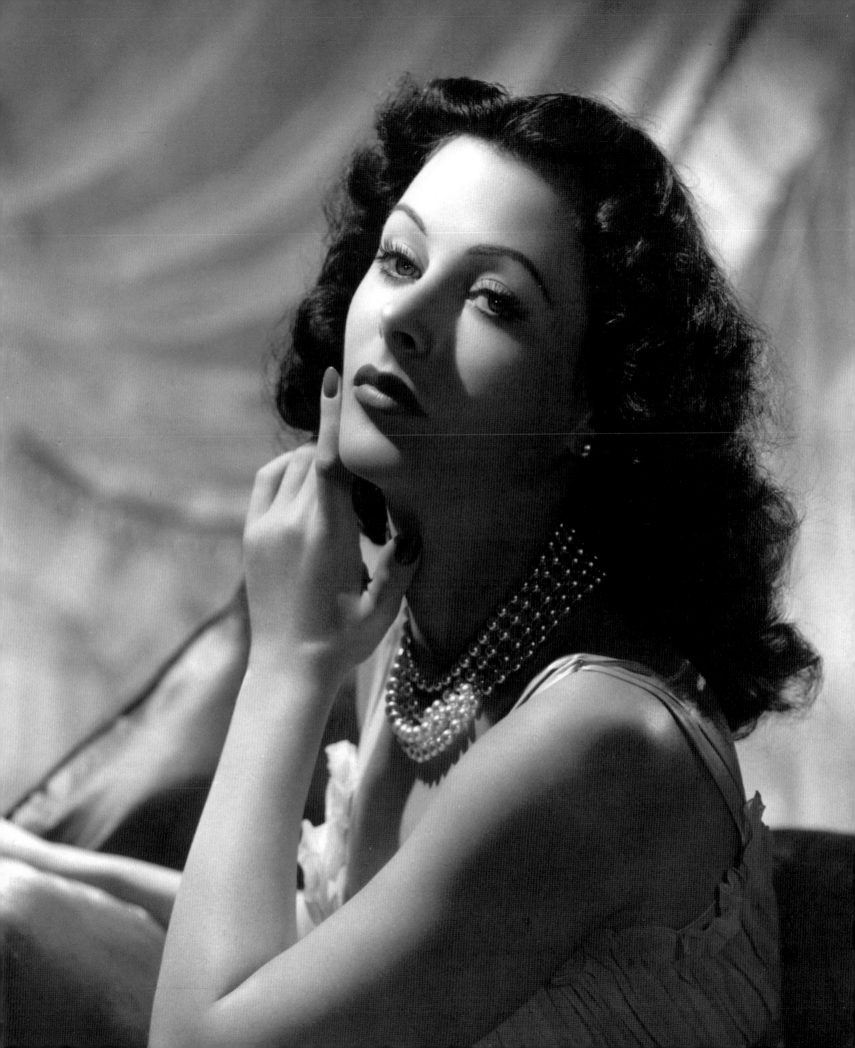

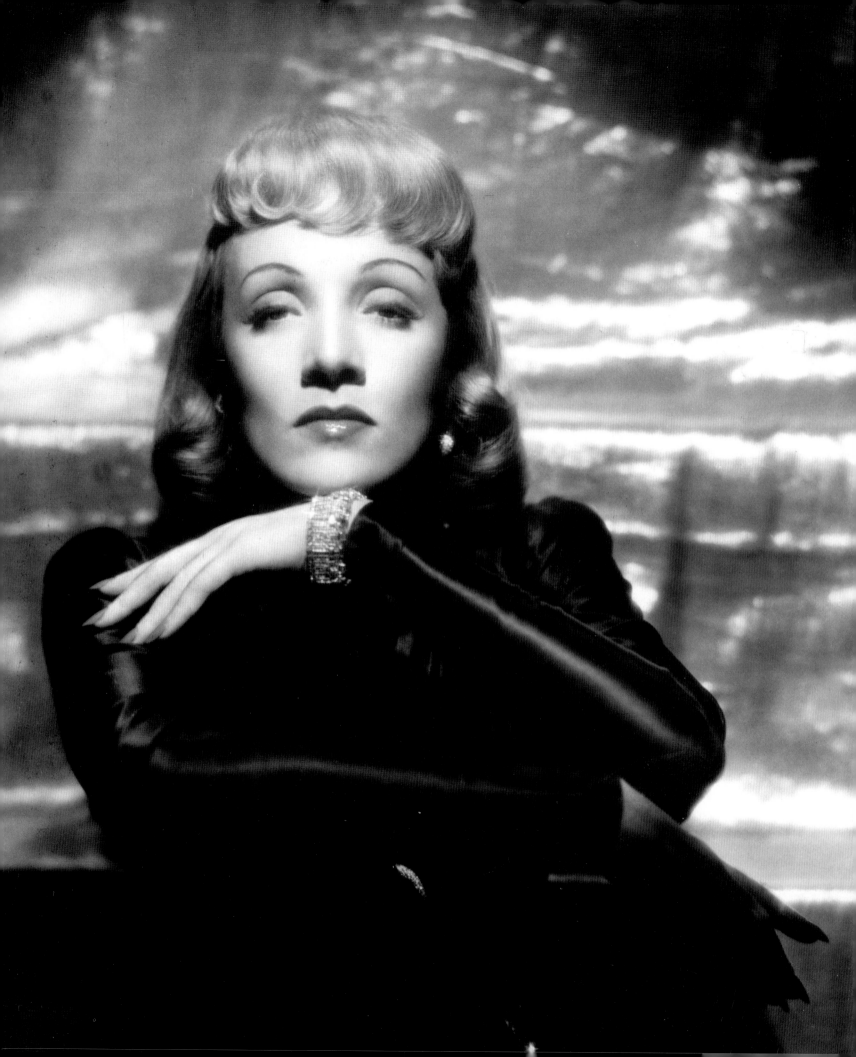

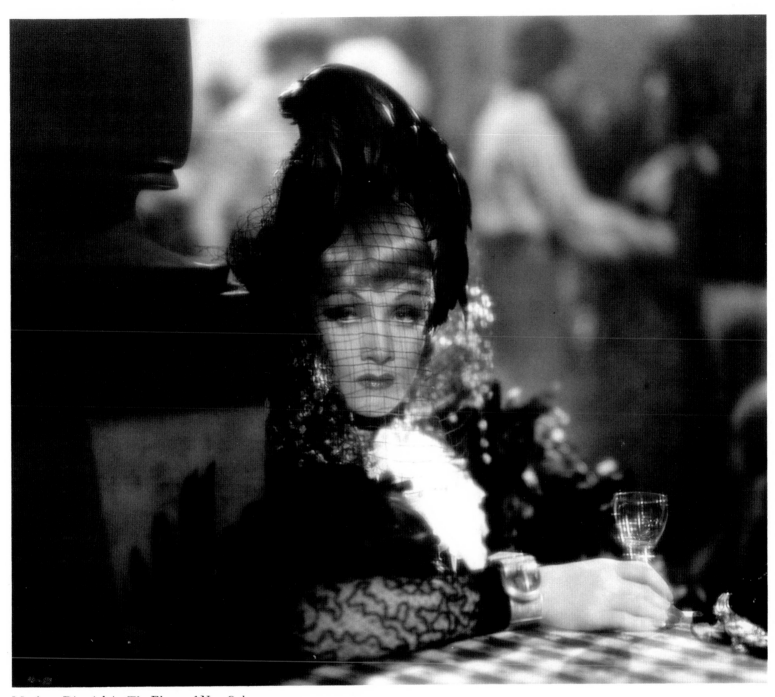

Marlene Dietrich in *The Flame of New Orleans*, 1941

opposite Marlene Dietrich in *Manpower*, 1941

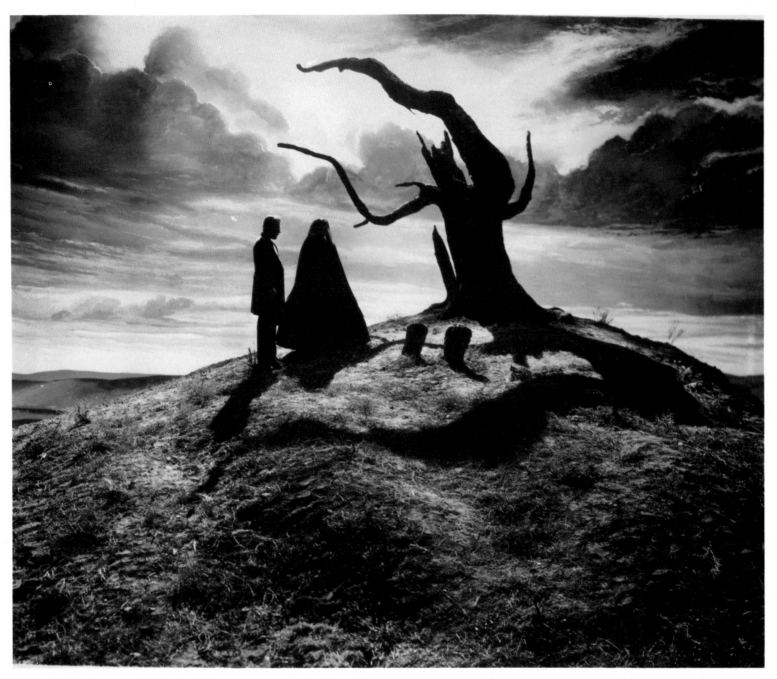

Brian Donlevy and Barbara Stanwyck in *The Great Man's Lady*, 1942

OPPOSITE Katina Paxinou, Ingrid Bergman and Gary Cooper in *For Whom The Bell Tolls*, 1942

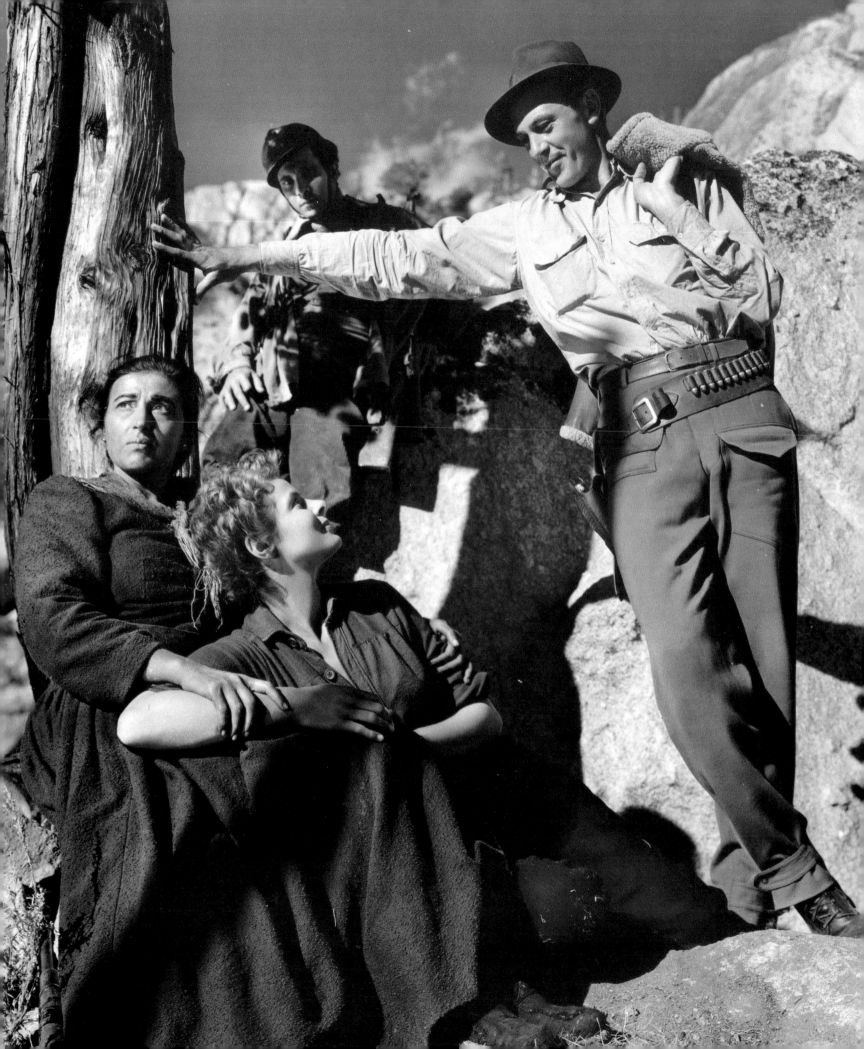

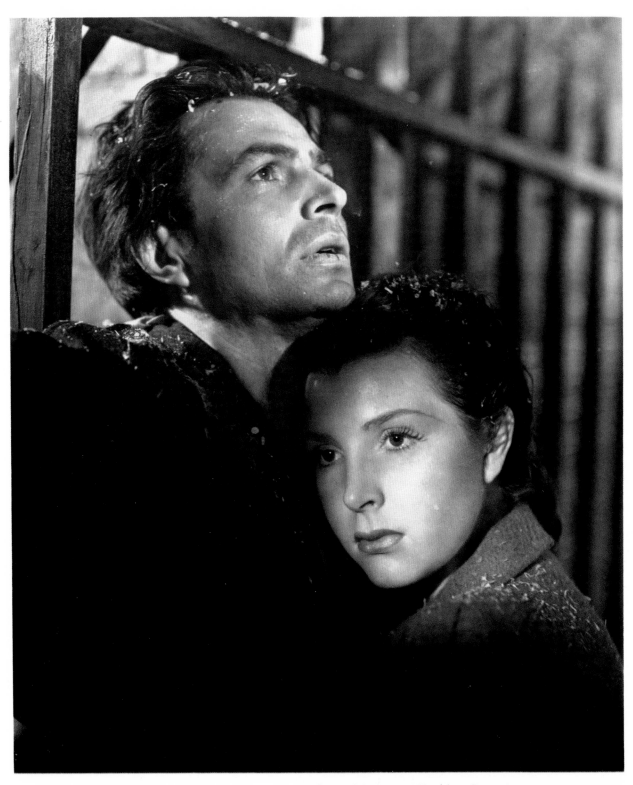

James Mason and Kathleen Ryan in *Odd Man Out*, 1947

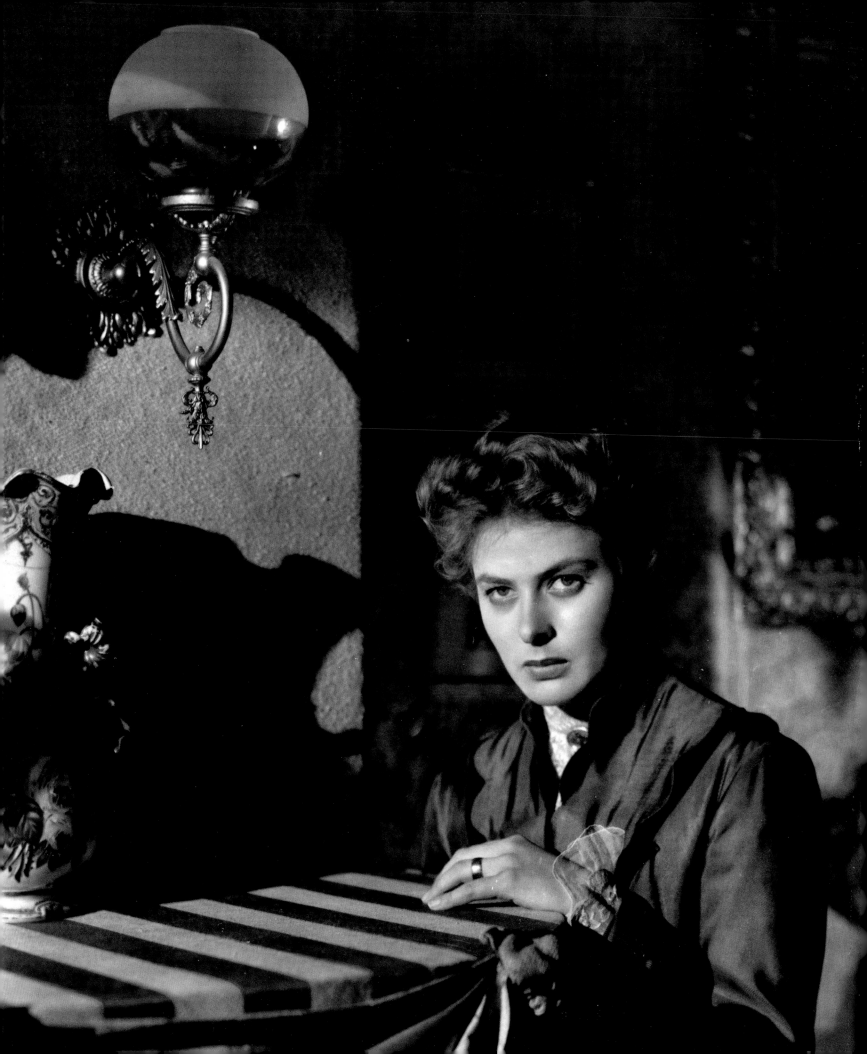

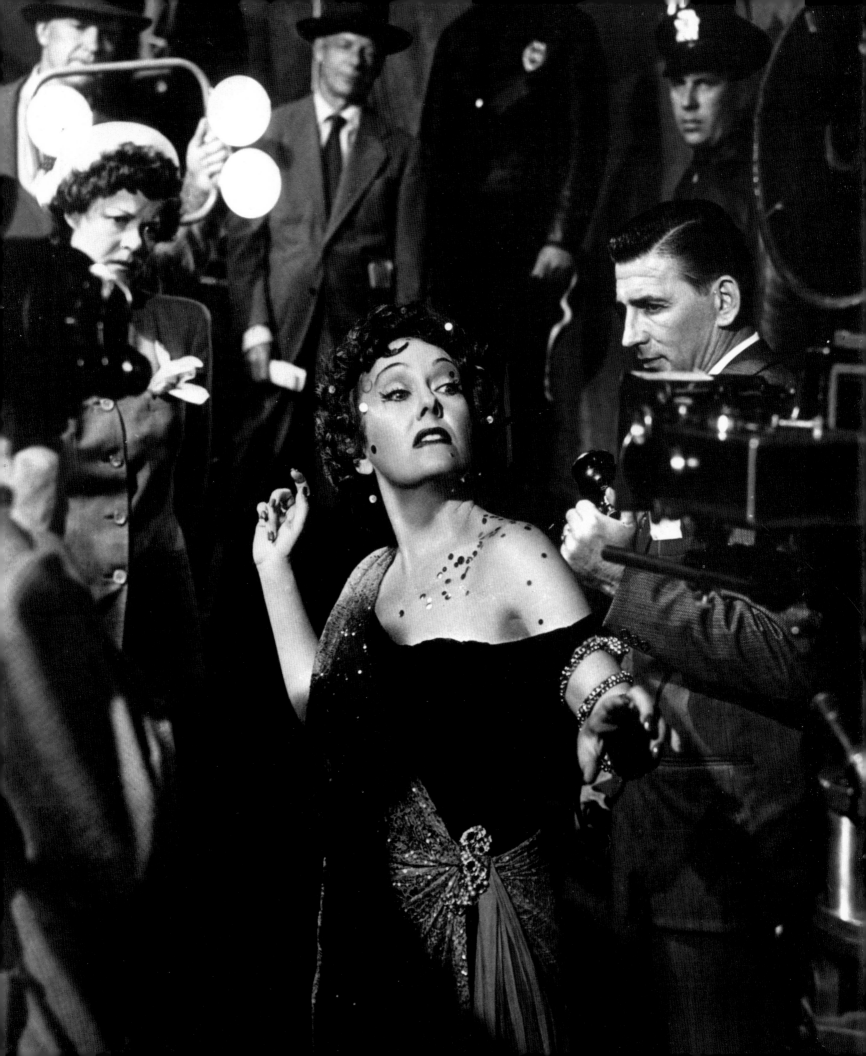

I never noticed the stars before. I always thought of them as great big diamonds that belonged to someone. Now they frighten me. They make me feel that it was all a dream, all my youth.

— F. Scott Fitzgerald

Index

Acknowledgements

I am grateful to the following for their assistance in the preparation of this book: Academy of Motion Picture Arts and Sciences; Irving Adler, Paramount Pictures; John E. Allen, Inc.; Marie Baxter, *Look* Magazine; Ralph Buck, United Artists; James Card, George Eastman House; William K. Everson; Monroe Friedman, Universal Pictures; Carole Moses Harman; Herb Honis, United Artists; Norman Kaphan, Metro-Goldwyn-Mayer; Jack Kerness, Columbia Pictures; Jack Lyons, Paramount Pictures; Lou Marino, Warner Brothers; Museum of Modern Art; George C. Pratt, George Eastman House; Mark Ricci; Jonas Rosenfield, Jr., Twentieth Century-Fox; Ella Smith; Charles L. Turner; Lou Valentino; Leo Wilder, Warner Brothers.

Richard Lawton 1973